THE COMPLETE IDIOT'S GUIDE® TO

Digital Photography

by Steve Greenberg

QUE®

A Division of Macmillan Computer Publishing
201 W. 103rd Street, Indianapolis, IN 46290

The Complete Idiot's Guide to Digital Photography

International Standard Book Number: 0-7897-2109-0

Library of Congress Catalog Card Number: 99-62406

Printed in the United States of America

First Printing: September 1999

02 01 00 99 4 3 2 1

Trademarks

Warning and Disclaimer

Executive Editor
Christopher A. Will

Development Editor
Sarah Robbins

Managing Editor
Thomas F. Hayes

Project Editor
Dawn Pearson

Copy Editor
Julie McNamee

Indexer
Heather McNeill

Technical Editor
Charles Maier

Software Development Specialist
Jason Haines

Proofreader
Maribeth Echard

Page Layout
Cyndi Davis-Hubler

Contents at a Glance

Table of Contents

Part 4: Let's See It: Imaging Techniques 181

About the Author

Steve Greenberg

Steve Greenberg has been a commercial photographer in Boston for more than 15 years. He is a 1979 graduate of the Rhode Island School of Design. In 1991, he started using electronic imaging to enhance his design capabilities, thus pushing his work past the physical barriers of traditional photography. He received additional advanced training at the Kodak Center for Creative Imaging and at the School of Visual Arts in New York.

One of the first photographers in Boston doing in-house electronic imaging and digital photography, Steve continues to develop new techniques and is a beta site for various software companies. He is a member of the International Design by Electronics Association, International Quick Time Virtual Reality Association, and a founding member of the Boston area Digital Photographers Color Management Users Group (no acronym yet!). Steve has lectured at advertising agencies and spoken at the AIGA symposium on electronic imaging, the Apple Computer conference on new media and technology, and has guest lectured at the New England School of Photography. His published work has appeared in *Photo District News* and in *Color Publishing*. Steve has authored articles on color management and digital photography, and was featured in the Portfolio section of *Photo District News/PIX* in the 1998 August issue. He has also won awards for electronic design and illustration from Step By Step Graphics, Graphics, and *Photo District News*.

In order to replace his fondness for splashing about in the darkroom, since going digital, Steve has taken up the hobby of brewing beer. We call it splash replacement.

Dedication

I want to dedicate this book with all my love and heart to my boys, Asher and Ari, who haven't seen much of me over the last few months. I would like to thank them for all the many deliveries of Coke and coffee. Guys, get those boots on—Dad is back, and we have a few new mountains to climb this summer! I especially want to dedicate this book to my wonderful wife Tova, without whose patience, love, and support I would have never been able to write this book.

Also, this book is dedicated to my parents, who taught me to work hard and strive for excellence; to my friends and family, who supported me and cheered me on; and to the goddess of caffeine.

Acknowledgments

I want to thank my editors Kate Welsh, Dawn Pearson, Julie McNamee, Sharry Gregory, Chris Will, Sarah Robbins, and Maribeth Echard—and my technical editor, Charles Maier—for all their help. They helped turn my folk story into this book!

I would like to also thank the many vendors who supplied cameras and equipment for me to review, specifically Tara Poole (Kodak), Jill Martin (Epson), Sharon Fisher (Agfa), Karen Thomas (Olympus), and Steve Alessandrin (Minolta).

Tell Us What You Think!

As the reader of this book, *you* are our most important critic and commentator. We value your opinion and want to know what we're doing right, what we could do better, what areas you would like to see us publish in, and any other words of wisdom you're willing to pass our way.

As the Executive Editor for the Consumer team at Macmillan Computer Publishing, I welcome your comments. You can fax, email, or write me directly to let me know what you did or didn't like about this book—as well as what we can do to make our books stronger.

Please note that I cannot help you with technical problems related to the topic of this book, and that due to the high volume of mail I receive, I might not be able to reply to every message.

When you write, please be sure to include this book's title and author, as well as your name and phone or fax number. I will carefully review your comments and share them with the author and editors who worked on the book.

Fax: 317-581-4666

Email: consumer@mcp.com

Mail: Executive Editor
 Consumer
 Macmillan Computer Publishing
 201 West 103rd Street
 Indianapolis, IN 46290 USA

Introduction

We are in the age of information. With a few pecks at our keyboards and a glance at our monitors, we can find out almost anything. The massive amounts of information we can access, store, and manipulate are all due to the digital age.

When I was younger, everything you needed to know could be looked up in the encyclopedia set on the bookshelf or the books in the library. Encyclopedias in my day were heavy, expensive, bound tomes of information printed on ever-so-thin paper. Today, my sons load their encyclopedia CD, which came bundled free with their computer, to learn what they need to know, or with a few clicks race down the information superhighway to a Web site.

Our ability to rapidly acquire and process information coupled with the exponential growth of technology has led to the development of wonderful tools, including digital cameras. Image-enhancing software, cheap and transportable storage devices, and ever-increasing computing power have made it possible to photograph without film.

Computer stores are everywhere. You might be at a computer store right now, at this very moment reading this book (please buy it, it's great). Look down the aisles, and you'll see cartons of computers, miles of monitors, and plenty of peripherals. But now more and more shelf space is being given to digital cameras. Yes, it's true, Toto—we're not in Kansas anymore; we've entered a wonderful and colorful world.

This book takes in a wide view of digital photography. We'll start with a quick history of photography and along the way learn the basics of exposure and composition. We'll also learn how to purchase a digital camera and how to use it to get the most out of it. Enhancing and manipulating an image can be fun and exciting and we'll look at these issues, too. Along the way, you'll find plenty of insight and useful hints in the "Say Cheese" and "Behind the Shutter" sidebars. I strived to make this book accessible and useful to beginners as well as to advanced photographers.

Part 1
Digital Capture: The Future Is Now

When does the future become the present? When does futuristic technology become new technology? When will we all have tri-corders? Technology becomes real when it can be seen and when it can be used. As a professional photographer, I have been using digital cameras almost exclusively for eight years. If you look in the advertising sections of the newspaper or in the dozen or so computer catalogs you get in the mail each week, you'll see digital cameras everywhere. All the photographs in this book were taken with a digital camera. The future is now!

Look, Ma, No Film: Why Digital Photography?

In This Chapter

➤ History of photography

➤ Advantages of digital photography

➤ Disadvantages of digital photography

Why digital photography? Because we are control freaks, that's why. We want to move, recolor, and manipulate our photos. We want to see them right away, and we want to show them to everybody. With digital photography, I can email the most adorable picture of our dog to my parents, my in-laws, my wife's grandma, my sister, my wife's sisters, or anyone who has ever sent us a holiday card, or I can post it on our family Web site for all the world to admire. (Of course, the true power of digital photography is that I can make our dog, Wrinkles, look adorable in the first place.)

Painting with Light: A Brief History of Photography

The first cameras were not anything like what we use today. They were, however, used for the same reason: to capture light. The earliest cameras were, in reality, just darkened rooms. A small hole in a window shade or in the side of a wall let light in and a perfect (albeit upside down) image of what was outside the room would appear on a far wall or some other surface. This device was called the *camera obscura* (literally "dark room"). In 1558, Giovanni Battista della Porta's book *Natural Magic* was the first published account of the camera obscura being used as a tool to aid draftsmen and

illustrators; the camera obscura also became a great source of entertainment for the general public.

Digital photos of Wrinkles have the been the star of our family Web site many times.

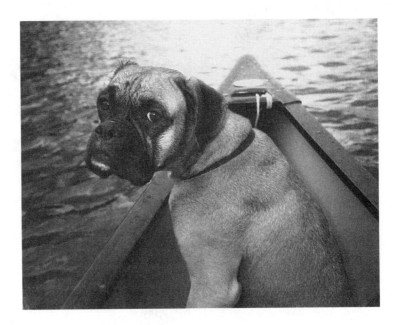

Save the Giant Camera!

Camera obscuras can still be found today. Unfortunately, many are in danger of being dismantled or are in poor repair—including the 50-year-old Giant Camera overlooking Seal Rock in San Francisco, which is slated to close at the end of 1999. To find out how you can help save the Giant Camera, write Joe Durrance at **savethecamera@hotmail.com**.

Gradually, the camera obscura became smaller and smaller, becoming a box, usually made of wood, with a lens attached at one end. On the other end of the box, a mirror was placed at a 45-degree angle. Above this was placed a frosted or ground glass plate. An artist would place thin paper over the ground glass and trace the image that was projected there. Now, with just a little skill, anyone could draw or paint!

A Modern-Day Camera Obscura

When I was in college, some of my friends made a camera obscura of their dorm room. They blocked out all sources of light from a room, covered a window (which faced out onto a park) with opaque paper in which they cut a small hole, and fashioned a shutter out of tape. On the opposite wall, which was the focal point, they hung rolls of transparency slide film. After the tape was removed and the film was exposed, they rolled the film up, placed it in a light-tight box, and had it developed! To display the developed images, my friends built a huge back-lit box with a frosted piece of plexiglass. It was beautiful!

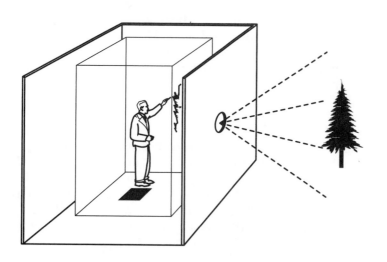

Some camera obscuras were as large as rooms. Others were small and portable and mounted on horse-drawn wagons.

In 1764, Count Francesco Algarotti devoted a chapter to the camera in his *Essay on Painting*. He said, "The best modern painters, among the Italians, have availed themselves greatly of this contrivance; nor is it possible they should have otherwise represented things so much to life." The camera had grown from an amusement center to a tool. This was also the beginning of painting by numbers.

As the camera obscura became much smaller, it began to be used in the field to help artists render life and nature.

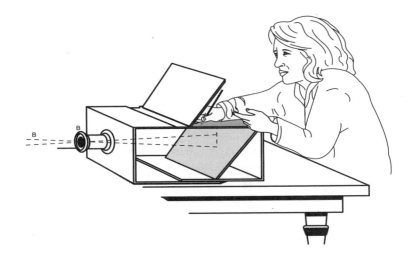

Schulze's Silver Substance

In 1727, a German physicist named Johann Heinrich Schulze discovered that light could be used to alter substances. He put silver, chalk, and nitric acid together in a bottle, did the hokey pokey, and shook it all about. He then exposed the mixture to bright sunlight and found that the mixture darkened to black. To prove that this was a photosensitive reaction as opposed to a heat-induced reaction, he repeated the process but exposed the mixture to intense heat. Proving his theory, this experiment produced no change in the mixture.

Heliography

Joseph Niépce, a Frenchman, began to experiment with photosensitive materials around the early 1800s. Niépce found that bitumin, an asphalt-like substance, would harden when exposed to light. He coated metal plates with bitumin and exposed them to light inside a camera obscura. After a long exposure, the plate was washed to remove the "unexposed" bitumin, and was then dipped in acid, which etched the exposed metal. Finally, the plate was coated with ink and struck to paper. A print of the original image was produced. Niépce called this process heliography.

Daguerreotypes

Around 1825, another Frenchman, Louis Daguerre, was experimenting with the same process. Although Daguerre and Niépce did collaborate on the photographic process, Daguerre took a slightly different direction. He chose to coat a copper plate with silver, and then expose the silver to iodine fumes, creating a silver-iodide salt. This made the plate photosensitive. The plate was then placed in the camera obscura and

exposed to light for a long period of time. As demonstrated by Schulze, the silver-iodine would darken when exposed to light. The downside for Daguerre? Once exposed, the silver salts would continue to darken until, eventually, the entire image became black.

Daguerre solved this problem by accident: He left an exposed plate in a cabinet in which mercury was being stored. When he retrieved the plate, he noticed that the image had stopped developing; it did not continue to darken. The mercury fumes had developed the image. Because this was not the healthiest way to make a photograph or to remove the unused silver, Sir John Herschel, a British astronomer and scientist, suggested in 1819 that the plate be washed with a solution of sodium hyposul-

That Famous Photo Perfume: L'air du Darkroom

Sodium hyposulfate, aka sodium thiosulfate ($Na_2S_2O_3$), is called *fixer* by those of us who still "do film." By the way, if hardener (potassium alum) is not mixed with fixer, it will not produce *its* famous odor.

fate, which would chemically remove the unexposed silver. Daguerre called his photos *daguerreotypes*.

Daguerreotypes were originally rare and expensive; only the very rich could afford to have daguerreotypes taken of them. Later, after the Civil War, they became very common and affordable to the general public.

Talbotypes

Working at the same time as Daguerre was Englishman William Henry Fox Talbot. Talbot used a similar process to Daguerre's, except that he used paper instead of metal

Eggs…Not Just for Breakfast!

Many improvements to these processes were made over the next 50 years or so. Better "negative" and "positive" materials were produced, and chemical processes helped decrease the exposure times. Some of the most beautiful prints I've ever seen were made with 16×20-inch glass plate negatives that were printed out on paper with an albumen and silver emulsion. Albumen, which is made from egg whites, forms a suspension, which holds the silver nitrate particles. This mixture is called an *emulsion*. The emulsion can be coated on paper, glass, or even tin.

for his "plate." The image he produced was a negative. (Remember, where light struck the silver, it turned black; where it didn't, the silver was unaffected or remained white. The daugerreotype was also a negative image, and had to be held at a proper angle for it to look "positive.") Talbot took the paper negative, waxed it to make it translucent, and rephotographed it to produce a "positive" image. Talbot could now reproduce his—you guessed it—*Talbotypes* over and over again.

Father of the Yellow Box

In 1888, George Eastman perfected the process of flexible, plastic-based films. Eastman's new company, Kodak, marketed a camera that contained a roll of film long enough for 100 exposures. The user would return the used camera to the Kodak Company, which would process the film, print the images, and return them to the owner with a freshly loaded camera.

Fast Forward: Digital Cameras

As with many of our modern inventions, digital photography owes much of its advancement to the military and to space exploration. The need to take sharper images and to view them as quickly as possible lent much to the development of digital cameras and imaging technology. Using digital technology, images could be beamed from miles above the Earth to reveal hidden missiles or help predict crop growth. Unmanned spacecraft beamed back our first look at the dark side of the moon and the heavens above.

In 1981, the Sony Corporation produced the first consumer electronic camera, called the *Mavica*. Short for *magnetic video camera*, the camera produced still video images (the Mavica wasn't *truly* a digital camera, because its images were actually analog recordings). The race to produce "filmless" cameras was on.

The first truly digital camera, the QuickTake, was developed by Apple Computers in cooperation with Kodak. (How very forward thinking of both companies!) The handheld camera had a fixed focus lens and could take anywhere from 8 to 32 images depending on the resolution of the images. Images were stored internally and could be downloaded to a Mac or PC via a serial port. It sold for about $700.

Kodak also produced one of the first "professional" digital cameras, called the DCS 2. It produced, in a single shot, a 4MB color image. The camera was built on a 35mm Nikon SLR platform, but a digital chip was fixed in the camera's back.

These days, everyone's in on the digital camera action. Of course, most of the major camera manufacturers are producing digital cameras; some, such as Ricoh, have stopped marketing film-based cameras in the United States altogether. In addition, companies that never produced film-based cameras, such as Dicomed and PhaseOne, are selling good-quality professional cameras. Even more interestingly, companies such as Leaf/Scitex and Agfa, which produce prepress scanning equipment, are now also producing digital cameras. These companies are evolving their scanning technologies into digital camera equipment. Many digital cameras are really "camera-mounted scanners."

So Now You Know

There are many rumors about how George Eastman coined the word Kodak. Some thought it was in reference to the sound the shutter on his cameras made, but as he explained: "I devised the name myself. The letter *K* had been a favorite with me—it seems a strong, incisive sort of letter. It became a question of trying out a great number of combinations of letters that made words starting and ending with *K*. The word *Kodak* is the result."

Sorry, Paul, Momma Done Took My Kodachrome Away!

If you ask companies like Kodak, Fuji, Agfa, or Polaroid why they produce cameras, you'll get an interesting answer: to sell film. Film is where they make the most profit. Why, then, would they become involved in the digital–camera market? My guess: They see the writing on the wall. It is very clear from these manufacturers' actions that film-based consumer-level photography is expected to become a thing of the past.

Can You Say "Sticker Shock"?

The DCS 2 was the first digital camera I owned. My introduction to digital photography cost me $35,000, not including the necessary computer, software, training, or aspirin. Don't worry—it won't cost you that much!

First, the Good News: The Advantages of Digital Photography

Digital cameras are everywhere. Store shelves are lined with them, and Sunday newspaper circulars are filled with advertisements for them. But why buy one?

If you are perfectly and completely happy taking pictures with your film camera, then don't buy a digital camera. But remember, you have to finish the whole roll, bring the film to the processor, and wait for the prints to come back, just to find out everyone in the "once-in-a-lifetime picture" had their eyes closed. Let's also not forget that you have to pay for the processing and buy film. Oh, by the way, you had better buy a few extra rolls, some for indoors and some for outdoors.

So what are the advantages of digital?

➤ **No more film!** That's right, ladies and gentlemen, children of all ages, you'll never need to buy film again. Using a digital camera means that you can take pictures without paying for film or wondering which type of film to buy.

➤ If you are careful with your storage, you will also never run out of film. The PCMCIA storage cards, which slip into the side of your camera, can hold up to 80 images. With a few of these in your camera bag, you can go on taking pictures for days. (There's nothing like that special feeling you get when you run out of film while on vacation. Not to worry; if you give the guy in the photo booth all your travelers' checks and promise him your first born, he'll gladly sell you a fresh roll with 12 exposures on it.)

➤ **No more processing costs** No matter how you get your film processed, it gets to be expensive. You can't get around paying for processing unless you are taking digital photos—and you'll never have to decide about matte or glossy prints again.

➤ **"I wanna see them now!"** Digital photography enables you to see your photos instantly; no more waiting for your film to return from the lab. Many cameras have LCD preview screens, so you can see the image instantly, or you can download your images to your computer as soon as you take them.

➤ **Reshoot!** If somebody walked into your carefully composed shot or if the baby's eyes were closed when the shutter snapped, you'll know it immediately. You can simply retake the image. (On the flip side, you can also preview all the poses you just took of your dog and delete the ones you don't like.)

➤ **Control** If you couldn't get close enough to your subject or the camera wasn't level when you took the picture, have no fear! You can fix it. You can easily crop or rotate your picture; remove spots; fix color; and lighten, darken, blur, or sharpen your images. With a little skill, you can even add Uncle Harry into the family photo even though he arrived late. Try that with a drugstore print!

➤ **Get out of the dark.** For those of you who spent hours splashing about in your darkroom to produce only a few prints, you are free. You can set up your computer in the light of day and image edit all you want. Imagine! You can be social and manipulate images at the same time. You can see and be seen by your family and friends. If you have special talents, you can even work on your computer and watch the football game simultaneously!

I "Walk" the "Talk"

As a professional photographer, digital photography has become an indispensable tool. My clients can use my computer monitor to view the image I have just taken; they can approve it on the spot or we can make changes. When the image is finished, I can then move on to the next setup or job. I don't have to wait for my film to come back from the lab or worry that I missed something in the Polaroids.

➤ **Everyone can see it.** With the advent of email and modems, you can easily send a photo of a newborn to distant relatives or post it on your Web site. You no longer need to take the time or spend the cash to make multiple copies of an image and distribute them.

➤ **It will last forever.** Negatives and prints fade. They are subject to ultraviolet light, humidity and grubby fingers. Digital images, however, will last forever if carefully stored! And if your printout of the image gets damaged or you want to make a duplicate, all you need to do is pull up the file and reprint it. Your only cost is a sheet of paper.

➤ **Get green!** Digital photography is environmentally sound. There are no processing chemicals to wash down our sewers, and the massive amounts of water and electricity used to process film are no longer needed. Plus, you won't need to worry about recycling those little plastic film containers. (You do recycle them, don't you?)

➤ **It's fun!** Photography is fun, and digital photography is more fun! And because you don't have to worry about having enough film with you or whether the picture came out, you might even say it's liberating. So grab a camera, take a few shots, and go have fun!

Now the Bad News

There are some downsides to digital photography. Digital photography is not yet perfect, and we are all still paying for the manufacturers' research and development costs. Although storage devices are getting less expensive every day, they still are not as cheap as a cardboard shoebox. Here are some of the cons:

➤ **Image quality** The amount of information that is contained on a piece of film or that can be reproduced on a photographic print is easily tenfold that of a typical digital camera. A camera crammed with enough chips to produce a film-like quality photo would be wildly expensive (remember that $35,000 I spent?); a disposable plastic camera will capture more info than your $300 bells-and-whistle digital job.

➤ If you are going to use the image in a company newsletter or on a Web site, you will probably have no problem using a digital camera. If you plan to enlarge the picture to poster size and frame it on the wall, you had better use film. If, for example, I were to spend hours to climb to the top of a mountain (and I do), I would not use a midrange digital camera to capture the skyline for a print on my wall or to sell as a stock image. I would have no problem, however, using a digital camera to grab a shot of my wife skipping over the rocks and streams (and she does).

➤ **This stuff is expensive.** With digital cameras costing from $300 for a "point and shoot" to more than $1,200 for some of those bells and whistles, these cameras are not cheap. In addition, you are limited to using only a few accessories, such as lenses, filters, and the like (not to mention that any accessories you have for your current camera will likely be useless for a digital camera). And that's just for the camera!

➤ Assuming you already have a computer, you might need to buy more RAM (memory). If you don't already have a good color printer, you had better put one of those in your shopping cart, also (while you're at it, please buy a decent surge protector). If you are serious about this new hobby, a larger monitor screen will help keep eye fatigue down.

➤ Have I spent all of your money yet? Don't forget the aspirin!

➤ **It's dark in here.** Digital cameras are not as sensitive to light as their film-based cousins. Simply put, they require more light to make an exposure. That probably won't be problematic outdoors, but problems might occur inside. Even if you are using a flash, you'll either need to augment with additional lighting or just settle for darker images.

➤ **Noise** If you were to look in the dark areas of an image, such as in a shadow or on a black surface, you might see *noise*. Hmm. Seeing noise. Now that's a funny thing!

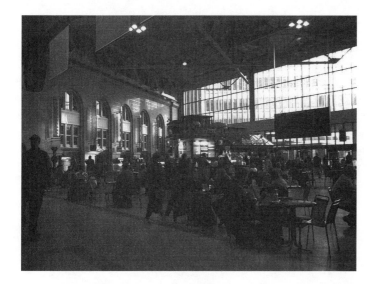

A dark interior, such as Boston's South Station, can wreak havoc with your camera. Bright areas, such as the windows, make automatic exposure even more difficult.

➤ If you think of digital information as a television signal, noise would be just like the static you get when you try to tune in to a weak station. Noise generally appears as blue or red/blue static in the shadow areas.

➤ **Pixelation** When you have enlarged an image too much, you'll see pixelation, or little squares in the image. These squares occur when the image file doesn't contain enough information to properly display the image at the size you've specified (another word for the information in a photograph is *resolution*). Sure, you can continue to make the image bigger, but that means your computer will only make up the information it needs to display the image, interpolating it.

Interpolation

Interpolation is a technique that the computer and software use to estimate the tonal value for a missing pixel that should appear between two existing pixels. This is also known as an *intelligent guess*. It is much better to have the information there in the first place than to have your computer think it up for you.

A very pixelated image due to a low resolution.

➤ **Stair-stepping** Another result of low resolution is *stair-stepping*, which usually occurs on diagonals in an image (you guessed it: they look like little stairs). The more information (resolution) your image has, the smaller those stairs become. You might also see stair-stepping on round objects or curved objects, such as balloons or wheels.

➤ **Color distortions** A digital camera might just get the color wrong. No, you're not going to see blue grass or red skies (unless you're on Mars), but you might see orange when you expect to see yellow or purple when you expect blue. Color distortion is usually due to poor interpolation by the camera software. Most of the time, this can be easily corrected; I'll show you how in Chapter 13, "Improving Your Images."

➤ **Wait, wait.** Most cameras, in order to save battery power, will automatically go into a energy-saving or *sleep* mode if not used for a few minutes. Depending on the camera and how "awake" it is, there can sometimes be a second or two delay between the time you press the shutter button and when the camera actually takes the picture. You might also have to wait a few moments after taking one picture before the camera is ready to take the next one (the camera might have to process the image and store it to memory).

➤ **The learning curve, again** Taking a picture with a digital camera is not any more difficult than with a film-based one; it might be even easier for you. Getting the image out of the camera, processing it, and getting a great-looking print, however, are not going to be as easy as they were before (at least not at first). You are going to have to learn some new skills and invest some time in practicing them.

It is very difficult to avoid "stair-stepping," as seen on the diagonals of the scissors, unless there is adequate resolution.

If you enjoy playing with your computer and learning new skills, digital photography can be a lot of fun. If not, you might not want to "do the digital."

Go for It!

Digital photography can be a load of fun and an inexpensive way to take pictures after you get yourself set up. It provides a spontaneous way to create images without having to worry about film, processing, and the costs involved, and it gives you the freedom to create images, to explore, and to be an artist. Digital photography also can be an invaluable business tool, providing a great way to communicate ideas and broadcast images.

So who needs a digital camera?

> ➤ Insurance agencies are using digital cameras to photograph for claim records. Agents can take a picture of a crumpled fender or broken window, attach it to the claim form, and instantly email it to the central office. This can cut a day or two off the settlement time (oh, happy clients!). Also, the image can become a permanent (read: nonfading) part of the electronic record and can be accessed by anyone at the firm at any time.

➤ Realtors can use digital photographs to show off that beautiful house they are listing. The images can be shown to a prospective buyer, published into a listing sheet, or even posted on a Web site. With QTVR (Quick Time Virtual Photography), virtual tours of the inside of a home or office building can be produced to show to a client.

QTVR

With the advent of Quick Time Virtual Reality (QTVR) technology by Apple Software, photos can be taken of an object or a scene and then the images can be animated. To begin, the object is rotated in front of the camera, and a picture is taken each time the object moves 10° until it has completed a 360° revolution. To photograph a scene, the same process takes place—except that this time the *camera* rotates 360°, taking one picture every 10° for a total of 36 shots. You can post these QTVR images on a Web site or display them as part of a multimedia presentation. The viewers can see all 360° of the object, or take a virtual tour through a hotel lobby or museum.

While still in their offices, realtors can take pictures of homes for prospective buyers.

➤ Small business owners and professionals can use digital photography to help skip the traditional prepress scanning process. They can save time—and we all know time is money! A word to the frugal here: Be sure you know what you're doing before you try to "go it alone." It is very costly to have a press house fix your mistakes. A missed deadline can also be very expensive!

➤ Databases can include photographs of all those various gizmos you sell, which means your customers don't have to use their imaginations to see all the large and the small gizmos in red, green, blue, or whatever variation is available. Imagine the competitive edge you'll have! Again, using QTVR photography, you could even animate your gizmo so that your customers can see the top and bottom or all four sides.

➤ Digital pictures are perfect for the Web. (Note: The smaller the image is, the faster the image can be delivered to your screen from a Web site.)

Digital cameras have more than enough resolution for Web site photos.

➤ Digital photography is great for use in small offices. You can produce newsletters or take reference photos of products for your sales force. You can use a digital camera to photograph a new client so all your staff and sales team will be able to greet your new client on sight and by name. Interoffice mail can be made more personal and Web sites more informative.

I use a newsletter to inform my clients about recent events at my studio. Digital photography is a great way to facilitate the newsletter and improve its visual appeal.

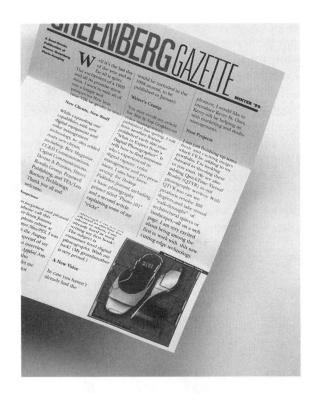

➤ Doctors, dentists, and surgeons can use digital cameras to take reference photos of patients. You can show your patients before and after images; you can use images for your medical records, or attach them to an insurance claim. But before you spring for a digital camera, spring for a few new magazines in your waiting room!

➤ Newspaper and other journalistic photographers are using digital cameras on an increasing basis. The resolution from a mid- to high-end camera contains plenty of information for the typical newspaper or magazine. In fact, many of these digital images are being delivered via satellite. Photographers are carrying small up-link satellite dishes to beam their images directly to their editor's desk.

➤ At home, you can take pictures of all your valuables—not to show to your friends, but to be kept as a record for insurance purposes. (It might be a good idea to keep a copy of the files in a safe place outside of your home.)

➤ Take family pictures. You can take these cameras anywhere. You can take tons of shots and edit out the ones you don't want later. You'll be surprised at what pictures you'll take when you are not worried about wasting film.

➤ You can make art! You can have loads of fun being creative and manipulating images. You can take many views or variations of a picture; you can take pictures at different times and places and collage them together. This can be a very liberating experience.

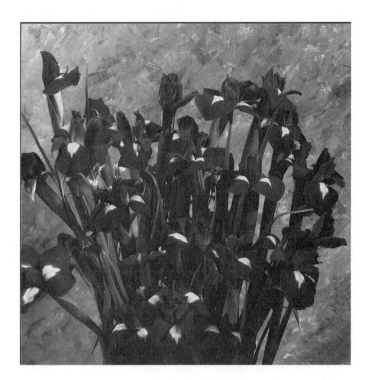

Digital photography can be used to enhance reality. Can you tell which flowers are original, and which were cloned?

The Least You Need to Know

➤ Photography as we know it began with the invention of the camera obscura.

➤ There are many pros to using a digital camera, but there are some cons as well.

➤ You can use digital photography for many purposes.

Pixel, Pixel, Little Star, How I Wonder What You Are!

In This Chapter

➤ What's a pixel?

➤ All about light

➤ How digital cameras work

So what is a pixel? Are they small and do they have rapidly beating wings? What is light? How does the camera work, and how do you change those light rays into electronic data? Read on!

It's a Three-Color World (RGB)

When white light is passed through a prism, a whole spectrum of color is visible. You could reverse this process, stuffing the entire spectrum of color back through the prism to get back to white light, but you don't need to—all you really need are red, green, and blue. If you don't believe me, go and try it yourself. If you do believe me, go and do it anyway; it's an impressive demonstration.

When in Doubt, Use Visual Aids!

If you're a nonbeliever, conduct the following experiment: Get three strong flashlights, and cover one with a red gel, one with a blue gel, and one with a green gel. Then tack a piece of white paper on your wall. Darken the room, and shine the lights on the paper. You should get white light. (If you feel foolish doing this, get your kids to do it as a science fair project.)

We call this color world the *RGB color world* (where *RGB* stands for *red, green, blue*). And because we *added* the three colors together to get to white light, the process is called *additive color*. While we're at it, we might as well call those three colors—red, green, and blue—*primary colors*.

Some of you might be jumping out of your seats and yelling, "But green isn't a primary color!" Well, you're right and wrong. The primary colors of the *light* spectrum are red, green, and blue. For any coloring matter such as dyes, pigments, or paint, the primary colors are red, *yellow*, and blue. If you don't believe me, check out a few books on color theory from your public library and look it up for yourself. If you are curious, it makes for a mind-boggling, but fascinating read.

The classic double triangle.

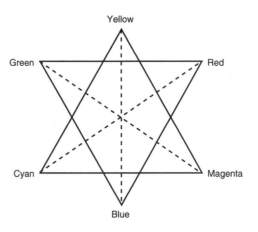

Okay, this part gets tricky, but hang in there. It will all make sense in the end. Take a deep breath; I promise there will be no test. Let's say the green light that you're

stuffing back through the prism was blocked. The resulting color would be magenta, a *secondary color* that is opposite green in the classic double-triangle illustration shown previously, and a combination of two remaining primary colors, red and blue. The other secondary colors are yellow, which is the opposite of blue, and cyan, which is the opposite of red.

To make this discussion more relevant to photography, suppose you were to reduce the amount of green in a photograph. Yes, you guessed it, the picture would appear to be more magenta.

Three-Channel Illustration

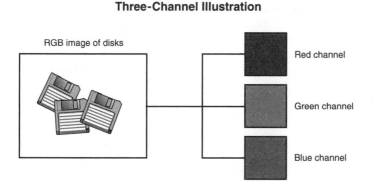

A photo broken up into three channels.

Eye to Eye: How the Camera Mimics Your Eye

The color our eyes see is a result of light reflecting off an object. An apple appears to our eyes as red because the apple's skin absorbs both blue and green light and reflects back only the red. (Unless, of course, you are looking at a Granny Smith apple.)

Our eyes are made of three basic parts:

➤ A *lens* focuses the light on the back of the eye.

➤ The *iris* helps form the *pupil*, the little black hole, which regulates how much light enters the eye.

➤ In the back of the eye is the *retina*. On the retina are the nerves that send the light pulses to the brain. Some of the nerves on the retina see red, some see green, and some see blue. Your brain processes all the information and voilà, you see color! (See what I mean about RGB being primary colors?)

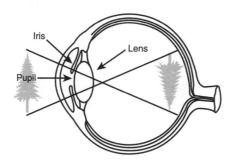

Just as early inventors of flying machines mimicked birds, camera designers mimic the eye.

It's no wonder that the camera mimics the eye almost exactly. Both incorporate the same two fundamental laws of light:

➤ Light travels in a straight line unless it is interrupted. This helps explain why an image is inverted when it travels through a lens. As the light travels from the top of your subject, it continues through a hole in your camera (the lens) and to the bottom of the back of your camera. As light travels from the base of your subject, it again passes through the lens and continues to the top of your camera back. Voilà, your image is inverted. This theory works for eyeballs, pin holes, lenses, and camera obscuras.

➤ When light enters a denser medium, it bends. To get a little more complicated, when entering a thicker medium, light bends toward the denser part of the medium. This is how a lens works.

The eye is a good model to copy for our camera. It has all the necessary parts we need. First, we'll use a few lenses to focus the light. Next, we'll use a mechanical diaphragm to replace the iris and regulate how much light enters our camera body. And finally, we'll use film as our retina.

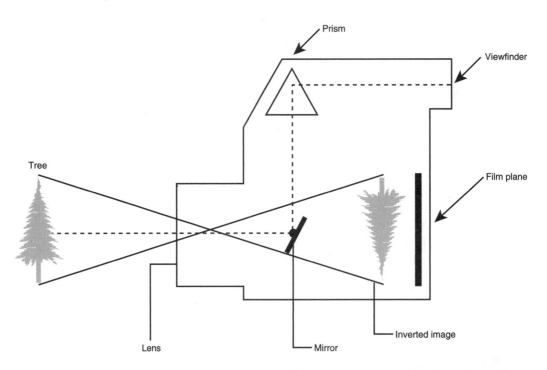

Light travels through the lens, reflects off the mirror, and is redirected by the prism to your eye. When the mirror is in an up position, the light continues to the back of the camera and strikes the film.

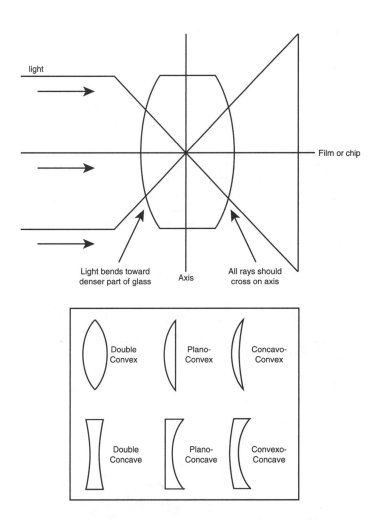

Notice how similar the lens is to the eye!

light

Film or chip

Light bends toward
denser part of glass

Axis

All rays should
cross on axis

Double
Convex

Plano-
Convex

Concavo-
Convex

Double
Concave

Plano-
Concave

Convexo-
Concave

In the Beginning There Was Film

Let's start by discussing how black-and-white film works:

1. Silver nitrate crystals are suspended in an emulsion. Think of emulsion as gelatin (Jello) with pieces of fruit (silver nitrate crystals) floating in it. The emulsion is bound onto a clear substrate. (We call this substrate *film.*)

2. The silver is exposed to light (a picture is taken).

3. The film is developed. If the silver on the film has been fully exposed, it turns black. If the silver has been partially exposed, it turns a shade of black (aka gray).

4. The development is stopped (stop bath) and the unexposed silver is removed (fixer).

5. The film is dried. We now have a negative!

6. Light is sent through the negative onto another film (or paper) to make a positive. (Remember, two negatives make a positive.)

The photochemical process.

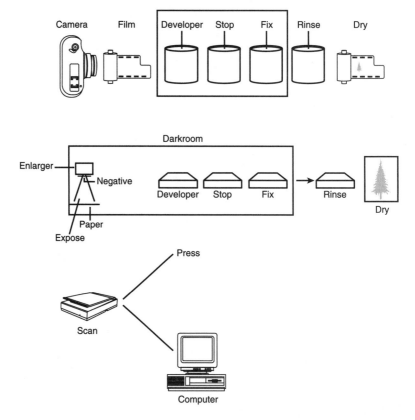

So just how does color film work, exactly? To put it simply, color film is broken down into three basic layers. (Actually, there are many more layers, but I'm trying to keep things simple.)

➤ The red layer turns red when red light strikes it.

➤ The blue layer turns blue when blue light strikes it.

➤ You guessed it: The green layer turns green when green light strikes it.

Sound familiar? When light is passed though the film and all the layers of color, we see a colored picture.

Into the Light: Color Film Magic Revealed

In case you're curious, here's how this all works: When light strikes its corresponding layer, it excites the silver residing on that layer. The layers are filtered so that only red light affects the red layer, only blue light affects the blue layer, and so on.

But wait! Doesn't silver turn black or shades of black? How can silver turn into a color? Here's how: The silver, in its excited stage, activates a *color coupler* (the color coupler is mixed with the silver in the emulsion).

When the film is being processed, it is dunked into a solution called *developer*, which contains color dyes. Those excited color couplers grab these semitransparent color dyes out of the developer solution and lock them onto the film base in layers.

After the chemical developer is stopped, a bleaching bath is used to strip away the silver, leaving only the color dyes. There is no silver in a color negative or in a color print—it's all left in the bleach.

Pixel Schtick: How Digital Cameras Work

Instead of film, digital cameras contain *imaging arrays* onto which the lens focuses light. (Many people call arrays *chips*, which is perfectly legal; no points will be deducted from your score.) On these chips are CCDs (*charged coupled devices*).

When the CCDs are struck by light, they emit an electrical charge that is in turned into binary information by the camera's processor. This digital information, the ones and zeros (or offs and ons), are the heart of how computers work. In fact, the capability of the processor to change color and brightness information into machine code is the reason we are able to manipulate a photograph in the first place. In a color camera, the CCDs are filtered, or *tuned*, to accept only certain colors—you guessed it: red, green, and blue.

Pixels

So what is a pixel? I've been throwing the word around a lot so far. A *pixel*, which is short for *picture element*, isn't a *thing*, exactly; it is more of a description of a thing. If you were to enlarge a digital photograph, eventually you would see little squares of color. These are pixels, which are created by the CCDs.

You might say you are seeing the CCDs themselves, but you would be wrong, so don't say that. CCDs only tell the imaging software to draw or create a little square to represent how much light struck it and what color the light was.

The more pixels there are in a given area, the more resolution the area is said to have.

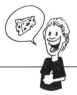

CMOS Technology: Always a Bridesmaid, Never a Bride!

CMOS chips are being used by only two or three camera manufacturers at this time. After more research and development, however, CMOS chips might make their way further into the marketplace. The CMOS cameras currently on the market are being used by professional photographers to capture images where high resolution is not needed, such as for Internet and small catalog shots. These cameras are not as expensive as high-resolution digital cameras, and are a good alternative.

Digital cameras capture information in many ways:

➤ CMOSes (*Complementary Metal-Oxide Semiconductors*) work like CCDs to produce electrical charges when struck by light. CMOS chips tend to be a bit noisy and less sensitive to light, but they are less expensive to produce and use less power than their cousins, CCDs. CMOS chips can be found in certain modestly priced cameras.

➤ The simplest type of array aligns the CCDs in a line. This is called a *linear array*. A linear array can capture only one color at a time; the array is moved across the long direction of the image plane three times to capture color (once for red, once for green, and once for blue). The major drawback of a linear array is that the subject cannot move, and the lighting must be constant during the exposure. Many photographers will use photo-floods or filmmaking equipment to light their sets. There can also be color registration problems if the camera moves because the chip must return to the exact same starting place at the beginning of each scan.

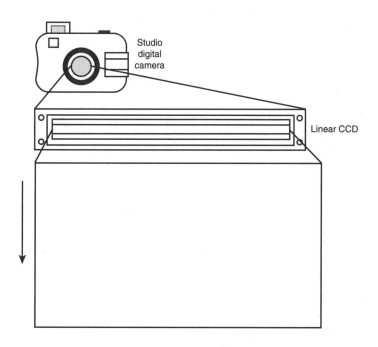

The CCDs on a linear array digital back travel across the back of a camera three times to make an RGB exposure.

➤ The next step up the evolutionary chain is the *tri-linear array*. This array has three rows of CCDs on it; each row is filtered for one of the primary colors. The array *scans* the image plane only once, which greatly reduces the time it takes to make an exposure. Color registration is also greatly increased. Because there is little to no interpolation, these arrays are very accurate when it comes to color. If these arrays are long enough and allowed to travel over a large distance, they can produce very large files—100MB or more. These arrays are commonly used in professional still-life photo studios, but again, the array must be moved down the image plane, the subject cannot move, and the scene must be constantly lit.

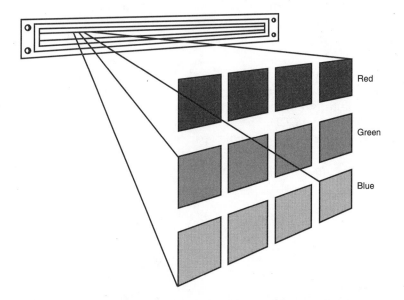

On a tri-linear array, the CCDs need travel across the camera back only once.

29

➤ If you take the chip and line the CCDs up in rows and columns, you can create a great black-and-white (B&W) chip. With this type of chip, you can use a flash instead of a constant source, and can photograph live action. To produce a color photograph, the camera must make three exposures, or passes. To do this, a rotating color filter is placed in front of the lens. First, a red filter rotates in place and an exposure is made, then green, and then blue. The color in the image will be very accurate. Also, the exposure times are greatly shortened because a flash can be used during each pass. The subject, however, still cannot move.

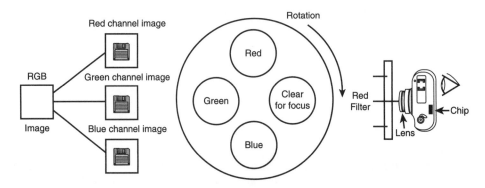

Light passes through each of the color filters to strike a black-and-white chip set. When the colors are combined by the camera software, a full-color RGB image is produced.

➤ Some manufacturers are placing a glass filter called a *liquid tunable filter* in front of the lens or inside the camera on the surface of the chip. The filter rapidly changes from red to green to blue within the time duration of a flash, which has the effect of making three passes with one flash! With this technology, you can get the best of both worlds: accurate color and stop-action photography. The technology is still young and there are still a few bugs to work out, but it is promising.

➤ Single-shot color can be produced by a *stripped array*. This will be the most common type of chip set you will find in today's cameras. The CCDs are again arranged in rows and columns, but tiny (one might say itty, bitty) colored filters are arranged over the individual CCD. The filters can be arranged in a repeating simple pattern (RGBRGB) or in a more complex pattern (RRGBRRGB). The patterns differ depending on the chip and camera manufacturers; color resolution depends on what type of chip is being used and what type of interpolation is being done.

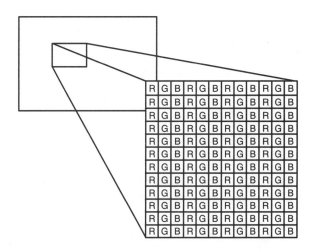

The stripped array arranges tiny filters over the CCD devices, enabling one-shot color photographs.

Better Color, Better Algorithms

On color film, the red, green, and blue layers are stacked over each other. As the light passes through these layers, true (accurate) color occurs. Because the CCDs are not layered over each other but rather sit side by side, you can run into some problems with the color. If a beam of red light strikes the red-filtered CCD, everything is fine; life will be beautiful. But if the red light strikes a differently filtered CCD or a different color strikes the red CCD, you have problems.

But not to worry. Interpolation algorithms look at the information as it comes off each CCD and decide whether the information is correct or not. The algorithms look at the information and say, "Yup, that looks like red light. Pass it on," or "Nope, that's not red, but it looks like blue." (Go ahead, put your ear up to the back of a camera!)

Color cameras, especially on the professional level, are totally dependent on the color algorithms. Simply put, the better the algorithm, the better the color.

The algorithm can be applied during the camera's internal processing of the color or by software on your computer after the image is downloaded. On most professional-level systems, or with larger files, the processing is done on the computer.

The Least You Need to Know

➤ The visible spectrum can be broken down into red, green, and blue primary colors.

➤ Cameras and lenses mimic the human eye.

➤ CCDs are activated by light and send electrical impulses, which are changed into digital signals.

➤ There are many variations of digital cameras. These include scanning backs and one-shot action backs. These produce black-and-white (B&W) and color (RGB) images.

Part 2

Cameras, Computer Hardware, and Software for Digital Capture

The exponential growth of technology is staggering. In the not-too-distant past, a computer took up an entire room. The vacuum tubes and mechanical switches took hours or days to crunch through a problem set. Today, CPUs are the size of a pad of Post-it Notes. They are made of silicon and copper. The width of the wire circuits are measured in microns—thousandths of a piece of hair. Every 12 to 18 months, Motorola or Intel rolls out a new CPU that is 50% faster and can process 50% more information than the last one.

The blazing speed of computers has spawned a revolution in software development. Software has, and probably always will, lagged behind CPU development. Nevertheless, today's software programs allow us to manipulate images in ways we've never dreamed of before. Once upon a time, we were happy if we could rotate a black-and-white image. Today, we can correct the color of an image, triple its size, and sharpen it while we sit in front of our monitors.

Over the last 10 years, digital cameras have developed from clunky, power-hungry, expensive beasts to handheld, point-and-shoot cameras. With the speed of development in higher-resolution cameras and lowering of production costs, camera manufacturers are predicting that digital cameras will soon outsell film-based models in new-camera purchases.

What is the best camera for you? Do you need a computer that will help you predict the weather or just simply design a newsletter? Read on!

So Many Choices: Finding and Buying the Digital Camera That's Right for You

In This Chapter

➤ What's the best camera for you?

➤ Camera types

➤ Useful camera features

Digital cameras are being produced with so many variations in size, design, and features that it's hard to choose the best one. It seems as if almost every day a new camera is coming out with a new or better feature than the last. Although we will be looking at specific cameras and their features, reviewing specific camera models would be fruitless because the industry is moving at such a quick pace. By the time you read this book, some of the camera models on the shelves today will no doubt have been replaced by newer and fancier siblings.

Research, Research, Research

The best way to get the "down and dirty" about a specific camera is to do a bit of research. Most of the popular photography and computer magazines review digital cameras regularly—it seems as if a new review about a specific camera comes out each month. Also, you will find overall "compare and contrast" reviews about cameras grouped by price range, resolution, or ease of use. Many of these reviews rate the cameras, such as on a scale of 1 to 10, or with stars, shutters, or other weird icons. You might even see a "best buy" or "editor's choice." You can also find great information on the Web or in a consumer's guide magazine such as *Consumer Reports*.

Another good way to learn about what's new and hot is to look at the manufacturers' advertisements. See what they are hawking and why, and what gizmo or feature they have that is different or new. Watch out for confusing terminology, however; one manufacturer's "supersonic zoom system" might be identical to another's "wonder wizard system."

Set a Budget!

It's important to set up a budget before you go out to buy a camera. A budget helps you decide which camera, printer, or accessories to buy. Plan for the future. Will this be the last camera you ever plan to buy (I hope not)? Is your purchase planned to get you started or will you upgrade your equipment in a few years? Do you want to invest in a system that can be upgraded, or will you just go out and buy new stuff in a few years? Do you want to get cutting-edge equipment, or will last month's "wonder" technology do? Some of these decisions might be influenced by your economic advisor (in my case, my wife); other times, you just gotta have the best camera on the block!

Narrowing It Down: Camera Types

First, let's figure out what you type of camera you need. Basically, four major groups of camera designs are available, each with advantages and disadvantages:

➤ **Range Finders** Range finders are simple (not to be confused with *inexpensive*) cameras. You will find both traditional and digital cameras in a range finder configuration. With a range finder, you view the subject though a viewing-only lens (called a *viewfinder*) that is separate from the lens through which light exposes your film (I'll refer to that lens as the *photographic lens*). On a less-expensive model, the viewfinder might be a simple hole in the camera body, covered by clear plastic. On a more expensive model, a range finding (read: distance measuring) system allows the viewfinder lens to be focused and otherwise manipulated. The photographic lens, which is separate from the viewfinder, is usually in the center of the camera.

The good thing about range finders is that they are usually smaller and weigh less than the other types. The downside is that you experience *parallax* because the viewfinder and photographic lens are not one and the same; the image you see is not identical to the image that is captured on film (see the following figure).

Parallax

The best way to demonstrate the effects of parallax is to look at an object first with one eye closed, and then the other. The object you are looking at appears to shift! Which view is correct? Try this again with your finger held in front of your face; the problem gets worse when the object is closer.

The problem of parallax.

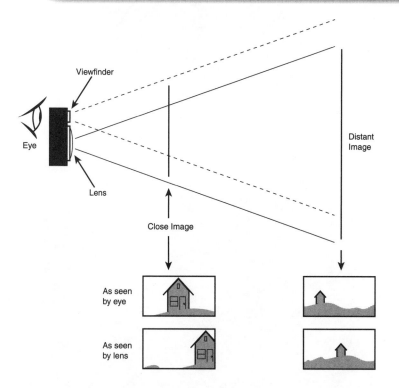

➤ **Single Lens Reflex (SLR) Cameras** The single lens reflex (SLR) camera corrects the parallax problem because, through the use of a prism and mirrors (not to be confused with *smoke* and mirrors), you look directly through the photographic lens to view your subject. The most common example of an SLR is a Nikon, which is available in traditional and digital cameras. The Olympus 620 DL is another fine example of a digital SLR. Although some SLRs use 120mm film, most use 35mm film.

One downside of using an SLR camera is that when the camera is pointed upward or downward, image distortions—such as *keystoning*—can occur. With a keystoning distortion, the part of an object which is closer to the camera will appear larger than the part which is farther away. Tall buildings often look keystoned when the photographer points upward with an SLR camera.

*The trusty workhorse...
I haven't used mine in
years!*

*Boston's Federal Reserve
Bank; a classic example
of keystoning.*

➤ **Twin Lens Reflex (TLR) Cameras**

A twin lens reflex (TLR) camera is like a range finder in that the viewing lens and photographic lens are separate. However, unlike with a range finder, a mirror is used to view the subject through the viewfinder; in addition, the viewing and photographic lenses work in tandem, so when the viewing lens is focused, so is the photographic lens.

Quick Quiz

We call 35mm film by that name because A) the length of a frame, horizontally, is 35mm, B) the film measures 35mm in width, or C) all the other names were taken.

Answer: B

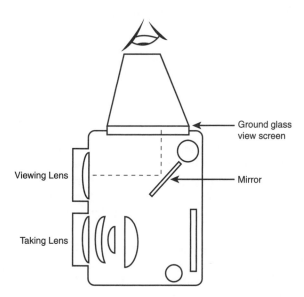

Twin lens reflex.

TLRs suffer from the same parallax problems as range finders. On the plus side, however, TLRs use larger film sizes (120mm) and produce wonderfully crisp images. A good example of a TLR is a *Yashicamat*. You will not find a digital TLR—sorry!

My Yashicamat from college.

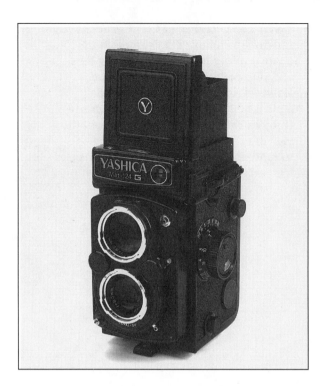

➤ **View Cameras** *View cameras* are by far the simplest cameras of all. A view camera has a lens mounted on the front standard of the camera, and a ground glass focusing screen/film holder mounted on the back standard. The standard is the mechanical device that is attached to the center rail. In between the standards is a bellows, the accordion-shaped flexible bag, to keep out the light. After focusing, film (or a digital back) is positioned in place of the ground glass, and an exposure is made.

The standards are movable and provide a few advantages: depth of field and perspective control. (We'll learn more about that soon.) Also, view cameras use large sheets of film, usually measuring 4×5-inch or 8×10-inch (imagine the image quality!). Because of their size, view cameras are usually found in a professional studio being supported by a tripod (because the sheets of film have to be exposed individually, you won't see many sports photographers running around with them!).

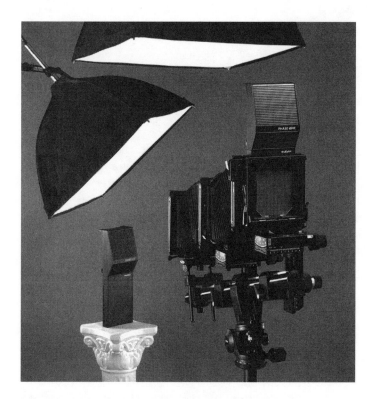

A 4×5 view camera shown with a Phase One scanning back in place.

Types of Digital Cameras

One of the most important features of a digital camera is the size of the CCD array. After the chip size is taken into account, there are many other bells and whistles that have found their way into the mix. There are simple and advanced metering systems, focusing systems, color-management systems, and so on. Please don't be alarmed or overwhelmed by all the options. Even the simplest of digital cameras will take a good picture. Read through the description of camera types and options, a few times if necessary, before you decide which camera to buy. Decide how you will use the camera and how much control you want to have over your picture taking. Don't buy more camera than you can handle. It will be a waste of money and might frustrate and hinder your photographic experience. The most important thing is to feel comfortable with your camera.

One Mega-Pixel Cameras

Most commonly, you will find cameras that have chip arrays measuring 1,280×960 CCDs on the chip (see Chapter 2 if you need more information on CCD arrays). These are called *1 mega-pixel* (1Mp) cameras, and will give you great snapshots.

Interpolation

Some cameras depend on interpolation to increase image size. Be careful of these and try not to get confused by the actual array size versus the size of a finished image. Interpolation is an increasing in size of an image via the computer, the camera, or camera software. The new information (data), which is created during the interpolation to increase the image size, is a result of a "best guess" by the software. It is not as good as the original data. Typically poorly or overly interpolated images will have poor color quality and will be *soft* (lack focus and sharpness).

Helpful Hint

Unless you are working on a tight budget, stay away from cameras that depend on a lot of interpolation. These cameras won't provide an image with a lot of detail.

These types of cameras come in a variety of shapes and sizes, ranging from *P&S* (point and shoot) range finders to SLRs (and with a price range from $300 to $1,000—the SLR cameras tend to be the more expensive). The cameras also range in complexity, from the simple P.H.I. (Push Here Idiot) to some that have so many bells and whistles you should expect to keep the instruction manual always at the ready. Using a 1Mp camera, you can expect to make good-quality prints from a 4×5-inch to a 5×7-inch, depending on image quality.

Depending on Image Quality...

The "depending on image quality" caveat is not meant to be a dodge. If your image has a lot of diagonals or detail, such as texture, the image quality is going to suffer if you make too big of a print. You can still make a big print—just stand back from it a bit! If, however, your image doesn't have a lot of detail (it's a nice big blue sky, for example), you can make bigger prints.

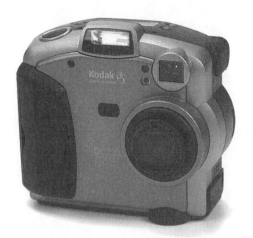

Kodak's DC220 Zoom camera is loaded with many features. It can even record sound, and is USB ready.

Barbie Cam

One camera I reviewed while doing research was the Barbie camera, a great point-and-shoot camera for girls. It comes with software that enables children to take images and manipulate them. In addition, the software allows the young photographer to make animations with her images. I think it is a wonderful way to get children excited about photography; I'm sure the GI Joe camera will follow soon!

Every girl has to have one!

2Mp Cameras

In addition to 1Mp cameras, there are also cameras just coming onto the market that have larger chip arrays measuring, more or less, 1,600×1,200 CCDs. (If you are following the math, the chip field actually has a total of just more than 2Mp, but the effective useful area of the chip measures 1,600×1,200.) I would not be surprised that by the time you read this book, 1Mp cameras might be difficult to find! These 2 mega-pixel (2Mp) cameras offer twice the image resolution as a 1Mp camera, greatly increasing image quality. Many of these cameras do not cost much more than the 1Mp camera. If I were buying a camera today, this is what I would buy.

Better All the Time!

These advances, and the advances that are soon to come, are going to greatly increase the quality of digital images, bringing digital cameras into the mainstream and ultimately replacing film cameras in sales.

Midrange/Semipro Cameras

Midrange, or semipro, cameras have chipsets that deliver images between 4MB and 8MB. Not surprisingly, these babies are pricey—from $2,000 to $5,000—but remember that for this type of money you are going to get a lot of camera (usually an SLR) with a lot of bells and whistles. Most importantly, you can be sure that the image quality of photos taken with these types of cameras is going to be a lot better than with the 1Mp or 2Mp cameras. (For that money, I certainly hope so, Ollie!) You should expect to be able to easily make a 5×7-inch to just under 8×10-inch print and still hold good detail.

Be ready for life's big moments!

Professional Cameras

Professional-level digital cameras start at about $17,000, and range up to just short of the cost of some lakefront property! You can expect image sizes of 18MB to 36MB with one-shot professional cameras.

Models such as the Canon/Kodak 560 have chipsets built into the camera at the film plane, making them extremely thin and lightweight (see the following figure); these cameras have been adopted by many news and sports photographers.

Kodak digital back mounted on a Canon body, shown front and back.

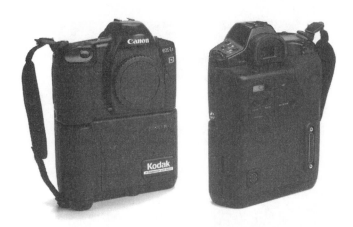

Other companies, such as MegaVision and Phase One, manufacture detachable film backs, which slip onto the camera. These typically are mounted on a Hasselblad or Fuji 680.

Phase One LightPhase, one-shot digital back.

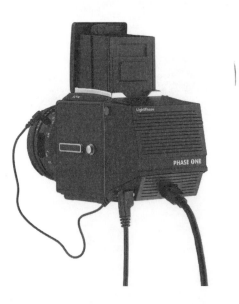

Scanning-back cameras usually are manufactured to slip into the rear standard of a 4×5-inch view camera. These babies put out 100–200MB files. You can do a whole lot with that much information! A good example is shown in the following figure.

Phase One PowerPhase FX scanning back.

Did You Know?

Did you ever wonder how the daily newspaper was able to run a photo of an "Olympic Moment" within hours of it actually happening? Many news photographers now carry satellite up-link dishes with them, meaning that they can send images directly from their cameras or laptops and deliver them to the photo editor's desk. As Jimmy Olsen would say, "Holy Cow!"

Features

When it comes to which features on a camera you want or need, the decision-making process can get very confusing. Again, I suggest you first decide how you will be using your camera. Will you use it mostly outdoors or will you need to make very detailed reference photos? Is a powerful flash needed or do you need an accurate metering system, or both? Do you want a camera that can slip into your pocket or are you comfortable lugging around a camera bag? The LCD screens, which are prevalent on most cameras, can be difficult to see well. Take the camera outside and look at the

screen in bright light. Look closely at these types of details. Take your time when you make these decisions. Don't fall in love at first sight. If you can test the camera out before you buy it, great. See whether your camera dealer will let you walk around with a demo model for a while.

Camera Design

Digital cameras are being manufactured in many new sizes and shapes; some no longer look like their traditional film-based cousins. The main reason for this is that they do not have to adhere to many of the mechanical restrictions that film-based cameras do, such as film transport systems. The only two parts of the camera that need to be aligned are the lens and chip field. After that, anything goes!

Split/Pivot Cameras

Many new digital cameras *split*, or *pivot*. This design is found mostly on cameras that have LCD view screens. Although the LCD screen stays with one half of the camera, the lens, flash, and optical viewer (if there is one) stay with the other. This design can enhance your ability to see the image on the LCD screen and, at the same time, make taking the picture easier. These cameras are great, especially if the LCD panel can be used as a real-time viewer (like a movie camera). For example, you can hold the camera over your head in a crowd, point the lens toward the subject, and follow the action on the LCD screen. Up periscope!

Agfa's 1680 split-body camera takes a little getting used to, but after that, it's great!

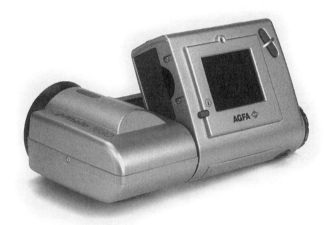

One camera, the Minolta Mirage V, even has a *detachable* lens and chip assembly. The assembly is tethered to the camera body via cable; you detach the lens and place it in a spot that is awkward to get to or out of reach. I'm sure James Bond must have one of these!

Helpful Hint

Many times you'll see news photographers holding cameras over their heads in a crowd to get a shot. These guys, including me, have a pretty good idea what the camera is seeing. We also cheat a bit by putting on a wide-angle lens, ensuring coverage. It is a lot better than missing an important shot or photographing the back of the head of the photographer in front of you. Try it out. You've got nothing to lose—you're a digital photographer now!

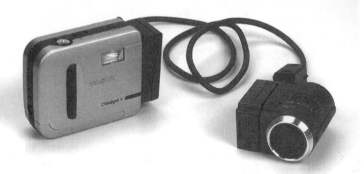

Now you can take pictures around the corner.

Reality Check

Of course, it isn't *that* important that the camera be able to twist, bend, or tie itself into a knot. Many of the basic camera shapes still function perfectly well. So before you purchase a camera, it is important to evaluate how you have been taking pictures or how you plan to take pictures in the future. It is also important to determine how the camera fits into your budget. You can save a lot of money if a simpler camera style will work for you. That way, you can spend the money you save on more important items, such as a better printer or an autographed Mark McGwire baseball card.

Other Design Considerations

Many of the SLR cameras are also breaking new design boundaries; specifically, their bodies are being designed to make holding them easier, or to incorporate larger flashes. Some of these look so aerodynamic you might think they could fly!

Very slick-looking Olympus DL 620.

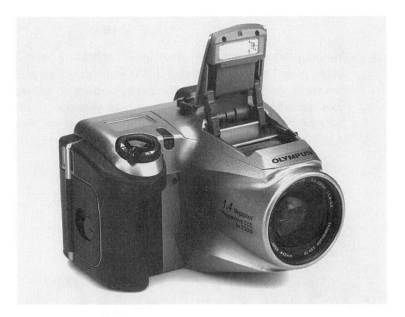

No matter what the camera looks like, however, you should pick it up before you buy it (if you were to spend this much money on a new sports coat, you would try it on, wouldn't you?). You are going to be holding this thing for a long while, so you should see how it feels. Those of you who "hunt" with your cameras (you know who you are) will appreciate a comfortable camera. Ask yourself the following questions:

➤ Is it well balanced?

➤ Is there a good place to hold it?

➤ If you are a southpaw, does it work for you?

➤ If you hold the camera up to your eye, does your elbow end up in a place that would be uncomfortable after a while?

Battery Life

Simply put, no digital camera works with dead batteries, so you should check out how many batteries your camera needs, and what kind. Not only do batteries add to the weight of your camera, they also reduce the weight of your wallet. Are the batteries

your camera requires readily available for purchase, or are you going to be chained to the local Radio Shack? Also, pay attention to the camera manufacturer's specifications. Many of these specs tell you how many pictures your camera will take on one set of batteries. Be sure the specifications include flash use, because you are going to be using one a lot!

There are many types of batteries on the market today. Some batteries, which are usually rated for photography, deliver full output and then die, although others, usually cheap, general-use alkalines, output less and less power until they're dead. Alkaline batteries are the most common and the cheapest, but it is not recommended that you recharge them. NiCad (Nickel Cadmium) batteries are rechargeable and make good economic and ecological sense. NiCad batteries must be completely drained before they are recharged; otherwise, they develop a "memory." In other words, if your battery is recharged while it is 2/3 full, it will always need to be recharged when 2/3 full and will take only a 2/3 charge. NMH (Nickel Metal Hydride) batteries are also available for use in cameras; they provide even greater power and endurance than NiCads. NMH batteries also have the great advantage of not developing a memory, and can be "topped off," or recharged to full, at anytime. These batteries are a little more pricey, but well worth the extra cash.

Memory

Many rechargeable batteries, especially NiCad batteries, develop a *memory*. If they are not fully drained before you recharge them, they will either not fully charge again and/or not deliver their full capacity.

If you suspect your batteries are weak, or if your camera is acting a little slow, here's a great way to drain your batteries before recharging them: Place the batteries in a flashlight that can be left on. When the flashlight no longer works, you can be reasonably sure that the batteries are completely drained. Then go recharge them.

Rechargeable Batteries

Rechargeable batteries should be kept in sets to help you be sure all the batteries in a particular set are totally drained. Color code your batteries or write "set one," and so on, on them.

When you're buying a camera, you should consider whether it comes with a battery charger or whether you will have to buy one. If the camera does come with a charger, determine whether it is a quick charger or one that requires 8–12 hours.

Many battery chargers allow you to "trickle-charge" the batteries. Trickle chargers supply a small charge to the battery, after it has been fully charged, without overcharging them. That way, you can keep your batteries in the charger, always at the ready. Nontrickle chargers can overcharge or ruin your batteries. Be careful where you charge your batteries. I have found that the charger and the batteries can get quite hot. Be sure there are no combustibles, such as paper, near the charger.

NMH batteries and charger are included with Olympus DL 620.

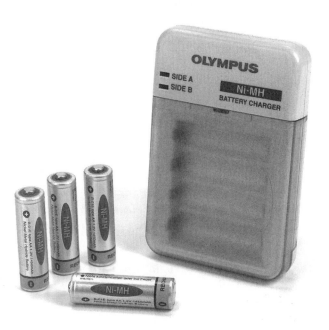

Some cameras come with an AC adapter, which allows you to plug your camera into the house current and charge your batteries while they are still in the camera. If you don't mind trailing an extension cord (or if you forgot to charge the batteries and have no choice), you can run the camera from the wall outlet.

Lenses

Unless you are going to be the first digital "pin-hole" photographer, you need a lens. With the exception of some upper-end SLRs, most digital cameras come with one lens—usually a wide-angle to telephoto lens combination (28mm–150mm), commonly called a zoom lens—permanently attached. (You'll learn more about lenses in Chapter 7, "I Can See Clearly Now: Lenses.")

If you want to know how much of a zoom lens to buy, consider the following:

➤ **Look through the lens.** Place a group of people 10 or 15 feet away, zoom all the way out to wide angle, and see how many people will be in the shot. If you think you need even a wider view, you can either go buy a wider zoom, or take a few steps backward! (Taking a step back can be the difference between a 23mm and 28mm lens, for example.) The same test can be applied to the telephoto end of a zoom. If your kid is playing center field, you need more of a telephoto lens than if he or she is pitching. With a camera that has a smaller chip array, or that depends on interpolation, filling the frame of the viewfinder is much more important. Remember, you want to get as much original image data into the camera as possible. This way, you will end up with a better-looking image if you need to crop or enlarge the image later. A longer focal length telephoto helps here.

➤ **How does the lens operate?** Can you zoom manually, or do you have to push a button and let a motor do it? (Remember your batteries!) How fast does the lens zoom if it is motor driven?

Check Your Batteries!

Be sure to check the batteries in your camera before you plan to take pictures. Keep an extra set charged always. If you plan to be taking a lot of pictures, take a few sets of batteries with you; you won't regret it.

Don't Be Fooled!

When you are comparing cameras to buy, don't be fooled by a lens that might be a few millimeters better than another. If there is less than a 10–15% overall difference, it's not a consideration.

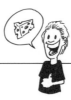

Interpolation

Many cameras depend on interpolation to increase the size of an image, or "zoom in." This is not a true telephoto. The problem this might cause is that the image might degrade due to the interpolation when enlarged. Be careful to check what is the true optical focal length of your lens.

➤ **How crisp is the lens? How good does the image look? Is there good contrast in the picture?** Evaluate these criteria by viewing images photographed by the lens on your computer screen. (Be sure you use the same computer screen when you compare lenses! No fair looking at images taken with one lens at home and images taken with another at work.)

➤ **How sharp is the image?** Many lenses use plastic optics. Plastic optics generally do a good job, but glass optics are better. However, and this is important, a camera that does not have a big chip array or is depending a lot on image interpolation does not need glass optics. The camera won't be able to reproduce the difference in detail that a glass lens offers over plastic optics.

➤ **Can you attach filters to your lens? Do you need to buy filters that will work only with this camera, or can you use them on other equipment? Can you use previously purchased filters?** Some cameras offer a built-in lens cap device that automatically covers the lens when it is not being used to protect it. But as a matter of precaution, it is a good idea to always have a UV (ultraviolet) filter over your lens if possible. The UV filters are clear and serve two useful purposes: They filter out UV light (haze) and protect the lens from dirt, fingerprints, and dog noses.

➤ **How fast is the lens?** The more light a lens can pass through to the chip or film, the faster it is said to be. Because digital cameras are not as sensitive to light as film cameras are, and perform poorly in dimly lit situations, the faster the lens, the better.

Lens speed is calibrated in *f/stops,* which are numerical values that tell you how much light can pass through a lens. The lower the f/stop number, the faster the lens. For example, an f/stop of 2.8 lets in more light than an f/stop of 3.5. Why the goofy numbering system? Bookmark this page and go read Chapter 6, "Exposure"; otherwise, just take my word for it for now!

F/stop!

Is an f/stop of 2.8 faster than an f/stop of 3.0? Yes, but not by much. If it came down to deciding whether to buy a camera with an f/2.8 lens versus one with an f/3.0 lens, all other things being equal, including the cost, I would buy the faster f/2.8 lens.

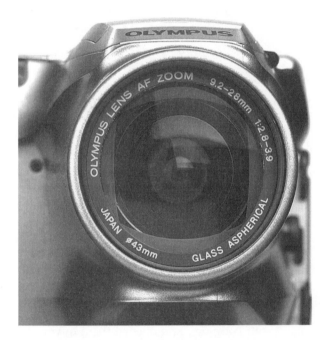

Check out the information on your lens to find out the maximum f/stop and focal length.

➤ **Does the camera have auto-focus?** Many cameras employ sophisticated methods of automatically focusing the lens. Some use sonar to determine distance, and others judge the contrast of an image to determine whether it is in focus. It really doesn't matter how a camera auto-focuses, as long as it does it well.

Fixed Focus

Fixed focus, generally found on less-expensive cameras, might well be your only option, but it can serve you well. You are limited as to how close you can get to your subject, but all cameras focus to infinity (and beyond).

Did You Know?

Flash in the pan refers to old-time photographers who would put flash powder in a pan and ignite it to serve as a light source.

Flash Meter

If you can borrow a flash meter, which measures flash output, you can get a qualitative answer. Most photo stores that carry professional equipment should have a flash meter available for you to use.

My suggestion? Pick up the camera you are planning to buy, and see how long it takes to focus. If you are using a non-SLR camera, listen for the whirring (if there is any) to stop. See how well the camera focuses, and on what, when two objects are at different distances from you (an example of this would be if your image depicted a single person standing a few steps in front of a group of people).

➤ **If your camera is an auto-focus camera, can you switch to manual focus?** If your camera really wants to focus on a group of leaves and not the flowers in front of them, an override capability comes in handy.

Flash

If the camera you are planning to buy does not have an onboard flash unit, don't buy it (unless it's a professional model). As I've said before, digital cameras need all the exposure help they can get!

Most camera manufacturers do not tell you how powerful their flashes are, but they should! A bigger-looking flash doesn't necessarily mean it is more powerful than a smaller one. The best way to tell how much "flash in the pan" you're going to get is by testing. Shoot the same subject, at the same distance from the camera, with two different cameras (be sure to test cameras with equal chip sensitivity/ISO ratings), and then see how bright the subject appears after you've downloaded each image to your computer and opened them in your image-editing program. Also look behind the subject to see how much of the background is lit. The more the background is exposed, the better! Set the camera to wide angle, and repeat the test. Again, the more area that is exposed, the better.

Small but effective flash mounted on a Minolta body.

You should also consider where the flash is located on the camera body. The flash should be as far away from the lens as possible (this might be a little tough to accomplish on a camera with a small body). This distance helps render better shadows and helps you avoid the "deer caught in the headlights" effect. Cameras with flash units right next to the lens greatly increase the odds of your subjects getting "red eye."

Red Eye

"Red eye" occurs when the flash is too close to your lens. Because the flash is directing light straight into your subject's eye, you are actually photographing your subject's retina. This happens more frequently when your subject's iris is dilated (opened wider), such as in a darkened room. Some cameras employ "red eye reduction" gizmos—most work by strobing the flash a few times before the actual exposure is taken, to force the eye's iris to close. This technique works adequately, although it does rob the strobe of a lot of its firepower for the actual exposure. Also, if you notice, most of the people in the photo have annoyed or quizzical looks on their faces! Check out alternative lighting techniques in Chapter 9, "Lighting: It Makes or Breaks a Shot!".

Recycle time, the time it takes the flash to recharge, is also important. There is nothing worse than waiting for your flash to charge. When the batteries in your camera are fresh, this should happen almost instantaneously. A good indication that your batteries are getting *tired* is when the flash starts taking too long to recharge. How long is too long? Without getting too philosophical, too long is when you have to wait for the strobe instead of taking pictures! Swap out the batteries for a fresh pair.

On cameras that split or twist, the flash should "travel" with the lens and remain pointed in the same direction as the lens. Although I have not seen this yet, another option would allow the flash to point in another direction to help facilitate bounce-flash techniques.

Viewfinders

Two types of viewfinders are available on point-and-shoot cameras:

➤ Most cameras incorporate an LCD (liquid crystal diode) screen on the camera body. These flat screens show you what the lens is seeing. (They might show you the image you have just photographed, or they might be *active*, and show you a real-time view of what the lens is pointed at.) These types of viewfinders can be a lot of fun; using an LCD screen, you can take a picture, and then pass the camera around for all to see. LCD screens can be difficult to see in bright light. I found myself shading the LCD with my hand in order to see the image more often than I liked. The Epson Photo PC 750 offers a nice little switch that allows the LCD to be "back-lit." This made it much easier to view in bright light. I strongly advise you to check the camera you are considering purchasing in a brightly lit area or outdoors. If you have trouble seeing the LCD panel, don't buy it!

A bright LCD screen helps you preview your images.

You Gotta See This

Most LCD screens must be looked at straight on to work; you should see how well they work in subdued or bright lighting situations. Also, look to see what *intelligence* is offered on the screen (is frame count, compression rate, battery condition, time and date, or other information available?). Although it might not be a significant amount, be aware that an LCD screen is going to draw power from your batteries.

➤ A simple optical viewfinder might also be incorporated into your camera (if no LCD screen is available, this is your only way of seeing your subject). Depending on whether your camera has a metering system, you might see *intelligence* (lights and dials) in the viewfinder; you might also see scribed markings indicating what your camera sees when it's in the telephoto or wide-angle mode. Ideally, your viewfinder will have an indicator to tell you that the strobe is recharged, as shown in the following figure. I like this feature; it lets me frame up a subject and fire the camera without taking my eye from the viewfinder.

Detail of optical viewfinder. Note LED readouts.

If your camera relies on an optical viewfinder, think about the following:

➤ Can you see through the viewfinder?

➤ Is the viewfinder too small?

➤ Will your nose get in the way?

➤ If you wear ocular enhancers (eyeglasses), will they get in the way?

➤ If there is no protection on the eyepiece, will you scratch your eyewear or your forehead?

➤ What information, if any, is in the viewfinder? If a metering system is present, can you see it well?

If, on the other hand, your camera relies on an LCD viewfinder, consider these issues:

➤ Can you see it well?

➤ Does the LCD viewer work well in brightly lit situations?

➤ Can you see the LCD viewer in dimly lit situations?

➤ Is the LCD viewer big enough?

I like an LCD screen on the camera, but it might take a bit of getting used to—especially if there is no optical finder. You have to hold the camera a few inches away from your body to see the screen. If you have shaky hands, this might be a problem. (I might suggest that you drink a little less coffee…)

Selected Delete

Although this might sound like a type of weapon from a *Terminator* movie, selected deletion makes great use of the LCD screen. With the LCD screen, you can review—on the camera—all the images you have taken that still remain in memory. You can then delete the images you don't want, like the one where everyone has their eyes closed. This is a great way to save space in the camera's onboard storage.

Onboard Storage

Unless you plan to have your camera permanently tethered to your computer, which is no fun at all, it needs some kind of onboard storage. Many storage options are available; if you are comparing cameras, trying to decide which type of memory to buy is going to be the most difficult part. Here are some considerations:

➤ If a camera offers no removable memory (storage cards), it has built-in memory, usually RAM (Random Access Memory). Obviously, the more memory available, the fewer times you are going to have to download images from your camera to your computer. It can be frustrating to take only six or eight shots and then have to go running to your computer to download them.

➤ Some cameras, usually the higher-priced ones, have built-in RAM alongside removable memory. Cameras can access the built-in RAM memory more quickly

than they can access memory on a removable card, which is why the built-in memory is usually used as a *buffer*. That is, the camera saves images in its buffer before sending them to the hard-card removable memory; this enables you to more quickly take your next picture. You might also have the option to save your image with different compression modes while the image is still stored in the camera's built-in RAM.

➤ Flash card memory (removable storage media), often called flash film, uses SRAM (static RAM technology which will hold its data without electric current applied), and is found in many sizes, shapes, and storage capacities. For example, the larger-bodied and/or more professional cameras use PCMCIA cards (also called PC cards), the size and shape of a thick business card. These cards are actually miniature hard drives as opposed to flash card memory, which relies on SRAM chips. A stack of five or six PCMCIA cards, which are made of metal and very durable, consume as much space as a box of film; each card holds 8-, 16-, or up to 32MB of memory. You can expect to pay about $4 per megabyte for flash card memory.

Similar Devices

PCMCIA cards, PC cards, Type 1 memory, ATA cards, and AT cards are all similar devices.

A PC card.

➤ Type III memory cards, which are actually mini hard drives, hold more memory than the SRAM cards—typically up to 240MB. They cost about $4 per megabyte.

➤ Compact flash cards are similar to PC cards, except they are about two-thirds the size. Each card can hold anywhere from 8MB to 45MB, and they cost about $4–$5 per megabyte.

A compact flash card.

Swapping Cards

Some camera manufacturers design and manufacture their own memory cards as well, using unique sizes and shapes to fit only in equipment made by them. Compact flash cards are a good example of this. If you are going to be buying a few memory cards, and you will, be sure to buy cards that will fit other cameras. After all, you might buy another camera in the future, or hang out with a group of people who have cameras of their own and want to swap or loan cards. These cards are an investment, so plan to use them as long as possible.

➤ SmartMedia cards, also called SSFDC media, are another form of removable storage, currently used by many smaller-bodied cameras. SmartMedia cards are the size of a matchbook; are about 1/8 inch thick; can hold 2-, 4-, 8-, or 16MB of information, and cost about $4 per megabyte. Although they look sturdy, smart media cards are a little more fragile than PC cards. However, this consideration is outweighed by the portability of smart media cards. For example, you can use a SmartMedia adapter—a small device into which you insert your SmartMedia card—to transfer images to your computer. This is a lot easier than messing with cables to connect your camera; plus, when you use the adapter, someone can be taking pictures with the camera even as you download the images from your last shoot. In addition, many devices, such as printers, now feature slots to allow you to insert SmartMedia cards directly into them. This eliminates the need to first

download your images to a computer if, for example, you just want to quickly print out a contact sheet. Because of their size and portability, SmartMedia cards will likely become the standard removable device.

SmartMedia card.

Check out how small the SmartMedia card is in comparison to the Minolta camera!

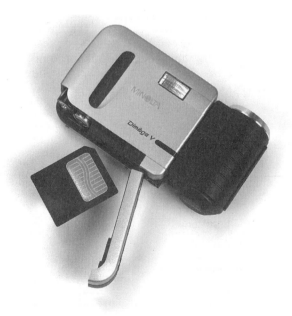

Many new storage devices are in development, some of which will be on the market soon. For example, IBM is manufacturing a mini hard drive, called the *Microdrive*, which will have a capacity of 340MB and range from $340 to $500. In addition, Sony Corporation will soon be marketing *memory sticks*, which will measure 0.85×1.97×0.11 inches, hold 4-, 8-, 16-, and 32MB of information, and cost less than $4 per megabyte. These SRAM devices will be designed to interchange between cameras, printers, and CPUs.

Downloading Options

Cameras offer two ways of getting information from them to your computer (or vice versa):

➤ **Direct cable** If you download by direct cable, it's best to leave the cable attached to the computer. That way, you'll avoid playing with cables instead of downloading.

➤ **Removable disk** If you use a removable disk, you will need some sort of docking device or reader. These also can be left attached to the computer to avoid hookup confusion.

Consider the following options when deciding which way you want to download your images (you should also consider the additional cost of cables or readers):

➤ Most cameras, especially ones with no removable memory cards, allow you to download via a cable (usually through a serial cable that connects to the back of your computer).

➤ Universal Serial Bus (USB) cables are becoming more and more common; they also make it possible for manufacturers to produce equipment that can be made for either the Mac or the PC. USB cables and connections, which allow much faster data transfer, will soon replace the traditional serial cable and port as we know it. Some cameras are being manufactured with USB connections only. You should definitely purchase a camera, or any device, with a USB port before a regular old-style one.

The business ends of a USB cable.

➤ FireWire connections are found mainly on high-end cameras (used primarily in conjunction with Macintosh G3 computers), so don't look for these on any sub-$7,000 cameras. FireWire connections are very fast, and offer the wonderful option of being disconnected, and plugged into another computer, or simply put away while the original computer equipment is on. This is called "hot swapping."

➤ PC cards and compact flash cards require some sort of reader to allow you to send image data to your machine. Most laptops come with PCMCIA slots built into them, and you can buy adapters for most PC card readers that

Warning!

You should never connect or disconnect any peripheral device to a computer while it is powered up (unless it is a FireWire or USB device). You risk seriously damaging the machine or at least the hard drive.

enable you to use compact flash and SmartMedia cards. However, if you don't use a laptop, you'll probably have to buy a PC reader for your desktop machine.

PCMCIA card reader.

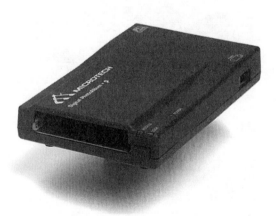

➤ Some camera systems, especially the Sony Mavica, actually use common 3 1/2-inch disks. Imagine that! Then again, with the recent disappearance of floppy drives on iMacs, you should probably avoid this option; you might have to buy a separate floppy drive.

➤ SmartMedia cards can be put into adapters that fit into the floppy drive of your computer. This makes good sense, as most of us still have floppy drive slots. (If you own an iMac, you'll have to buy a drive, download your images via a network, or download directly via the USB port.)

On the Plus Side...

One nice thing about using PC cards is that you can be downloading information from one PC card into your computer while shooting pictures with another PC card in your camera.

The SmartMedia transfer card fits in a 3 1/2-inch floppy drive.

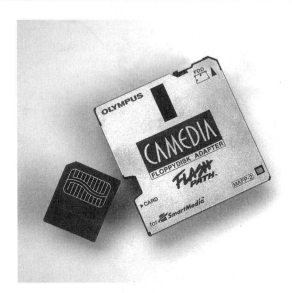

Be on TV!

Many cameras are equipped with NTSC video out plugs, which allow you direct output from your camera to a television set. You can preview your images on your set or, with included software, give a slideshow. This is a great way to show your family and friends the images you have taken without first downloading them to your computer. If you're visiting your computer-phobic grandmother, this can be a great option!

Burst Exposures

When you take pictures with a digital camera, there is usually a lag time between exposures, which is due to the camera processing or shuttling information between the RAM and the storage device. To counteract this, some higher-end cameras offer a *burst mode*, which allows you to take up to 10 exposures in a rapid sequence (the number of exposures and the lag time between differs by manufacturer). This is excellent for taking live action shots such as at a sports event or of a fast-crawling baby. As if that's not cool enough, some auto-exposure cameras use burst mode to quickly take four or five shots of the same image, varying the exposure, and then select which exposure is the best!

Metering

If you really want to have as much creative control over your photography as possible, you should buy a camera with an exposure meter built in (you'll usually find exposure meter readouts in the viewfinder). This will allow you to precisely control your exposure. This comes in handy in toughly lit scenes, such as with backlighting, which can fool an automatic meter. But even if you don't have an exposure meter, some cameras enable you

More About Exposures

We'll get into the topic of exposures a bit more in Chapter 6.

to select either the shutter speed or the f/stop. This is called *shutter* or *aperture priority exposure*, and is a nice compromise over fully manual exposures.

Resolution

A camera usually records your image in full resolution (using every CCD on the chip) as a TIFF file. To save space on your hard drive, however, your camera might offer you the ability to take images with lower resolutions. Each manufacturer handles this in different ways; one is to actually take a photograph, reduce the image in size, and then store it (some cameras compress the image even further after this process). Although this allows you to pack a lot of images in storage, it has the disadvantage of making your files low resolution.

You can also shoot a full-resolution image and then compress it using a compression rate that you select. Although the compression process degrades the images slightly, this is a better way to go. (Resolution and compression are covered in more detail in Chapter 11, "Compression.")

Speed and Sensitivity

Some cameras allow you to vary the sensitivity, or ISO rating, of the chip, which has the same effect as using a higher-or lower-speed film. Specifying a faster ISO rating enables you to shoot in lower-light situations, and gives you some degree of control

over the exposure. Realize, however, that using a faster ISO rating usually means that some sort of amplification is being done on the chip, which produces *noise*. Noise appears mostly in dark areas of your image as blue and red/blue "static."

A good way to compare cameras for sensitivity is to look at their slowest ISO rating. If you find one camera's specification with a minimum rating of, let's say, ISO 100, and another with a "spec" minimum rating of 200, opt for the ISO 200 camera (provided that the ratings are true and not already amplified).

Generally speaking, only cameras with bigger chips and/or cameras in the mid to professional range offer this option. However, it could be a good deciding factor when trying to choose between two otherwise similar cameras.

Helpful Hint

Don't overtighten a tripod screw; you might drive it into the camera body. I did!

Extras

You should look for a few more bells and whistles on a camera when buying one:

➤ Your camera should have a threaded hole on its bottom to allow you to attach it to a tripod. If it doesn't, don't buy it. Be sure the tripod mount will not be in the way of the door for the memory cards. Otherwise, you will have to remove your camera from the tripod to change cards.

➤ Another good thing to have is a flash cord socket. This allows you to fire a flash, via a wire, that is mounted off the camera. You'll probably find this on a more expensive camera.

➤ How are you ever going to be in your group shots if you don't have a self-timer on the camera? Most cameras do, but double-check!

➤ A cable release (a mechanical or electrical cord that you attach to your camera and use to fire the shutter) is a great thing to have if you are going to be taking pictures with a slow shutter speed or in low-light situations. Using a cable release prevents you from shaking the camera when you press the shutter button.

Helpful Hint

If you don't have a cable release, try setting the camera on a tripod or a surface that is not moving, and set the self-timer. Your camera will go off with nary a shake!

Bundled Software

Most cameras come with some sort of bundled software. Be aware that while many of these might be complete programs, some might be "lite" versions or timed versions that stop operating after a specific amount of time. Check this out before you think you're getting the deal of the century.

A Final Word...

It is always hard to decide when to buy new equipment, but if you need the new equipment immediately, for whatever reason, find the best deal out there and go for it. On the other hand, if you're in no real rush, remember that there is always something better—some new gadget—on the horizon. Do your research to find out whether something big and new is about to come out, and decide whether you can live without it. If you can live with yesterday's technology (which worked great yesterday), you can get a good deal. (Remember when the new Intel Pentium III chipset machines came out? The P-II machine prices fell, big time.) If, however, you want the newest and best, get the new stuff—but be careful what you buy. The technology might still have a few bugs in it, or it might eventually be replaced (can you say *Betamax*?). But whatever you decide, don't miss any great shots by putting off your decision!

The Least You Need to Know

➤ With all the available options and choices, your best bet is to do your homework to find the best deal.

➤ Decide how involved you want to get when taking pictures. Don't buy more camera than you need, but leave yourself some room to grow.

➤ Don't become "camera poor." Be sure you have enough cash left over to buy a few batteries and any computer equipment you might need.

Mac Versus Windows: System Requirements for Digital Capture

In This Chapter

➤ Which computer will do, a Macintosh or a Windows platform?

➤ How much computer do you need?

➤ What is the best monitor for you?

➤ What peripheral devices do you need?

➤ How to buy a printer

➤ How to buy a scanner

There are so many automobiles on the market today! There are sports cars, family cars, and SUVs (we'll buy anything that is spelled with an acronym); some cars offer huge, powerful, gas-guzzling engines, some cars offer tons of cargo space.

No, I haven't suddenly switched to writing *The Complete Idiot's Guide to Buying a Car*; rather, I want to make a point. Almost any car can get you down the road. Likewise, you can use almost any computer to store and manipulate images you obtain with a digital camera. The issue is how well the computer you use can handle the task.

Windows or Mac?

The first question that might come to mind is do I need a Windows machine or Mac? The answer is simple. They both work, and work well!

Macintoshes were the first computers to offer any graphic software and photo manipulation, and in the beginning, most photo-manipulation software was developed

solely for Macs. Macintosh's *GUI* (Graphical User Interface) worked perfectly with digital photography. Macintosh computers also were the first to have graphic cards which were very speedy and offered millions of onscreen colors, both of which are very important when working with onscreen photographic images.

Nonetheless, Windows OS (operating system)–based machines have come a long way since they first appeared. They offered a usable GUI that was an alternative to the expensive Macintosh computers, and were much easier to use than plain old MS-DOS (Microsoft Disk Operating System) machines. Over time, Windows computers have become powerful graphic machines. In fact, most new software is written for the Windows platform first and then ported over for Macs later. In addition, graphic card development has brought millions of colors and tack-sharp resolution to Windows screens.

Camera manufacturers design their equipment to work on either platform, and most also include software that will work on both systems. If you own a Windows platform and are comfortable with it, stay with it. If you own a Macintosh system, ditto! If you don't own a computer at all (where have you been?) or are considering changing sides, go do your research. Ask yourself the following questions:

➤ How involved are you going to get in this new hobby of yours?

➤ How much will a new disk drive cost? How much for a printer?

➤ Will one system be more economical than another?

➤ If one system does cost less than another, will you be trading off ease of use? If you are staying up all night or wasting tons of paper trying to print something out, was the $50 or $100 you saved worth it?

Plug-and-Play Perks

Macintosh machines are still easier to *plug and play*, meaning that adding equipment and new software or upgrading is generally easier and less time-consuming.

Before you buy a system or a camera, decide where you are going to get technical help. Will your dealer supply it? If you buy equipment from a superstore, can they supply help? Many equipment manufacturers offer Web sites for help; phone support might also offered. Call up a manufacturer or visit its Web site, ask a question (make one up!), and see how long it takes to get an answer. Are you put on hold for an hour? When you get through (or find the right Web page), do you get the right answer?

If you already own a system, you might find that the software packaged with the camera (or any new software you plan to buy) works very slowly or not at all. Most of the software and equipment that is on the market now is designed to work with Windows 95/98 or with a Power PC. Ask your dealer/supplier questions. Will the software work on your system? Remember that you might need to upgrade software down the line; will the upgrades be backward-compatible to your system? If you can get a demo version of the software before you purchase the camera, install it and see how it performs. Does it choke your machine? Does it bother you to have to work a

little slower? You might ultimately decide to start out with your current system and buy new equipment later.

General Requirements

It can be frustrating to use a computer if you don't have enough under the hood. Let's take a look at what you'll need.

Random Access Memory (RAM)

RAM is where the software and files are loaded in the computer. Think of RAM as a computer's brain capacity, but don't confuse it with hard drive space, which refers to a computer's storage capacity. If you plan to be doing imaging, don't even think of working with less than 32MB of RAM, or you will spend more time rebooting your machine than anything else due to lock-ups. Using 64MB will make working much easier; many new machines are being sold with 128MB already installed. The more RAM, the better!

Getting Tech Help

Because more Windows machines are on the market and in homes than Macs (even though Macintosh is starting to get back its market-share with the iMac), it might be just a little more difficult to get technical support for questions that deal with Macs. This doesn't mean you won't get support; you just might have to wait a bit for some-one who is a little more Mac savvy.

Getting More RAM

If you want to purchase more RAM, shop around either on the Web, in the back of computer magazines, or by making a few phone calls. You can find great prices, but beware! Not all RAM is created equally! Most manufacturers or suppliers of quality RAM offer a money-back guarantee on damaged RAM. The extra few dollars you pay for this is well worth it. Also, RAM is sold in many configurations; be sure the RAM you buy will work on your machine! If you plan to upgrade your machine, be sure you can use the RAM you are buying on your next machine as well.

Although installing RAM is not difficult, you might want to have a qualified repair technician install your new RAM. If you decide to do it yourself, see whether your RAM dealer will talk you through it. Alternatively, you can go out and buy a book that tells you how to maintain and install accessories. (It's a good idea to have one of these around, anyway.)

Central Processing Unit (CPU)

On the Windows side, suffice it to say that Intel isn't the only CPU game in town; there are alternatives, such as AMD and Cyrix. Also, each CPU manufacturer offers a few different lines. For example, Intel makes the Celeron, Pentium II, and Pentium III chips, each with its own benefits and drawbacks. Chips might be manufactured to perform some functions better than others, such as multimedia or 3D graphics. As a general rule, the more you spend, the more you get (within reason). On the Mac side, you won't find different manufacturers of chips, but you will find different generations of technology. Don't buy more chip than you need, but plan for the future.

Remember: Some software might not work on older chips.

Speed and Performance

The type of CPU, the type of bus, and the clock speed of your CPU all work in concert to determine how long you will wait for something to happen.

Bus

The *bus* is the path the information flows through, connecting all the peripherals (such as the hard drive, graphic card, and CPU) together. I like to equate the bus to a highway. The faster the speed limit and the wider the highway, the more cars will get through. The bus is usually tied to a specific type of platform. For example, the bus on a 601-type Macintosh is much slower than on a G-3 (603-40) type Mac. Although you can't specify what type of bus you get when you buy a computer, it is important to know that it is a factor in performance.

Clock Speed

Clock speed measures how fast your CPU can think, and is another important component of speed and performance. A similar-type CPU running at 300MHz is 25% slower than a 400MHz machine. What does that mean to you? If you are working on a 4–10MB file, it might take a few seconds more to rotate a file on a 300MHz than on a 400MHz. However, if you are working on a 100MB file, like I usually do, it could mean a few minutes. Get as much speed as you can afford—time is money!

Hard Drive

The hard drive is like a filing cabinet; it's where you store all your information. The rule here is, again, the more, the merrier. Hard drives are cheap; the difference between a 2MB and a 4MB hard drive might be minimal. How much you need depends on you. If you are a pack rat and never take anything off your hard drive, I suggest you get an 8–10GB (gigabyte) drive. For the rest of us, a 4GB hard drive will do. If your internal hard drive isn't adequate for your needs, consider bolstering your machine's memory by adding an external hard drive, like the one shown here.

An external hard drive.

Access Speed

On Windows platforms, you will probably see drives that plug into IDE connections on the motherboard. Most of these spin at 5,400rpm, but you might also see drives spinning faster, at 7,200rpm. Although the rpm is an important factor in how quickly you can access information, it is not the only one. Unless you are planning to do intense multimedia presentations, don't worry about access speed.

Ports

Ports are the holes on your machine where you plug in all your cables. In addition to the monitor port, keyboard port, and SCSI port, you will find a port or two for your camera (if you can't find them, see whether your computer is using the same port for more than one task). The following list describes the different types of ports:

Other Drive Types

SCSI (Small Computer System Interface) drives are also available on Windows platforms, but are more commonly found on Macs. SCSI drives are a little more expensive because of the added costs of a driver card, but they allow more drives to be connected.

You might also soon be seeing FireWire drives available for Macs as add-on peripherals (the new G-3 Macs have FireWire drives standard). FireWire drives and peripherals might be connected or disconnected while the system is running. Also, FireWire allows many more devices to be chained (connected) together than SCSI drives.

➤ A *serial port* is the port you will probably use to attach your camera or other accessories.

➤ *USB (Universal Serial Bus) ports* are becoming more and more common, and will probably become the default standard for all new computers—Macs and Windows—as well as on all cameras. They are fast, and more importantly, are universal to all new equipment. They also greatly increase your machine's capability to be *plug-and-play compliant*. I recommend that you think seriously before buying equipment that does not have a USB port on it.

Kbps

56Kbps speed refers to the best possible download speed from your ISP (Internet service provider). Poor phone lines, older switching technology, and sometimes your modem's mood will slow down the download. I find that during peak usage times (between 6-11 p.m.), the Internet gets very busy and your modem speed can get very slow. For night owls like me, this is not as much of a problem. Also, remember that the maximum upload speed on these modems is only 36Kbps.

Modems

Although an argument might be made that a modem is a peripheral, it is hard to find a computer on the market today that does not have an onboard modem as standard equipment. With so much of our lives now revolving around email and surfing the Web, it is almost impossible to own a computer and not need a modem. Most modems on the market today offer 56Kbps (Kilobytes per second) speed; buying a modem that is any slower is a waste of money.

Alternatively, you might look into getting a cable modem, which allows you to send and receive information via the same broadband cable that your television uses. Using a cable modem is much faster (maybe as much as 10 times) than a standard telephone line. Cable modem speeds will slow down if there are a lot of users logged in your area. If you decide to go this route, find out how the modem will be connected to your computer. You might find that you won't be using an internal or external modem, and would be wasting your money to buy one.

Graphic Cards

Some computers offer video boards that are hard soldered or integrated onto the motherboard. This is fine as long as the boards can be upgraded or have enough onboard memory. Most machines, however, offer the graphic cards as standalone boards that take up one of the accessory slots. The benefit of standalone cards is that you can upgrade your video capacity without getting a new machine.

Monitors

Which monitor you buy might be the most important decision you make as far as image quality is concerned. If you can't see the image you have taken and its details, you will have a hard time editing it. However, there are so many CRT (cathode-ray tube) monitors on the market that buying one can easily become confusing.

Before you buy a monitor, it's a good idea to see what's hot and what's not. Pick up a computer magazine or visit a Web site that features tests and comparisons. Many of these reports will make it easier for you to compare monitors of similar size and with similar features. They might even rate the monitors as a best buy or editor's choice.

Internal Modems

Having an internal modem might not be such a great thing, especially if the modem won't hang up the phone line or the computer freezes. With an internal modem, you often have little or no choice but to crash the machine. With an external modem, however, you can turn off the modem or disconnect the phone line when these problems occur.

2D Versus 3D

A lot of different video cards are available; many are geared toward 2D image graphics, whereas others include 3D graphics. The 3D cards greatly improve your video performance when it comes to viewing games. (You are going to play a few games, aren't you?)

Video RAM

The amount of VRAM (video RAM) on your video card determines how large a monitor you can use and what bit depth you see (for now, we'll define *bit depth* as the amount of color you can see). You don't want to cheap out here. Do not purchase a 2D card with less than 8MB of VRAM (although you can get away with 4MB, you will be very unhappy). If you have a 3D card on your system, you might want to have 16MB or even 32MB of VRAM installed. With more VRAM available, you can get better texture and colors, and you will see a marked increase in video speed.

Go Fast

You can have the fastest computer in the world, but if your video card is slow, the benefits of that fast computer are counteracted. The faster your video card, the faster your screen redraws. This means you will see the changes you made to your images faster.

Consider the following when buying a new monitor:

➤ **Size** Monitor size is typically measured diagonally from corner to corner of the picture tube (the monitor's case might take a little off this dimension). Most computer systems come with 15-inch monitors, which are pretty small for imaging. (If you find that you are leaning into your screen or you are constantly cleaning off nose prints, your screen is too small!) If you can, buy a CPU without a monitor or try to trade up to a monitor that measures 17 inches—a great size for most imaging. Monitors should cost between $300 to $900, with most found in the $350 to $600 range (you will pay more for extra controls, higher resolutions, or faster refresh rates). The next size up from a 17-inch monitor is a 19-inch model, which ranges in price from $600 to $1,100. On top of the heap,

king of the hill, and all-out huge, are the 21-inch monitors, which are primarily used by professionals and cost $900 to $2,500.

Although the old standard "bigger is better" applies here, also bear in mind that monitors take up a lot of real estate on your desk. Fortunately, some monitors are available in "short" models, which use different monitor tubes and configurations to decrease the distance between the front of the monitor and the back. This might be worth a few dollars if you have a small desk.

Doubling Up

Many professional photographers, illustrators, and graphic designers use two monitors with their systems. One monitor, which is run off the onboard video card, displays the imaging software's tools, such as the color palette. This monitor is referred to as the *toolbox monitor*. The other monitor, which is usually run off an in-slot monitor card, shows only the image. The benefit here is that the image can be viewed without the clutter of the software interface. Remember, each monitor needs its own graphic card.

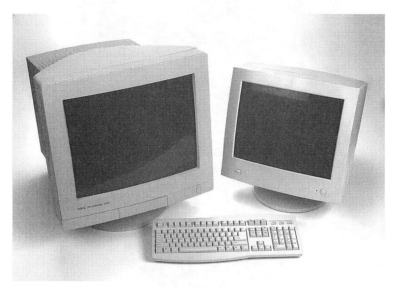

A 21-inch imaging monitor and 17-inch toolbox monitor.

LCD Monitors

Flat-screen LCD monitors are becoming more popular due to their size and relatively small footprint. They also weigh a lot less. As with most new technology, however, they are still a bit pricey compared to CRT screens (expect to tack on about $1,000 to the price of a comparable-sized CRT screen). LCD monitors are sharper than CRT screens, but they have the disadvantage of being fixed resolution. Although the newer LCD screens have solved the viewing angle and brightness problems of their predecessors, they have yet to come into their own for use in photo imaging.

*A beautifully designed
IBM flat-screen monitor.*

➤ **Mask** When the electron beams are projected onto the monitor's phosphor surface, they pass through a *mask*. There are two types of mask technologies:

 ➤ *Dot masks*, also called *shadow masks*, have small holes arranged in a pyramid pattern that the electron beams shoot through. These are the most common types of monitors. For a shadow mask, a 0.28mm diagonal pitch is the largest you should use.

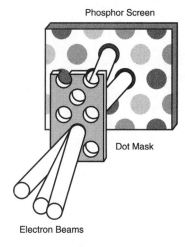

Shadow-mask technology.

 ➤ *Aperture grille* masks are composed of thin wires that run vertically from the top to the bottom of the screen; the electron beams shoot between the wires on their way to the screen. Aperture-grille technology has the advantage of being a little brighter, because there is less to hold back the light. They are, however, more sensitive to movement, and the wires will stretch out of alignment after some time. Also, some people find the wire grid difficult to look at. On an aperture grille screen, a 0.26mm to 0.27mm diagonal is acceptable.

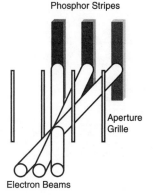

Aperture-grille technology.

➤ **Dot Pitch** Dot pitch is the measurement of distance between the phosphor dots on the screen. A monitor's dot pitch is a good measure of its sharpness. Whether your monitor uses shadow masks or aperture grilles, a smaller dot pitch is better. The price of a monitor quickly increases as the dot pitch decreases.

➤ **Refresh Rate** This refers to the number of times the screen is redrawn in a second. A slow refresh rate causes the screen to appear to flicker, making the screen difficult to look at and tiring for your eyes. Monitors of 17 inches and smaller should have a refresh rate of 75Hz. Monitors larger than 17 inches should have a rate of 85Hz.

➤ **Controls** Your monitor should have a set of easily accessed controls that you can use to adjust contrast, brightness, color, image size, and image location. Many monitors also have controls for image shape such as pincushion, trapezoid, and parallelogram. These controls should be easy to access and the screen image should not "float" away from the settings.

➤ **Energy-Saving Features** Monitors are becoming energy conscious, many sporting an *Energy Star* decal. These monitors use less than 30 watts in their power-saving mode. In addition, many monitors, and even computers, go into sleep mode when they are not being used. A tap on the keyboard or wiggle of the mouse wakes the machines up and turns them back on.

➤ **Safety Considerations** A few more things to look for are safety considerations. For one, your monitor should have an FCC class B certification, ensuring that your monitor will not interfere with other electronic devices in your home such as your television or radio. A class A device is meant for a business environment where interference is less of an issue (assuming no one is watching television at the office).

Monitors emit a lot of radiation. Most monitors should, at least, comply with MPRII low-emission standards. Those that comply with TCO 92 or TCO 95 even have lower emission ratings.

Reducing Strain

If you want to save yourself a lot of eye, neck, and back strain, set your workstation up with your body in mind. Your keyboard should be on your desk or keyboard tray, resting at the level of your elbows when you are sitting in a chair (that is, if you are sitting in your chair with your arms at your side, the desktop should be at the same height as your elbows).

The next important thing is the monitor height. The monitor should be at your eye level when you are sitting in the chair. You should not have to look down or up at it. This will greatly reduce neck strain.

If you find yourself squinting at the screen, try to reduce the ambient lighting in the room. Put up a few shades or turn off some lights. I usually have a small desk light on my desk lighting up my paperwork or keyboard. Because you are sitting so close to the screen, especially for those of us who wear glasses, you might consider getting reading glasses. You can also push your glasses down your nose a bit to shorten the focal length of your glasses.

Remember, sit up straight!

Peripherals

Many peripherals are available to enhance your computer. These gadgets take up much space in computer stores, and many pages in catalogs. Some of these peripherals, such as a zip drive, are pretty handy to have. Some, such as a coffee cup holder for your monitor, are not really needed. Take a few moments to think about what you are buying and how it will fit into your system "plan." Will your purchases enhance your system's capabilities or just look cool on your desk?

Optical and Magnetic Storage

As discussed previously, you need a way to take data off your hard drive to store or transport; this section discusses myriad options.

Zip Drives

Zip drives, manufactured by Iomega, became popular as soon as they hit the market. These drives are light, fast, portable, durable, and—best of all—cheap! A zip drive costs about $100 and holds one removable disk at a time. Each removable disk, which is inserted into the drive like a floppy, holds about 100MB of data and costs as little as $10—that's 10 cents per meg, folks. (You can also purchase 250MB zip disks.) Zip disks are great for transporting images, because the transfer rate from the CPU is very quick—1.25MB per second. Zip disks are based on floppy disk technology, which is reliable. However, the disks can be damaged if exposed to excessive heat, water, or a magnetic field.

JAZ Drives

JAZ drives, which are also portable and made by Iomega, cost about $350, and hold one removable 2GB JAZ disk. You might find that a disk might be included in the "deal." The JAZ disk sells for $125 (8 cents per meg). The transfer rate on the drive is 8MB per second. Because the price of the removable disk is high, these drives are used primarily by professionals. The JAZ drives have been plagued by unreliable performance and are costly. I would not recommend them for amateur use.

Magnetic Optical Drives

Magnetic optical drives are not portable; they write to a magnetic media disk. The disk also has an optical track, read by a laser, which is used to guide the read/write head. This allows the drive to be more accurate, faster, and more compact in laying down information. MO drives are great backup and storage devices. The disks range in size from 128MB, selling for $10, to 4.6GB, selling for $135. The drives are reliable and the medium is durable and stable. You will find many companies selling drives under their own brand names, but the guts of the machines are usually manufactured by Sony or Philips.

Zip disk, JAZ disk, and magnetic optical disk.

CD-R

Compact disc recording drives are great for archiving information. The drives range from $300 for a midlevel drive to $600 for a drive that records DVD. After you get past the cost of the drive, the medium is incredibly cheap. A disk, which holds 650MB, costs about a dollar. That's very affordable. If you don't mind the initial expense, I recommend that you consider buying a CD-R. Besides it's cool to make your own CDs! (Note: These CD "burners" are a lot slower to record on than magnetic media drives.)

CDRW

In addition to a CD-R, just to confuse you, there are also CDRW drives. These enable you to write and overwrite the same disk many times, just like a magnetic disk. The cost of a CDRW disk is about $12 per disk. I'm not a big fan of this technology as a storage medium, because you can buy 12 regular disks for the same price and store 12 times as much information. (Of course, after you've written over the CDRW 12 times, you are making a "profit"; this works fine as long as you don't damage or lose the disk.)

Burn your own CDs to store data. Remember, however: Copying music CDs is a no-no!

Printers

It is a lot of fun to take pictures and see them appear instantly on the LCD screen on the back of your camera. It is even more fun to see the images on your big new 17-inch monitor (you did get the 17-inch monitor, didn't you?). But what makes the whole process totally worthwhile is printing out the images on your own printer. You can make an image any size you want, and make as many as you want, just for the cost of the paper and ink! Your printer might well be as important a piece of equipment as your camera; a few extra dollars spent on the right printer is well worth it.

The best way to decide which printer to buy is to test some. Take one of your own images to a store that sells printers (go when they will have the time to give you individual attention), and print it out on each printer you are considering buying. (Try to use an image that has detail in the shadows and in the highlights. You should also put a calibration strip in your image—check out Chapter 21, "Print It Out," for more info on this.) Be sure you are comparing similar technologies; comparing an inkjet with a dye-sub printer is not a fair fight. You'll want to "calibrate" each printer so that they are all printing at the same density; do this by adjusting your image for each printer. The calibration strips in each printout should be as close to each other as possible. In addition, you will probably have to make the image lighter or darker for each printer (this takes some time, but trust me when I say it's time well spent). Be sure you print the images out on the same type of paper, such as glossy or dull coat, and write the name of the associated printer on the back of each print. You might also want to keep track of how much time it took to print out each print. Now go home (you've created enough trouble), and place all the prints next to one another in a well-lit room. Which print best held the detail in the shadows and highlights?

You might find that some did a great job in the shadow but missed the highlights altogether. After you find the print that looks the best to you, turn it over. Voilà, that is the printer to buy! By the way, when you decide which printer to buy, please return to the store where you ran your test. It's only fair!

The image quality should be the paramount reason you buy a specific printer. However, there are a few more things to consider:

➤ **Printer Speed** If one printer prints a page in two minutes and another printer prints the same page in five minutes, all things being equal, you would probably buy the faster one. However, if the difference is a little closer, you might have a tougher decision to make. One way to get around a speed issue is to print out your image in *draft mode* first. This way, you can get an idea of what the image will look like. If you need to, you can go back and edit the image for color or density, and print the final version in high-quality mode.

➤ **Resolution** Resolution is also an issue to take into account when you buy a printer. After spending all the time and money on a camera, it would be disappointing to not be able to reproduce the details in the image.

Resolution is expressed as DPI (dots per inch) in printing. (If you were able to print a straight line and count the dots in one inch of it, you would be able to determine the DPI. Trust the manufacturer's count; you'll go crazy trying to do it yourself.) As the print head (or whatever mechanism is being used) moves across the paper, it lays down a dot of ink or dye. The more dots the print puts on paper and the closer they are to each other, the more detail you can reproduce.

Demo Images

Don't rely too much on the demonstration images that the manufacturers distribute or spit out automatically from the printer at the dealer. These images have been tweaked to make the printer look wonderful, taking advantage of the printer's capability to print some specific colors well. Additionally, an image might be chosen that has an "expanded" (very detailed) shadow or highlight area. I know; I've been paid to "tweak" a few in my time!

Speed Booster

Another way to get more speed out of a printer is to increase the onboard RAM. A printer that has 4MB of RAM runs slower than one with 8MB. RAM is cheap—you might be able to get away with spending a few extra dollars on adding RAM rather than spending much more for the next-model printer. Note: You will not see a big increase in speed unless you double the amount of original RAM.

You might also see printer statistics expressed as LPI (lines per inch). Each time the print head moves down the page, it creates a line out of all those tiny dots. Lines per inch refers to how many of the lines are on the page, measuring from top to bottom. The more, the merrier!

➤ **Expense** You must take into account the cost of running your printer. How much will the ink or ribbons cost? Will your printer need special paper, or will plain old copier paper do? Some printer technologies don't use off-the-shelf paper, and you must buy the paper you need from the manufacturer.

How Much for Ink?

It is tough to figure out exactly how much ink will cost. Depending on the amount of color in an image, your printer uses more or less ink. In addition, printers, especially inkjets, have separate ink colors that are stored in small, nonrefillable tubes or cartridges. Some manufacturers will sell you one cartridge filled with cyan, magenta, and yellow ink, and one cartridge filled with black ink; some manufacturers will sell you each color separately. This is important, because all the colors don't get used up at the same rate. For example, if you just came back from your vacation in Aruba, you will (I hope) have great pictures with blue skies and blue water, which means your prints are going to use up a lot of cyan ink (trust me on that one). It would be a shame to throw out a set of ink cartridges because you used up all the cyan ink, even though the other colors were still full. (Alternatively, you could plan your next trip to use up the other colors.) In any case, examine the manufacturer's specifications to determine how much ink your printer will use.

Inkjet Printers

Inkjet printers, ranging in price from $200 to $600, have become very popular. Inkjet printers spray ink through tiny jets, or nozzles, onto the paper. Pretty simple, huh? All in all, inkjet printers deliver great and affordable results, but there are some downsides:

➤ The ink from an inkjet printer tends to *migrate*, or spread out, on the paper, making the print look less sharp because the "dot" is less defined. A harder, less absorbable paper, such as paper with a glossy surface, helps contain ink migration, but the ink might take a few minutes to dry. You should handle a page, especially one with a lot of dense color on it, with care.

➤ Inkjet printers can be very slow. It takes a lot of time for the print head to scan across the page and deliver ink. Pay close attention to the page per minute (PPM) specification when you are choosing a printer. (You'll have to spend a lot more money to get faster PPM technology.) A printer that can print at 2-3 pages per minute is a good choice.

Epson, one of the chief manufacturers of inkjet technology, has a commercial line of inkjet printers that are used in the printing industry as proofing devices. In other words, these printers can mimic (that's what a *proofer* does) the color quality and sharpness of a printer press! Epson also has printers that are designed specifically for printing photos (Photo 750). I reviewed this printer while writing this book and found it reproduced my images with very good detail and very accurate color.

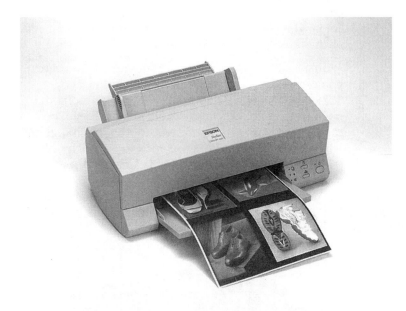

A lower-end, but very serviceable, Epson color printer.

Although you can use "plain old" paper to get a quick draft image printed, a better paper grade, such as a good-quality laser paper, yields better results. Some manufacturers, such as Epson, sell paper specifically designed to reproduce photographs. Although this might be a little costly, it will make your photos look great.

Dye Sublimation

Dye sublimation (dye-sub) printers deliver the closest quality to a photographic print. Dye-sub prints look and feel much like the drugstore color print you are used to looking at, delivering the best color clarity and sharpness. If I might put my bias in here, and I am going to, these are my favorite printers. I use a dye-sub, manufactured by Kodak, in my studio as a proofing device.

Don't Panic...

Many dye-sub printers lay down one color of dye, push the print out, and then suck the print back into the machine to lay down the next color. Because the dyes bond with each other, this is a natural way to produce color, but I admit that the first time I saw this, I thought the machine was broken. When finished, the prints—whether they've been generated using multiple- or single-pass technology—emerge dry.

Dye-sub printers work by transferring colored dyes by heat (for this reason, you might also have seen these printers referred to as *thermal dye sublimation printers*). The dyes are held on a ribbon or roll and transferred to the paper when heated. When the dye hits the paper, it *sublimates*, or sinks into the paper—it does not sit on the paper surface.

You cannot use any old paper in this process; you must use paper, sometimes called a *receiver*, that is made especially for this process. When you use the proper paper, the dye spreads out a bit on the paper's glossy surface and mixes with the other colors, producing a continuous tone much like that found in a traditional color print. Generally, this doesn't affect the sharpness of the print as with inkjet printing.

With a quick trip to a computer supplier's Web page, you can find dye-sub printers starting as low as $225–$500. Sony, Olympus, and Casio are among the manufacturers producing printers in this range. The caveat here is that these printers, in this price range, deliver prints in sizes from 4×5-inch to 5×7-inch only, which is fine if you are printing images from a 1Mp (megapixel) camera. If, however, you are planning to make larger prints, or are buying a 2Mp camera, you need to spend a little more on a printer. A printer that produces an 8×10-inch or larger print will cost you about $2,000–$2,500. Fargo has been making dye-sub printers in this class for quite a while now, delivering good-quality machines.

A dye-sublimation printer by Olympus. Dye-sub prints are the closest thing to a "drugstore" print.

Consumable costs in dye-sub printing are higher than with inkjet technology. As I mentioned, you cannot use any old paper to print on; you must use a special dye-sublimation paper. Also, the dye-sub ribbons are a little more expensive than inkjet cartridges. It is difficult to predict an average price per page, because the costs for consumables vary from brand to brand. The manufacturer should list the price per page in their literature. I find that it costs me about $3.00 to output a 8×10-inch print on my dye-sub printer. You might also not be able to find the dyes and paper at an office supply store or at some computer stores, as you would with inkjet supplies. You might have to depend on mail order or buy them over the Web.

Thermal Wax Printers

Thermal wax printers, as you might have already guessed, deliver colored wax instead of dye. The wax sits on top of the paper. On the plus side, you can use the now-famous "any old paper"; the print quality of thermal wax printers, however, is not all that great.

Micro-Dry Printers

Micro-dry printers, which can be purchased for about $350, work much like dye-sub printers, delivering resin-based ink via thermal transfer from a ribbon. You can use any old paper with a micro-dry printer, but because the ink hits the paper almost dry, the colors do not blend as well as with dye-sub printers. For this reason, you will likely see dot patterns and banding (*banding* looks like striping in solid-color areas, such as in the sky).

> **Hybrid Printers**
>
> Fargo makes a printer, called the Primera Pro, which takes advantage of both the dye–sub and thermal wax processes. It allows you to print out a draft print with wax and then produce a final print with dye-sub technology. This is a great blend of technology, quality, and budget.

Color Laser Printers

Laser printers work by magic. No, not really! A laser "exposes" a drum inside the printer. (Remember, a laser can produce a very small dot!) As a result, the drum is charged with static electricity. The drum picks up colored toner, which sticks to the static. The drum transfers the toner to the paper. The toner is then thermally fixed to the paper (this is why the paper is warm when you pick it up). Color laser printers produce a lot of heat—nothing dangerous, but it will warm your room up a bit—and consume a lot of electricity.

Color laser printers deliver great color, but before you get excited, you should know that these printers can get expensive. They start at about $1,500, but a good-quality printer costs upward of $3,000–$4,000. After you get past the cost of the printer, the consumables cost per page are similar to inkjets. You can again use "plain old paper" but a better-quality paper, a glossy one if you can find it, produces better results.

Thermal Autochrome Printers

Thermal autochrome printers, which range in price from $450–$600, do not use any ink or dyes. Instead, the color is already in the paper, and is "activated" by heat, somewhat like the process found in fax machines. Although you don't have to replace ink or toner, you do have to use photo paper made especially for this process. The results are good, but not as good as a dye-sub print. Also, most of these printers produce only (give or take) a 4×6-inch print. This is not a widely used technology, but Fargo, Fuji, and Panasonic manufacture printers and supplies.

You certainly have many options and you can easily get confused about which printer to buy. Decide on what your priorities are—does quality or price matter more? If you can find a printer that fits both those categories, terrific! Also, you might decide to stay away from technology that is used by only a few manufacturers. You might also want to look at printers that can handle your needs when you expand your system. Finally, if you have a home office or your kids need to print out their art or homework, you need to take that into consideration as well.

Another consideration when buying a printer is the archival limitations of the inks used. Many prints, especially when exposed to direct sunlight, will fade and change colors. There are special inks made by third-party vendors, which are manufactured to be archival (stable) for a long period of time. These ink sets are usually found for ink-jet printers. The best place to find these inks is in professional photography magazines such as *Photo District News (PDN)*, or at a professional photo supply store.

Scanners

Another accessory that you might want to consider for your digital darkroom is a scanner. A scanner can be a great way to add many of your old photos into your digital archive. You can use a scanner to reproduce or manipulate images you already have taken or images someone else has given you (my mom is always finding old prints that she wants me to scan in and reproduce).

Scanners cost anywhere between $300 for a basic one to $1,500 for a high-resolution one. I've even seen quite a few for the amazingly low price of $75. You will find many, many brands of scanners on the market; this is because scanners are the fore-runners of digital cameras, and have been on the market for quite a while.

Scanners work by moving a CCD chipset and a light source across an image—there is usually no lens involved. Single-pass scanners, which use a tri-linear array (a separate CCD for red, green, and blue), make one sweep across the image; a three-pass scanner, which uses a simple linear array, makes three passes (once for red, once for green, and once for blue). Triple-pass scanners might suffer from color misregistration, because the head has to sample the color from exactly the same place on each pass and that can be a difficult task due to vibration or mechanical misaliagnment. Vibration, from the machine itself or from outside the machine, might also cause color misregistration.

Agfa flatbed scanner.

Two different types of scanners are available on the market:

➤ **Flatbed Scanners** Flatbed scanners are used mainly to reproduce reflective art, such as photographic prints or paper (also known as your kids' artwork from school). These scanners look like a rectangular box with a hinged cover; under the cover, you'll find a glass plate on which you put your image face down. The scanner head and mechanism are under the glass surface. You can lower the cover to hold the artwork flat, or simply to keep the glass clean when not used.

Scanner Speed

Speed is a definite factor to consider when purchasing a scanner, which is one of the advantages of a single-pass scanner. When comparing scanner speeds, be sure you are comparing scanners of similar resolutions.

➤ **Slide Scanners** Slide scanners are made to scan 35mm (or larger) slide transparencies. Generally, these scanners cost more than flatbed scanners, starting at $800 and ranging to as high as $2,000. These scanners cost a bit more because optics are usually involved, along with a light source, to illuminate the slide. Basically, with a slide scanner, the slide is inserted into a slot and the scanner does the rest. Some scanners even offer a transport mechanism, which allows multiple slides to be loaded up and scanned automatically.

Many flatbed scanners also scan slides. Techniques vary from manufacturer to manufacturer, but nearly all of them have found a way to illuminate slides and scan them. It is economical to buy one of these scanners as opposed to buying one scanner for

each duty, but be careful when purchasing these types of scanners. Usually the slide-scanning technology has been an afterthought in the machine's development, so its quality might not be optimal. The best way to find this out is to test the scanner yourself or read an independent review of the machine.

You can test a scanner and its software in much the same way you test drive printers. Take a print or slide and scan it on a few scanners (you should view each image on the same monitor; this will be your control) to see which scanner gives you the best results. Which is the sharpest? Which gives you the best color fidelity? Which has the easiest software to use, and which software has the best interface?

Here's a secret: Scanners (and digital cameras, for that matter) will have the hardest time rendering the area between two adjacent contrasting areas. Type, for example, is a really good place to look for problems. You will probably see a good deal of *color fringing* around type if you magnify it on your screen (color fringing looks like a lot of small colored squares, or pixels, around the edges of your type). If your scanner is having a really hard time with it, the type itself will be made up of mostly colored pixels as opposed to black-and-white pixels.

You can drive a scanner crazy by expanding on this test. On a white sheet of paper, draw a cube, and then scan the sheet using various scanner models. Look on the diagonal sides of the box; do you see a lot of color fringing? If so, you might want to pass on this scanner. Do you see a lot of stair-stepping? Do the colors look solid? If they are not solid, something is wrong—it could be poor software or inconsistent movement of the scanner head. Which scanner gave you the sharpest image? Which delivered the best overall color? Did all the squares on the grayscale show up?

Alternatively, scan an image that has lots of tones in it, another image that has a lot of contrasts, and yet another image that has a small tonal range, such as a snow scene. Which scanner does the best overall job on all these images? To be fair, set all the images on "auto scan" and let them rip (you might find that you have to do some fussing with the software).

After all that testing, pick the scanner that did the best job for you. Remember also to pick a scanner you can grow with. Technology in scanners is not going to change much; the scanner you buy now should last a long time.

To USB or Not to USB

As mentioned previously, USB cabling is appearing on both Macs and Windows-based machines; your scanner should have a USB port, along with a serial port. If it just has a serial port and no USB port, don't buy it. The next computer you buy might have only a USB port.

On Scanning...

Get your final image as close to correct as possible during the scanning process. For one thing, it is less time-consuming; you don't have to waste a lot of time in an image-editing program to get things right. Also, and this is important, every time you rearrange information in your image file, you are degrading it. If you resize your image, then brighten it, and then adjust the contrast, you have degraded your file three times.

Resolution

When you examine the manufacturer's specs indicating the resolution of the scanner, such as 600×1,200, it helps to know that the first number indicates the resolution, or DPI, of the scanner as it scans along a line from left to right. In this example, the scanner scans at a resolution of 600 dots in one inch. This specification is similar to the resolution given for a printer. Because the scanner also travels from the top to the bottom of the page, however, a second resolution is given (in this example, 1,200). This number tells you how many sampling points, or movements, the scanning head takes per inch as it moves from the top to the bottom of the page. Although this is not quite the same as DPI, it doesn't hurt to think of it that way.

To add to the confusion, you will almost always find a second set of numbers that indicate how much resolution the machine is capable of if the scan is interpolated. The interpolated scan has nothing to do with the mechanics of the scanner or its resolution; rather, the interpolation is done via the software that runs the scanner. You will be interpolating a scan if, for example, you are trying to scan a 1×1-inch photo to get a 1-inch file at 1,200DPI on a 600DPI scanner, or if you are trying to scan that same 1-inch photo and make your file 2 inches across at 600 DPI. (You would not be interpolating if you were taking the same 1-inch photo and making a 2-inch file at 300 DPI.)

Although most scanners interpolate a scan for you during a scan, it is better to do any interpolation of an image in your photo-editing

DPI and Dimension

If you double the DPI and keep the dimension the same, or double the dimension and keep the DPI the same, you end up with the same size file.

software. You will have much better control if you do the interpolation yourself, because you can see any problems you might have and correct them.

Color Depth

Color depth or *bit depth* is a measure of how many colors your scanner can read. We will get into bit depth in more detail later; for now, just don't buy a scanner that has less than 24-bit color depth, or more than a 30-bit color depth (unless you have some really good materials to scan).

Software

You are not going to get your scanner to budge one dot without some kind of controlling software. The software that comes with your scanner allows you to specify the size of your image, the contrast, and the white and black point, and to adjust for color. You might also be able to sharpen your image using your scanner's software.

White and Black Points

The white and black points of your image are the points in your image that are pure white and pure black. Usually, you will find the white point in a spectacular highlight, such as in a reflection off a piece of chrome. A black point can be found in a dark shadow. Although it is not always necessary to do so, setting the white and black points helps your software determine the contrast of your image and give you a beautifully rich tonal range. Most software (don't buy a scanner with software that doesn't do this) allows you to sample, or pick, the points, usually with a little tool icon that looks like an eye dropper. Some software even allows you to pick a midpoint, which is the middle of the tonal range.

Many times, the software can perform an "auto" read, in which it looks at your file and finds the white and black point for you. This is fine as long as it does a good job. Sometimes, however, there might not be an absolute white or black in your image. In these cases, you have to adjust the contrast and tonal range by other means.

Software, be it standalone or plug-in, comes *bundled* with your scanner. Standalone software, as you might have guessed, works independently of any other software (other than the operating system, of course). Plug-in software works from within other software, such as your photo-imaging software or an illustration software. In some cases, you might even be able to control your scanner from your word-processing software.

You will probably think of your scanner software as an "acquire" module that enables you to scan images and save them as a file to your hard drive or view them onscreen. However, this doesn't mean that you shouldn't think about what features you want in your scanner software. For example, your scanner software should allow you to perform a preview scan—a quick screen resolution scan that gives you a good idea of what the image will look like as well as whether it's correctly set up in the scanner. You can also crop a preview-scan image, saving you time if you want to scan only a small section of the image. The most important thing your software needs to do is let you see your preview scan as large as possible on your screen—not just a tiny image that you can't see any detail in. Also, you need a large preview image to select points to apply your adjustments, such as selecting white and black points, contrast, brightness, and the like.

Optical Character Reading (OCR) Software

Many flatbed scanners come bundled with optical character reading (OCR) software, which allows you to scan a page of written text, and bring it into word-processing software as a file, appearing as though you typed it in. This can be great if you want to copy large lists or references.

The Least You Need to Know

➤ If you buy a Mac or a Windows machine, both will perform well.

➤ Buy the biggest monitor you can afford.

➤ Buy a removable storage device.

➤ Don't buy too many "toys."

➤ Watch out for consumable costs when buying a printer.

➤ If you buy a scanner, get one that can be as versatile as possible.

Software

All the fun in taking digital photographs is in being able to control and manipulate them. You can accomplish this and more with the many image-editing software programs that are available on the market. You will also find software that allows you to store and retrieve images just like a photo album. Small and home office software can help you create a brochure or newsletter.

Although you can transfer, or *download*, your images from your camera to your hard drive via the "on camera" controls, image-editing software is the primary way for you to move your images from the camera. Also, image-editing programs are needed to *acquire* (open) the images from your camera.

Let's take some time to overview what image-editing software can do.

Improving Composition and Image Quality

There are many ways to improve your image's composition and quality:

➤ **Cropping** The first major duty of image-editing software is to help improve composition. With little trouble, you can crop your images, enabling you to reframe them or change their proportions.

➤ **Resizing** You might also want to resize your image, enlarging it or reducing it. If you were not holding your camera perfectly straight and your horizon line is sinking to the left, no problem. You can rotate your image and straighten up the skyline.

➤ **Adjusting brightness and contrast** If your image looks a little flat, you can increase the contrast. Suppose the photo you took of a house was a little dark because it was in the shade; no problem, just brighten it!

➤ **Changing colors** You can change your image's color, adjust the contrast, lighten or darken it, and saturate or desaturate the color—all with your image-editing software. You can reshape reality!

➤ **Cutting and pasting** With a little skill and practice, you can cut and paste images from one photo into another. If Uncle Joe was late showing up for the family group photo, you can take a separate photograph of him and paste him into the group shot. Here's another example: I recently took a picture of a bunch of irises. I wanted a photo just filled with the flowers but I didn't want to take the time to arrange three dozen flowers. I copied a few of the flowers and pasted them back into the shot in different places.

➤ **Applying filters and special effects** You can apply many special effects to your images using your image-editing software. You can make your photo look like an oil painting, or add a texture to your backgrounds. Just as you could put filters over your camera lens, you can apply filters to your image. For example, if you choose a distortion filter, you can spherize your image and add reflection to it to make it look like you were looking into a crystal ball.

As you can see, there is almost no limit to what you can do to a digital image. If you can imagine it, you can do it. Remember all you are doing is manipulating pixels by using image-editing software. Also remember that the phrase you've been hearing all your life—"A picture never lies"—no longer applies. Ever since a photo editor at a magazine moved the great pyramids of Egypt closer together to fit them onto the page, photography has never been the same.

Proprietary and Third-Party Software

Most cameras come bundled with free software. This is handy, because it means you won't have to go out and immediately buy software. Some cameras come with software designed by the manufacturer, while other cameras are bundled with third-party software. We'll take a look at both.

A sampling of bundled software. With good, easy-to-use software, digital photography can be very accessible. Test drive your software!

Proprietary Software

Some camera manufacturers bundle their own proprietary image-editing software with their cameras. Most proprietary software packages more than cover your basic image-editing needs. The software enables you to download the images from your camera; adjust color, lightness, and contrast; and perform most of your basic image-enhancement tasks. You can also cut and paste, crop, enlarge, retouch, and make selections. These software packages also usually help you print your images as single photos or grouped on a contact sheet. Proprietary software can even help you dial up the Internet and email your images. If all you are interested in is basic image manipulation, a proprietary software package is all you need.

Agfa PhotoWise

Agfa packages its program *PhotoWise* with some of its cameras. PhotoWise will enable you to download images from the camera and create photo albums to help you store and organize them. PhotoWise will also help

Platforms

Most of the software distributed with cameras will work on either a Mac or a Windows platform.

you improve your image quality by letting you adjust color, contrast, brightness, and sharpness. You can also resize, crop, and rotate your images. PhotoWise is a good basic image-editing program.

Third-Party Software

Many cameras come bundled with third-party software—that is, software from third-party vendors that the camera manufacturer is licensed to distribute.

Lite and Demo Versions

Be aware that some third-party software might be "lite" versions that do not have all the functionality of a full version. You might also find software that is set to work for only a short period of time; after that, you'll have to pay for a fully working version. You might even find demo software that lets you do everything except save or print the image. This can be especially aggravating.

Adobe PhotoDeluxe

One of the most popular nonproprietary software programs you will find bundled with a camera is Adobe's PhotoDeluxe. PhotoDeluxe, baby brother to Adobe Photoshop, can perform all the functions that the proprietary software can and more. For example, using PhotoDeluxe, you can save the selection you made to be used again or as a mask, and you can apply filters and special effects to your images. I will be using PhotoDeluxe for many of the demonstrations in this book, and I highly recommend that you use this program as your image-editing software of choice. Besides, it's free. You will find a copy of it on the CD-ROM that is included with this book.

Adobe Photoshop

Photoshop is a robust image-editing program and, by far, one of the most popular on the market. It is used by virtually every imaging professional—professional photographers, art directors, designers, illustrators, and even the motion picture industry use Photoshop. Photoshop is also the core of most image-enhancement at printing presses. It would not be a long stretch to say I owe a lot of my career to Photoshop.

Photoshop can used to make complex image manipulations such as collages and multiple-layered images. It can also be used for complex color corrections and color management, and to help make images press ready. Although Photoshop is a complex

and in-depth program, it can be mastered with a little practice. If you decide to use Photoshop, which is available for all platforms, be aware that it needs a lot of RAM (at least 64MB) and a quick processor to run. Before buying Photoshop, you should master PhotoDeluxe.

LivePix

Another popular image-editing program that you might find bundled with your camera is Live Picture's LivePix Deluxe. LivePix performs all the common image-editing chores, and also lets you apply your images to templates—supplied with the software—to produce calendars, cards, and photo stationery. LivePix incorporates the FlashPix file format (we'll talk more about that later); by incorporating FlashPix technology, LivePix can manipulate large files up to 50 times faster than conventional software. This can be of great help to you if you are working with large files.

Albums: Storing Your Images

So, where should you keep all these wonderful images you are going to take? You might want to look for one more important piece of software to be bundled with your camera: photo album software. Photo album software is designed to help you keep track of your images. You can type in descriptions and/or assign keywords to your images to help you search and retrieve them later. For example, you might want to retrieve all the images with your pet in them. If you saved your pet's name in the description or as a keyword, you can use its name as a searching key. Your album software pulls up a thumbnail or list of all the pictures that have your adorable pet in them. Album software will also often produce "story board" pages for you. You can retrieve all the images from your Aruba vacation, caption them, and print them out. You can distribute them to all your co-workers and share your vacation with them.

Third-Party Album Software

Many imaging software programs include album software, but in case yours doesn't, you can always buy standalone album software such as Kodak's Picture Easy, Microsoft's Picture-It, and Live Picture's LivePix Album.

The techniques and technology used in the various albums differ in complexity and abilities. It would be difficult to review each album software here, as they are constantly evolving in their capabilities. If you are shopping for a cataloging software, my suggestion is to test drive a few packages; download demos from the software developers' Web sites.

When deciding what type of album software to buy, keep your current and future catalog and retrieval needs in mind. Although it will be hard to do, try to estimate how many photos you are going to need to store. You will need to ask a few questions when deciding which software to purchase:

➤ What are the capacities of the program?

➤ How many images can it store?

➤ Will the program keep track of multiple disks?

➤ How good is it at retrieving images?

➤ Can you use simple searches, such a looking for keywords in the image's file-name or description?

➤ Does the program create its own image formats, or can you use your own?

➤ Will it compress your files?

➤ Will it alter your images?

➤ Can you re-create a catalog description file if the original files get lost or damaged?

The easiest way to evaluate software (of any type) is to check out the advertising. You can learn a lot about a specific software by what is said and—more importantly—what is not said about it!

The Least You Need to Know

➤ Image-editing software helps you download your images from the camera.

➤ Image-editing software will help you improve and manipulate your images.

➤ Camera manufacturers and third-party developers make image-editing software.

➤ Catalog software will help you store and retrieve your images.

Part 3
Let's Take Pictures

It's easy to pick up a camera and take a picture. All you do is look through the viewfinder and press the button. But to make a photograph, that's another story altogether.

The difference between taking a picture and making a photograph is control. It is not meant to be a difficult task or hard work. The more fun you have making a photograph, the more satisfying your results will be.

Mastering your exposure, focus, and all the other technical aspects of using your camera takes a little time. After you get the hang of it all, however, you will no longer be hindered by the fear of which button to push or dial to turn. The camera will become comfortable in your hand. Your fingers will know what to do before you tell them.

When you look through the viewfinder, the world around you will be yours to capture. You will see your subjects as more than just being there in front of you. Your compositional and creative skills will bring your photographs to life.

If all this seems too heavy or metaphysical for you, relax and don't worry. Have fun!

Exposure

Taking a photograph that will reproduce what you saw through the viewfinder involves correctly exposing the film or chip. Too much light produces washed-out images. Not enough light reproduces as dark and murky.

The Lens

Let's explore, for a moment, how the light gets to the film or digital chip. Providing that the lens cap is off and your fingers are out of the way, light enters your camera through the front of your lens. It then passes through a series of lenses that bend the light and send it on its way to be focused on the film plane (where the film or chip is found). The lenses are usually found in groups of two or three, and are cemented together to form optical groups, or *optics*. Depending on what type of lens you have and its quality, you might find two to five sets of optics in a lens.

Inside your lens, usually somewhere between the groups of optics, is an *iris*, also called the *aperture*. The iris regulates how much light passes through the lens. Your finger, lens cap, and camera strap might also accomplish the same effect, although the results will not be desirable.

The iris, which is located between the groups of elements in the lens, is made up of tiny blades that can be opened and closed.

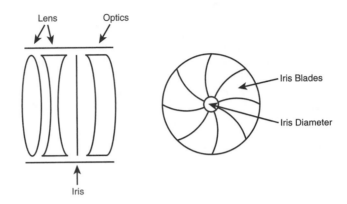

The Shutter

Next, there must be a way to limit the amount of time that the light strikes the film plane; this is where the *shutter* comes in. The shutter is usually found behind the lens; on a 35mm SLR camera, the shutter, called a *focal plane shutter* or *shutter curtain*, is usually part of the body of the camera.

A focal plane shutter works in a two-part motion. During the first motion, a metal or rubber curtain travels across the shutter mechanism to expose the focal plane to the light traveling through the lens. After the proper amount of time, another curtain travels in the opposite direction to close the shutter and cut off the light. When you advance the film, you reset the shutter.

The focal plane shutter starts out as a closed curtain, and travels to the right of the shutter until fully open. It then travels back to the left until closed.

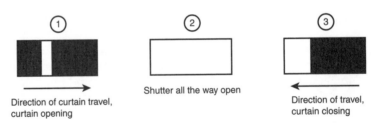

With some cameras, the shutter is incorporated into the lens itself. This is accomplished by incorporating the shutter into the iris. The iris remains closed until the shutter release is pressed; it then opens to the desired diameter. The iris closes when the proper amount of time has passed.

F/Stops

So what is an f/stop? The *f/stop*, or *f/number*, refers to the diameter of the iris and how much light it lets through the lens. To make it sound mysterious and confusing, f/stops are not enumerated in a clearly logical fashion. The f/stops progress in a series

of numbers, each of which lets in half as much light as the number before or after it. The higher the f/number, the smaller the diameter of the iris. The progression goes like this:

- ➤ f/1.4
- ➤ f/2.0
- ➤ f/2.8
- ➤ f/4
- ➤ f/5.6
- ➤ f/8
- ➤ f/11
- ➤ f/16
- ➤ f/22
- ➤ f/32
- ➤ f/45
- ➤ f/64
- ➤ f/90

An f/stop setting of f/8 lets in twice as much light as f/11, but half as much light as f/5.6 (remember: the higher the f/number, the smaller the diameter of the iris). This can be a little confusing, so try to think of it as a fraction. One sixteenth of something is less than one eighth of it.

Lenses are referred to by their focal length, such as 135mm or 35mm (we'll get to focal length in Chapter 7), but you'll also see a second number associated with the description of the lens, such as 2.0 or 3.5. These numbers refer to the maximum iris opening of the lens, also called the *speed* of the lens or how *fast* the lens is. A 2.8 lens lets in twice as much light at its maximum iris as a 3.5 at its maximum iris. The 2.8 lens also costs more than a 3.5 lens of the same focal length. You will also see 1.2, 1.4, and 1.8 lenses; these are pretty quick lenses—twice as fast (or more) than most consumer-level cameras' lenses, which are usually f/ 2.8 or so.

Half Stops

Of course, there are also half stops. Half stops are f/stops between the "regular" f/stops. These will enable you to fine-tune your exposure.

Shutter Speed

The shutter controls how long the film is exposed to light. Shutter speeds are measured in fractions of a second starting at 1 second. Each increase in speed is twice as fast as the shutter speed before it. So, if you start at 1 second, the next shutter speed will be 1/2 second, and the next one will be 1/4 second. The progression is not perfect after that: The rest of the shutter speeds are 1/8, 1/15, 1/30, 1/60, 1/125, 1/250, 1/500, and last but not (well, actually, I guess it is...) least, 1/1,000. Some really fast, expensive 35mm cameras have shutter speeds as fast as 1/4,000 of a second.

F/Stop Formula

Undoubtedly, a few of you tech heads want to know the formula for determining an f/stop. Remember: The f/stop indicates the diameter of the opening in the iris; it's the ratio of the diameter of the iris opening divided by the focal length of the lens. So if you are using a 100mm lens and you select f/4, the diameter of the iris will be 25mm. I hope I've made you happy!

Putting It All Together: The Relationship Between F/Stops and Shutter Speed

You might have noticed that both the shutter speeds and f/stops work in increments of a half or double. This works out well because the shutter speed and f/stop are used in conjunction with each other to obtain a proper exposure. (Remember again that a proper exposure is made when the film or chip is exposed to a specific amount of light.)

For a moment, however, let's forget about f/stops and shutter speeds. Let's play ball. Say you have a team of eight players that have arrived at the stadium on the team bus. All eight players need to be on the field to start the game. Between the team bus and the field is a gate, which is open only two feet wide. For all the players to get on the field, they must disembark from the bus and walk through the gate. So, one by one and slowly, they walk through the gate.

The coach of the team is upset about how much time it takes the team to get on the field. "Let's show a little hustle, boys!" He orders the players back onto the bus and tells them to do it all over, but this time twice as fast. The players are dumbfounded. They cannot figure out how to get onto the field any faster. From the back of the bus, a small voice is heard; it's the water boy. "Open the gate four feet wide. That way, you all can go through the gate two by two and get onto the field twice as fast." Such a smart boy!

Okay, back to photography. As you have seen, there is a direct relationship between the f/stop (the gate) and the shutter (the speed of the players). Each time you open up the f/stop (make it wider), twice as much light can get to the film to expose it. You therefore need to increase the shutter speed to get a proper exposure. If for some reason (and

there will be) you decide to use a smaller diameter aperture (higher f/stop number), you must slow down the shutter speed. Remember, the longer the shutter stays open, the more movement will be recorded—also known as blur!

Let's get a little more specific. Say your light meter (or, if you don't have a light meter, your best experienced guess) indicates that you need to use the f/stop f/11 at 1/125 second to expose your film properly. You decide, and rightly so, that the soccer player you are photographing is running down the field at a quick pace, and you'll need a faster shutter speed. Well, if you open your f/stop up to f/8, you can shoot at 1/250 second. That works, but what if you want to freeze the action of the players? You decide that you should set your shutter speed to 1/500 second. What would your f/stop need to be? Time's up: f/5.6!

Kitty Meter

Modern light meters work because as light strikes a photosensitive cell, called a *photoelectric cell*, voltage is produced and is registered by a meter arm or LED. Before these modern conveniences were invented, however, photographers still needed to know how much light they were dealing with. What was a photographer to do? Well, the answer was to bring a cat along on a photo shoot. A photographer of old would look at the iris in the cat's eye to determine how much light was present. If the cat's eye was very dilated, or wide open, then a longer exposure was needed. If the iris was very small, then a higher shutter speed could be used. Of course, to be totally accurate, the same cat had to be used every time!

The following figure further illustrates the relationship between shutter speed and aperture. Notice that the proper exposure line runs through f/stop and shutter speed "sliders" (for this demonstration, we will keep the sliders locked in position). When the proper exposure line moves to the left, a proper exposure still results because as the f/stops are increased (the aperture is made smaller), the shutter speed slows down. When the aperture is made smaller, less light gets in to the film; therefore, the shutter must stay open longer. If you move to the right, and the aperture size is made larger, the shutter speed must speed up. Of course, you can also see this relationship from the point of view of shutter speed: If you move the exposure line to the right or left, the shutter speed increases or decreases and the f/stop setting follows.

The relationship between f/stop and shutter speed is locked for a proper exposure.

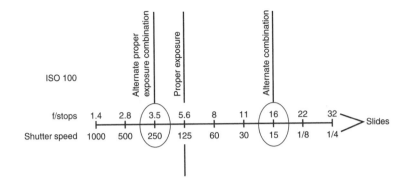

In all these examples, the relationship between the f/stop and shutter speed has been fixed. We've been picking arbitrary "proper exposures"—f/16 at 125th of a second or f/16 at 60th of a second. Have you been wondering what sets up this exposure relationship? Read on!

The Exposure Value System

The EV (Exposure Value) system, which is found on light meters, is determined by the amount of light present and the speed of the film. A higher EV value means that more light is present or that a higher speed film should be used. In the examples used in the previous figures, the relationship between the sliders was determined by an EV rating, which provided the original positions for the shutter speed and f/stop sliders. After the EV was set, the proper exposure settings (f/stop and shutter speed) can be determined. The EV rating is the same anywhere on the slider scale, as long as the relationship between the two slider cameras stays the same. Some cameras, such as Hasselblads, actually have levers built into their lens that would keep the f/stop and shutter speed locked to the EV. Because the shutter is built into the lens on a Hasselblad as you move the f/stop on the lens, the shutter speed will follow.

ISO/ASA

ISO and ASA are not leftover NASA acronyms! The ISO enumeration is the rating given to a film, or chip, that describes how sensitive the film or chip is to light. ASA ratings are seldom seen these days, but they are equivalent to ISO ratings. The higher the ISO rating, the more sensitive or faster the film is. If the ISO speed of film A is double that of film B, then type B film will be twice as fast as A. Generally, you will find ISO ratings between 50 and 400 on film (slide films are usually slower than negative films). On digital cameras, where the chips are given ISO ratings, you will find ISO ratings as high as 1600.

The one drawback to using higher-speed films is that film grain, which looks like tiny dots, is more apparent. This can appear as a texture in your film and affects the sharpness of your images. The general rule is to use the slowest film you can get away with. On a sunny day, an ISO 100 film serves well. Inside, however, you should use an ISO 400 film, because it is more sensitive to light.

One of the benefits of using a digital camera is that you can change, or *push*, the ISO rating of your chip. Digital cameras have an optimal ISO setting, which is determined by the manufacturer of the camera. You get your best results by using the optimal ISO rating for your digital camera, but this rating can usually be altered. Of course, just as with film, digital cameras suffer with excessive ISO speed. Higher than optimal ISO ratings produce noise, which is usually most apparent in the dark or shadow areas (it looks like a blue/black or blue/red dot pattern).

This is not to say, however, that cameras designed to work optimally at ISO 400 are noisier than cameras designed to work optimally at ISO 100. Nonetheless, you can be sure that if you push the ISO 100 camera to ISO 400, the image it produces will be noisier than the "optimal" ISO 400 camera.

We can now begin to unlock the relationship between the "exposure sliders." Let's assume that in the following figure, the optimal ISO rating is 100. If you push the ISO 100 chip to

Turn On Some Lights!

If you get into a dimly lit situation, try turning on some lights or using a flash before you push your ISO rating.

Digital Cameras Are Slow...

Digital cameras are inherently slow compared to film-based cameras; it takes more light than with a film-based camera to take a good shot. Plan on carrying extra lights with you. Some cameras, such as the Olympus DL620, allow you to hook up an additional flash to the camera.

113

400 or use an ISO 400 camera, you would move the top and bottom sliders apart from each other, two spaces in opposite directions (one space for the jump from ISO 100 to 200, and another space for the jump from ISO 200 to 400). The benefit of this jump is that you can use a faster shutter speed than before if you kept the f/stop the same, or a smaller f/stop than before if you kept the shutter speed the same.

ISO affects film speed.

Creative Control

The advantage of all the give and take of the exposure system is the creative control you gain. This is your camera, you are making the photographs, you have the control. Just don't let it go to your head!

Shutter Speed

The first control you gain is the ability to pick your shutter speed. With a fast shutter speed, you can capture and freeze action. With a slow shutter speed, your images can blur a bit. (After all, what better way to show a speeding car than to have it blurred a little?) You can also slow down your shutter speed to use a higher (read: smaller) f/stop.

Depth of Field

Your second creative control is created by the optics of your lens. It is called *depth of field* and has nothing to do with the height of grass. Depth of field is the area that will be in focus between two distances from the lens. If all the objects between two and five feet from your lens are in focus, you have a depth of field of three feet. With a shallow depth of field, you can, for example, take a portrait of someone and have them in focus and have the background be out of focus or blurred. With a deep depth of field, you can take a picture of your family and have all the mountains in back of them in focus. Very nice creative control!

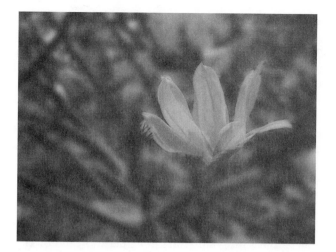

A wider or lower number f/stop yields less depth of field.

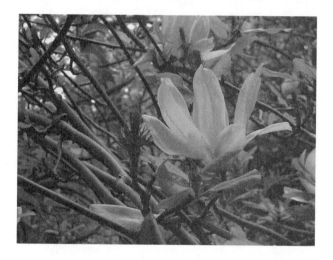

A smaller or higher f/stop yields more depth of field.

A few things affect the depth of field, and you can control all of them:

➤ **The closer an object is to your lens, the shallower your depth of field will be.** If you find yourself on your hands and knees, trying to take a full-frame close-up picture of the first spring crocus, you will have a hard time getting all the flower in focus. (By the way, this is not necessarily a bad thing; you can tell all your critics you were being creative!) If you are taking a picture of your family, who is standing 15 feet away from your camera, you can be sure that the background behind them will also be in focus. (This all hinges on the fact that you got your family in focus in the first place!)

115

➤ **Depth of field can be controlled by which f/stop is used.** This is a lot more practical than moving the crocus back and forth in front of your lens; this is also going to make all the exposure control contortions worthwhile. Without going into a long technical dissertation, please believe me when I tell you that the higher the f/stop (the smaller the diameter of the iris), the greater the depth of field, so you can creatively control the focus of your subject by choosing which f/stop you use (along with how close or far that subject is from you). Note, however, that if you want to alter your depth of field by choosing which f/stop you are going to use, you have to let the shutter speed fall where it may (remember, the f/stop and shutter speed are closely related).

Try to retake that photograph of the crocuses, but this time, back up a little and get a group of the flowers in focus. Let's say that your exposure indicates you should have an f/stop of f/8 (forget about shutter speed for now). So, what is in focus? If the whole group of flowers is in focus, that's fine. But is the grass behind the flowers also in focus? Is that a little distracting to you? Well, it is to me, so I'm going to open up the f/stop to f/3.5 or so. Now the flowers are in focus, but the grass is out of focus.

Suppose your flower plot is three feet deep from back to front. Suppose, too, that the depth of field at f/3.5 is three feet. If you focus in the middle of the flower plot, all the flowers will be in focus and the grass behind them will be out of focus. What happens if you *shift* your focus so that you are focusing on the space in front of the plot of flowers (keeping the same f/stop as before)? Anything that is 1 1/2 feet in front of the flowers will be in focus, as will all the flowers in the first foot and a half of the plot. All the flowers behind that first foot and a half, along with the grass behind the plot, will be out of focus. This might be a nice effect, especially if the flowers in the back of the plot were looking a bit shabby or thinned out.

Don't Be Boring!

Don't take boring photos. This demonstration has shown you that you have the control you need to take wonderful photographs!

Suppose, however, that some wonderful gardener has ripped up all the grass and replaced it with a sea of flowers! This time, you want to get them all in focus. All you need to do is focus somewhere in the middle of the group of plants and close down the f/stop all the way to f/22 (or more), and everything will be in focus.

Manual or Automatic Exposure

If after all the explanation about exposure you would rather not deal with any of it, relax. Many cameras, especially the lower-priced (point-and-shoot) cameras, come with fully automatic exposure control. You'll find these easy to use and, as long as you don't get yourself into an exposure pickle (this is a nontechnical term), you should make great photos.

The mid- and upper-priced cameras give you more creative control over your f/stops and shutter speeds. A few cameras give you the option of picking which aperture to use; the resulting shutter speed is determined by the camera itself. This is called *aperture priority exposure*. Other cameras offer the opposite, letting you pick the shutter speed and extrapolating an f/stop. This is called *shutter priority exposure*. Some cameras will offer both shutter and aperture priority settings. As you can see, there are pros and cons to both systems. You will not see a totally manual digital camera until you are using semi- or fully professional equipment

More Exacting Automatic Exposure

A few of the more expensive digital cameras employ *center-weighted-* and *matrix*-based exposure systems. A center-weighted metering system bases 90% of its exposure setting based on what it reads in the center of the image. This is a very good system, because the exposure will not be adversely affected by a difficult background, such as in a back-lit situation.

Matrix-based metering systems read specific spots in the image's frame. This comes in handy when, for example, you photograph the interior of a room with an open sunny window. If the meter were to take an average reading, the window light would cause the aperture to close down and the room would be too dark. With a matrix system, the window light and the interior lighting are taken into account. The system would know that the window light is a small part of the photo and would give more emphasis to the interior, making it brighter.

Digital cameras might not have shutters or apertures at all. You will find this especially true on lower-end cameras. These cameras replace the shutter on the camera by turning on or off the chip for the same duration as a true shutter might work. They replace the aperture by adjusting the sensitivity of the chip. Different manufacturers achieve the results in different ways. Don't be disappointed. If you didn't pay a lot for your camera, you still will get excellent results.

Think Creatively!

Even if you don't have shutter or aperture control over your camera, you might be able to force your camera to "think creatively." If you can adjust the ISO rating of your camera, you can make your camera change shutter speeds or pick a different aperture. Let's assume, for example, your camera is set to shoot at 1/60 second and the ISO dial is set at 100. If you were to change the ISO to 400, making your camera two stops faster, your shutter speed would be increased to 1/250 second. The same effect can be had on the aperture. It depends on the camera system as to which will be affected by your change. Bear in mind that you might suffer the effects of noise if you mess with the ISO speed too much.

Another way to fake out your camera is to put a neutral density filter (ND) over the lens (a neutral density filter can be purchased at a good camera store). ND filters are neutral gray tinted filters that darken the image without imparting color to it. This forces either the f/stop to open up more or the shutter speed to slow down, depending on your camera. Note: If you want to use ND filters, you must be sure that your camera is taking its meter readings from behind the lens and not externally. If your camera is not metering through the lens, you must cover the meter up, also.

The Least You Need to Know

➤ It is important to understand the basics of exposure and the creative control you can gain by manipulating the variables.

➤ Depth of field can be controlled by your aperture choice.

➤ Shutter speeds will control how you capture movement.

➤ You can control your exposure or have the camera set the exposure for you.

I Can See Clearly Now: Lenses

In Chapter 6, "Exposure," we talked about focus in relation to depth of field. But how, exactly, does "focus" work? Here's the skinny: Rays of light travel in a straight path through a transparent medium, such as air. When the light rays travel from one medium to another, for example from air to glass, they bend. This bending of light is called *refraction*. As the light rays pass through the lens, they refract and converge, or meet. This convergence point is called the *focal point* or *focal plane*. (The focal point is a great place to locate the *film plane*, which is where your film or CCD chip is located.)

Focus!

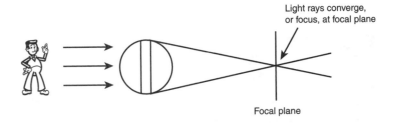

Light rays converge, or focus, at focal plane

Focal plane

If the distance between the lens and the film plane is not correct for the distance between you and the subject you are photographing, the convergence point will not fall at the film plane. You are out of focus!

Whoops! Light rays converge past the film plane, making the image you want to photograph out of focus.

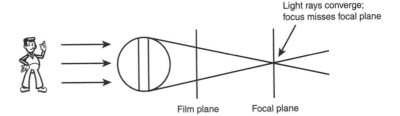

Light rays converge; focus misses focal plane

Film plane Focal plane

You can focus your image by adjusting the optics in the lens (or the lens itself) so that the convergence point falls on the film plane. Have you have ever held an SLR (single lens reflex) camera and twisted the lens barrel? If so, you were, in reality, moving the lens groups and adjusting the convergence point to fall on the film plane.

Types of Lenses

Different types of lenses can be used:

➤ A fixed-focus lens is a simple lens that has no moving parts. The lens is designed to focus on an average *taking* distance from the camera—usually anywhere from 12 feet to infinity. Fixed-focus lenses, which are usually found on low-end, point-and-shoot cameras, don't deliver sharp images.

➤ Lenses that can be focused have multiple optics in them. These optics are usually found in groups. When you twist the focusing ring or knob on your lens, you are moving the optics to direct the light to the focal point. You will find these types of lenses on midrange and professional cameras; they are almost always mounted on an SLR camera body.

Some digital camera manufacturers make their lenses out of plastic optics because, historically, CCD chips were not good enough to hold the resolution that glass could provide. These days, however, CCD (charged couple device) chips are vastly improved; if you're looking for clear pictures, you should buy a camera with a glass lens. Also, quality lenses have antireflective coatings (usually blue or purplish in color) on the front optic, which will increase the contrast of your image and reduce glare.

Caring for Your Lens

Nose prints, fingerprints, and other assorted muck and dust do not make for great optical coatings. All photographers, great and small, must carry lens–cleaning materials in their camera bags. Your kit should include lens–cleaning paper or a soft cloth (be sure the paper or cloth is not full of dirt!), lens–cleaning fluid, and a soft lens–cleaning brush (I like the kind that have a small bellows or squeeze bulb built into them). You can buy all these items at a camera or photo supply store.

If your lens has dust or grit on it, the first thing you should do is try to gently brush it off or blow it off with your squeeze bulb. The best bulbs are the kind used to suction mucus from a baby's nose (really!). You can also try lightly swiping at the lens with your soft cloth. Do not blow on your lens with your own mouth—you will end up spitting on your lens.

If you have smudges on your lens, you'll have to work a little harder. Put a few drops of lens–cleaning fluid on your cloth or lens–cleaning tissue, and then gently wipe the lens with the cloth. After you remove the gunk, you can try polishing the lens gently with a dry cloth. Never put the cleaning fluid directly on your lens; it will seep in between the lens and lens body and you will end up with fluid inside your lens!

A great way to keep your lens clean and safe is to cover it with a clear filter. If your lens has screw threads on its front barrel, you can buy a filter to fit on it. The best filters to buy are UV (ultraviolet) filters, which are clear and also provide the added benefit of reducing UV haze. These filters are cheap protection, and if you scratch one, you can just throw it away (recycle!).

Auto-Focus Lenses

Unless your camera has a fixed-focus lens, it probably employs some sort of auto-focus mechanism. The advantage of using an auto-focus lens over a fixed-focus lens is that your lens can be precisely focused for the correct subject-to-camera distance. Your images will look much crisper than they would if they were taken with a fixed-focus (or, as most professional photographers say, a *Coke bottle*) lens. There are a few different types of auto-focus cameras:

➤ Many auto-focus cameras measure the distance between them and the subject by sending out a pulse of sound, called *sonar*, or by transmitting a beam of infrared light. Both systems work similarly: The camera measures the time it takes for the sound or light beam to leave the camera, bounce off the subject, and return. It then calculates the distance and adjusts the lens. Although you can't hear the sonar pulse, you might drive a few nearby bats a little crazy!

Some auto-focus cameras measure distance by using sound or infrared.

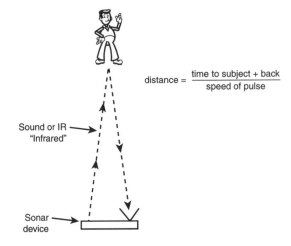

$$distance = \frac{time\ to\ subject + back}{speed\ of\ pulse}$$

Sound or IR "Infrared"

Sonar device

➤ Passive auto-exposure systems, which are found on higher-end cameras, focus a lens by assessing the contrast of the image. If you compare an out-of-focus image to an in-focus image, you will see that the in-focus image has much more contrast.

Auto-focus systems have a few weak points:

➤ If something—such as a fence—comes between the camera and your subject, the camera's focusing system might set the focus for the fence instead of your subject.

➤ If your subject is near a large object, that object can reflect the measuring beam instead of your subject, skewing the distance measurement your camera uses to focus.

➤ If you are photographing a group of people who are at various distances from the camera, the camera might have trouble determining the correct focus.

Focus Lock

Auto-focus systems that offer a *focus lock* are a good way to get around these problems. With a focus lock, you can prefocus the camera, lock the focus, and then move the camera to get the image you want. For example, suppose you want to photograph your kid standing on a stone wall, with a beautiful sky behind him, but you want to

compose the image so that he is to the side of the viewing frame instead of smack in the middle of it. Odds are that if you simply snap the picture, your auto-focus will focus the camera to a distance of infinity (and beyond) instead of on Junior, because auto-focus lenses typically focus on the middle of the viewing frame. To rectify this, do the following:

1. Frame the image so that Junior is more prominent (that is, closer to the middle of the viewing frame).
2. Let the camera focus.
3. Lock the focus.
4. Reframe the image to get the composition you want.
5. Shoot the picture.

Candid Camera

If you point your camera at someone but have to wait for it to focus, they'll probably figure out what you are trying to do, and you'll lose your candid shot. If, however, you use the focus-lock feature, you can focus on someone or something else (be sure the dummy subject is about the same distance away from you as the intended subject), lock your focus, and swing your camera back around to take your candid shot.

If you have your camera set up to take wide-angle pictures, you might be able to take candid photos without even looking through the viewfinder. Most professional photographers are very good at this technique, especially sports and news journalists.

Close-Up Shots

Taking close-up shots drives your camera and its lens into contortions. If you look at a good 35mm camera lens, you'll notice that it *racks*, or *extends*, way out when focused on a close object. Many auto-focus cameras have a *macro* setting, which adjusts the lens for close-ups. Sometimes the optics inside the lens are adjusted; other times, some other special arrangement is made to allow for close-ups. When you take close-ups, try to use the macro setting as much as possible. Not only will it help you focus your close-up image, it will also help increase your depth of field (which is almost nonexistent when you are close in).

Focal Length

Focal length is important because it tells you how big your image will be on the focal plane. It will also help you approximate the visual angle and area of coverage of the lens (I'll explain this in a second). The focal length of a lens is the distance, in millimeters, from the optical center of the lens to the focal plane when the lens is focused at infinity. Don't worry; you don't have to do this yourself. The manufacturer does all the testing of the lens design well before you ever see the camera.

Taking Angle and Area of Coverage

The following diagram describes the two important features of a lens:

➤ The first thing to look at is the *taking angle* or *visual angle* of the lens. Both describe how wide the lens can "see." Sometimes this might be referred to as the *field of view* (FOV). Lens #1 sees a small portion of the image because it has a small visual taking angle; lens #2 sees much more, or a wider angle, of the picture.

➤ The second thing to look at is the area of coverage, which is the area that the image covers on the film plane. (Note: Because the lens is round, the area of coverage is circular.) Notice that on lens #1, the coverage is much larger than the size of the chip or film frame, meaning that only a tightly cropped portion of the full image will be captured by the chip. Lens #2, however, has an area of coverage that is about the same size as the chip, meaning that this chip will capture most of the image.

Angle of view determines how wide an area a lens can see and area of coverage indicates how much of the image will show up on the film plane.

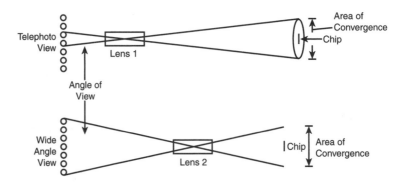

The visual angle and lens coverage usually work in conjunction with each other. However, it is not uncommon for a lens to have a wide angle of coverage *and* a wide visual angle. Actually, depending on the lens design, any combination of coverage and taking angle is possible.

So What's Normal?

The taking angle and area of convergence are much more important on large-format cameras where large film areas come into play; a normal lens has a visual taking angle that is approximately the same as your visual taking angle (that is, close to what you see without turning your head). A normal lens also has an area of coverage that is close to the same size of the diagonal measurement of your chip (see the following diagram to see how the chip diagonal is the same as the diameter of the area of coverage).

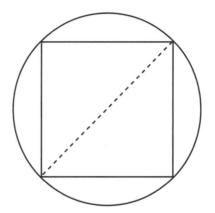

Normal lens will have a field of view approximately the same as your vision.

On a 35mm camera, a 55mm lens is considered normal. Although it is slightly telephoto, it is closest to the human field of view. (The diagonal measurement of a 35mm piece of film is 44mm, which would make a 44mm lens truly normal, but I've never seen a 44mm lens!) On a typical digital camera, the CCD chip is much smaller than a piece of 35mm. Therefore, a normal lens on a digital camera is much smaller. Because the CCD chip sizes vary from manufacturer to manufacturer, a normal lens on one digital camera might not be a normal lens on another. Also, as the chips become larger, such as on the new 2Mp (megapixel) cameras, what was normal last month might not be next month. Typically, a normal lens for a digital camera ranges from 4.5mm to 7mm.

The Telephoto Lens: A Long Story

Telephoto lenses have *long* focal lengths, which is why they are called *long lenses*. Telephoto lenses have a very narrow angle of view; they might also have a matching coverage circle, but not necessarily so. A wide film coverage will decrease the telephoto effect and introduce lens aberrations. Aberrations, which are errors in the lens design such as color distortions or soft focus, usually show up at the edges of the picture. Because the chip area is smaller than the lens coverage and the chip is located in the center of the coverage, lens aberrations are minimized. On view cameras, where the lenses are designed to swing and tilt (see Chapter 3), wide coverage is very important. It also makes view camera lenses very expensive. My 150mm (normal for a 4×5 view camera) cost $1,500!

125

Equivalents

To confuse the "normal" issue even more, some manufacturers label their lenses as *equivalent* to 35mm camera lenses. I reviewed one camera whose lens was marked as 9.2mm to 28mm (zoom). This would be a "fisheye" lens on a 35mm camera. This camera lens was marked as a true measurement. Another lens was marked 28mm to 110mm (zoom). How can this be? Either the second camera has a huge CCD chip array, or its manufacturer is giving the camera's focal lengths in 35mm *equivalents*.

I actually feel that using the equivalent method is fine. As I said before, chip sizes vary from camera to camera, and unless you know what size the chip is, you will have no idea what the normal lens is. Also, most of us are familiar with 35mm cameras, and are comfortable with the idea of using that marking system. As long as you know what system is being used, all should be well. The only problem lies in being able to compare one camera to another—it makes for great confusion!

Most commonly, a telephoto lens is used to photograph objects that are far away to make them look bigger. Conversely, because of the angle of view, you can photograph an object that is near and fill your frame with only part of the subject—such as when you want to photograph one person in a group of people. A slightly telephoto lens makes a good portrait lens, and enables you to get a nicely filled frame without standing too close to your subject.

One characteristic of a telephoto lens is called *visual compression*. Because you can get objects that are far away as well as objects that are close by in the frame at the same time, the objects look like they are compressed in space. To add to this, remember that objects that are close to the camera look very big in the frame.

A good example of compression can be seen on your TV set. If you have ever watched a baseball game, you have been a victim of compression. The shot from the center field camera that shows the pitcher throwing the ball to the batter is a great example. Notice how big the pitcher looks in relation to the batter; they also look like they are right next to each other. It seems like the pitcher spends an awful amount of energy to throw the ball such a short distance! Take a look at the following photograph to see how the buildings look compressed and stacked one next to the other.

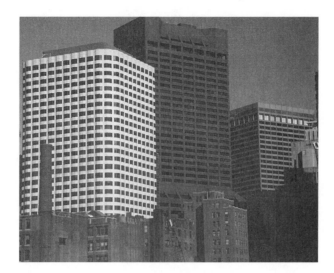

A long telephoto lens brings the object closer and also "compresses" the image.

Because you are photographing objects that are at different distances from each other, and with the added effects of compression, depth of field can be shallow when you use a telephoto lens. Be aware of the depth of field fall-off, and focus carefully—you might even be able to use this shortcoming to your creative advantage. Also, because of your narrow angle of view, camera shake is much more apparent. Your margin of error when holding a camera with a telephoto lens in your hands, especially in dimly lit situations, can be small. Brace yourself against something to steady yourself, or prop your camera up on something to steady it.

Wide-Angle Lenses: A Short Story

Wide-angle lenses are basically the opposite of telephoto lenses: They have a short focal length and a wide angle of view. They also have a small area of coverage on the film plane, meaning that your film or chip captures nearly the entire image.

Wide-angle lenses are used to photograph large areas, especially if you cannot get far enough away. Some of the most wonderful skyline shots and mountain views would need to be taken from three states away if you used a normal lens! Wide-angle lenses have a great depth of field, which means that you can photograph objects that are relatively close to you and still have other objects in the background stay in focus, as shown in the following photograph. On the downside, you see a lot of distortion in a wide-angle shot; your horizon line might even seem to bend! However, this can lead to some interesting effects.

127

A wide-angle lens allows you to get more view in your image.

Zoom

A *zoom* lens is a lens that has multiple focal lengths, which can come in pretty handy—especially if you have only one lens bolted to your camera. A zoom lens has many groups of optics in it, which are shifted internally to provide the different focal lengths.

Typically, a good zoom lens won't zoom all that much—you won't find a lens that zooms from wide to long telephoto. Mostly, you will find lenses that start just shy of wide and zoom to a moderate telephoto. For example, talking in 35mm speak, zooms that range from 35mm to 100mm are a good bet.

Because of all the shifting of elements, zoom lenses are not as sharp as *prime* lenses, which are of fixed focal length. Additionally, because of all the glass involved in zoom lenses, they are usually a stop or so slower than a prime lens. Zoom lenses are also harder to keep in focus; you should check the focus after you zoom. Having an auto-focus camera that refocuses after or as you zoom is a good idea—thankfully, most do.

All in all, unless you are using a high-end professional camera and can interchange lenses, buying a zoom lens is a great idea.

Lens Shades

Have you ever put your hand over your eyes to shade them on a sunny day? If so, did you notice that your vision improved? Well, guess what? If you do the same for your lens, your picture will look better, also.

Always try to use a lens shade when taking pictures outside, or any time that a lot of glare or stray lights are hitting your lens. It is the easiest thing you can do to improve your shots!

True Zoom Versus Electronic Zoom

Many manufacturers give a specification for their zoom lenses, such as 3×, 4×, and so on. Basically, this tells you that your lens zooms in a range that triples or quadruples itself. An example of a 3× zoom is a 25mm–75mm zoom. When you see a specification for your zoom lens such as 3×/2×, you are in for a ride! This type of specification indicates that you are getting a true 3× zoom lens, and your camera can zoom in two more times electronically.

So how do you suppose the extra zoom is accomplished? Time's up! Your camera is going to *interpolate* the image, also known as enlarging it, to simulate the zoom. This is not a great idea unless you really need it, because as soon as you start electronically enhancing an image, you invite pixelization (image distortions) and color errors. Do not buy a camera based on the extra electronic zoom; you can do the same, if not better, in any image-manipulation software.

The Least You Need to Know

➤ Focus is the meeting of the rays of light, after they pass through the lens, on the film plane.

➤ Your camera's lens can auto focus, or be focused manually.

➤ Wide-angle lenses let the camera "see" a wide field of view.

➤ Telephoto lenses make the image look closer to the camera and have a narrow field of view.

➤ A zoom lens has a variable field of view.

129

Composition: No Snapshots Here!

In This Chapter

➤ Balancing your composition

➤ Creating visual interest

➤ Point of view

➤ The use of color

➤ Texture and patterns

Even with all the tools you have at your disposal, you can still take terrible pictures if you don't compose them well. A good composition is a careful arrangement of all the objects in your photograph. Take a look at photographs you see in magazines and books. What makes them interesting? What makes them sparkle? Recording the moment is a good use for photography. But why not tell a story at the same time? A photograph should challenge the viewer to imagine what is happening in the picture. It should be inviting. Instead of taking a picture of your family on top of a mountain, take a picture of them standing next to the signpost that says how high the mountain is. Now the viewer can see how much you accomplished.

If a picture is worth a thousand words, let it speak for itself. Before you take a picture, think about why you are taking it. What are you trying to say? What is the story? How do you feel about where you are? Can you make the viewer feel the same way? Ask yourself, "How can I make this a better picture?"

Make your photos visually interesting. Don't just use the viewfinder as a targeting device. A good photographer (and by the time you finish reading this book, you will be one) frames the picture in her "mind's eye" before taking it. Take time to look at what you are shooting. Enjoy the moment! Have fun!

Not in the Center, If You Please!

The subject in your photo should be the interest point, and the story line of your photo should revolve around your subject. All the artistic elements in the photo should lead your eye toward the subject. Draw in your audience; involve them.

One way to involve viewers in your photograph is to guide their eye through the photo—in other words, their eye should start somewhere in the photograph and travel across it. Imagine a photograph of a line of people waiting; at the end of the line is a clown making a balloon animal for your child. When you view that photo, your eye travels across the group until it gets to the end. And not only have you made the viewer's eye travel across the photo, you've also told a story at the same time.

The longer a viewer looks at a good photo, the more interesting it becomes. You can enhance a viewer's visit to your photo with color, shape, and subject. Keep the viewer's eye moving. If you put your subject dead center in your photograph, you quickly kill the viewer's interest. The viewer looks at the photo, looks at the perfectly centered object, and leaves. Next!

So where do you put the subject in your photo? Take a look at the following figure for a classic composition diagram. Begin by imagining a tic-tac-toe game in your frame. The areas where the lines cross are your *hot spots*. Try to center your subject on one of these spots.

A composition diagram helps place the subject of the photo.

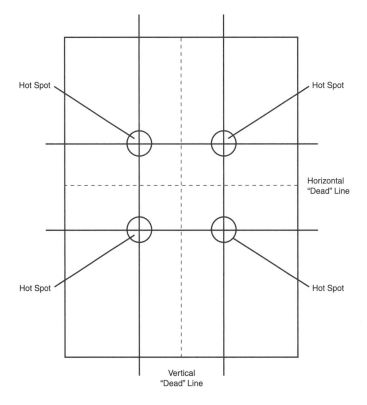

The following two photographs illustrate the difference between placing your subject smack in the middle of your frame and placing your subject elsewhere; don't you agree that the second photograph is much more compelling than the first? Notice that its subject is on the lower-right hot spot.

Of course, this doesn't mean you have to leave an empty space in the middle of your photo. Imagine you are taking a picture of a sailboat on the harbor. The sun is shining on the water, and birds are soaring through the air. Where do you put that boat? You could put the boat on the horizontal dead line and slightly to the right, and the image looks okay. But try placing the boat in the lower-right hot spot. Doesn't that feel better? Maybe you can get the birds to fly through the upper-left area or put the fluffy clouds or the setting sun there.

See the second image on the next page for better composition.

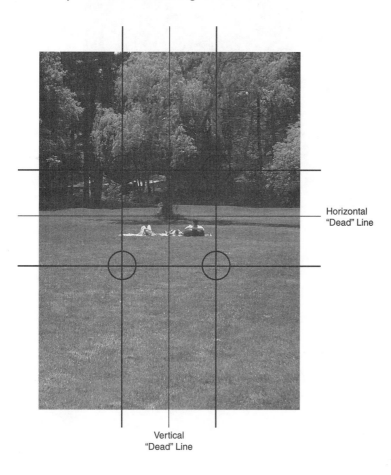

Horizontal "Dead" Line

Vertical "Dead" Line

Notice how much more compelling this image is than the first.

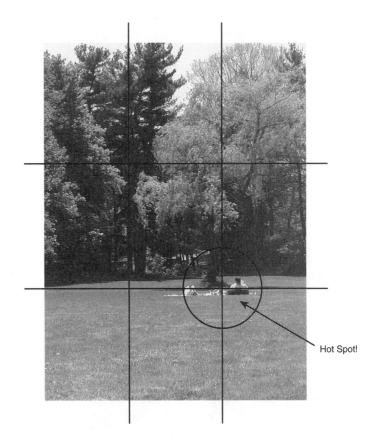

Hot Spot!

Let's take another mind's-eye photo. Your darling daughter has a new kitten sitting in her lap. (If you don't have a darling daughter or a kitten, you can substitute freely. It's your mind.) Put your daughter's face in the upper-left hot spot, and put the kitten in the lower-right hot spot. Nice picture. Composing your picture this way gets nice viewer involvement, as their eye travels from the girl's face to the kitten and back again.

The cat's face balances out the face of the little girl.

Balance

Your photos should use balance to make them exciting. In the picture with the little girl and the kitten, the kitten served as a balancing object for the little girl. In our imaginary photo of the sailboat, the balancing object was the birds or the setting sun.

The balancing object and the subject don't have to be the same size; a small object can balance a large one. The idea is that your eye travels from the subject to the balancing object and back. The balancing object should be a clearly defined object or action.

Let's take a few more mind's-eye photos. On the right side of your photo, imagine a big beautiful flower. On the left, maybe coming in from the lower-left corner, is a bumblebee. Obviously, the bee and the flower are not the same size, but look how each balances each other.

Try another one: Your two-year-old son has just built his first tower out of wooden blocks. He is so proud of himself; he's smiling from ear to ear. But next to him, coming into the frame, is the puppy, headed directly for the tower. Click! You've got a great photo. You're telling a story, your composition is exciting, and the small puppy balances out the boy.

You don't need two objects to have balance in our photograph. Suppose you just baked an apple pie, and you want to take a picture of it. How can you compose your shot? Try taking a wedge out of the pie to show the contents of your pie, and also to

give your pie some dimension. You'll find that the missing pie piece, or the space it leaves, balances the rest of the pie. Then put the pie off-center in the frame—the missing pie space should be slightly over the center line. Notice how the space and the pie balance each other.

Horizon

The horizon line can be a powerful composition tool; the sky, the water line, the roofs of buildings, clothes hung on a line, a fence, or a tree line can be used as horizontal elements, and can also set the horizon in your shot. As a general rule, the horizon line should not divide the picture exactly in half; a shot with the horizon line neatly dividing the sky and water is stagnant and boring.

If you take another look at that composition diagram I showed you earlier, you'll see the horizontal lines that run through the hot spots. These lines divide the frame into thirds. It's a good idea to place the horizon line in your photo so that it divides the frame in a like manner. Another rule I try to follow is to keep my horizon line parallel to the bottom of the frame. Take your time and be sure things look straight in the viewfinder. There is nothing more disconcerting than having a boat sailing uphill in a photo!

This photo shows the water line and horizon over Boston harbor.

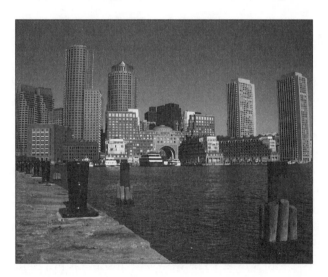

Cropping: Be Frugal!

The frame in your photograph should contain only your subject and its balancing object. Don't get sloppy. If you don't crop out unnecessary objects or people in your shot, your image becomes *diluted*. The viewer will get confused about the subject of your photograph. Are all the objects in the shot important? If you are photographing

a scenic view, such as a skyline, don't include more than you need to. Also remember, especially with a digital camera, that resolution is a premium. If you use software to crop an image after you take it, you affect the optimal resolution of the image. Be frugal. Get everything you need in your image, and nothing else!

Use your telephoto or wide-angle lens to help you fill the frame, and be creative by using the effects of compression and distortion. If you need to move a little closer to your subject to fill the frame, do so. Take a few extra moments to compose your shots.

Here are a few guides to follow when deciding when to take an image in a horizontal or vertical mode:

➤ Use your camera in a horizontal mode when you need to fill your shot with a landscape. Group shots, scenic views, and crowd shots all work well horizontally. A horizontal shot emphasizes the width or breadth of your photo.

➤ Vertical shots are a great way to emphasize height. They make wonderful portraits. Also, photographing a small object and a tall object in a vertical frame is a great way to show height comparisons.

➤ When photographing for a newsletter or magazine, be sure you photograph your subject in both modes if you can. Your art director might have a layout that calls for only one or the other. Chances are that if you don't ask beforehand, you will use the wrong mode. (That, folks, is one of "Murphy's Laws" that professional photographers hate!)

Take your time to fill your frame. Make every pixel count.

This is an example of a poorly cropped photo.

This is an example of a tightly cropped photo.

Color

Color can be a wonderful compositional tool. A vividly colored bed of tulips can be an interesting photograph; an old red barn can tell a wonderful story. Frame your image so that the barn is predominate in the image; this allows you to use the color of the barn to your advantage. Of course, too much of a good thing can be a disadvantage; be careful not to get too carried away with color. Just as you would not wear a suit of clothes with many different colors in it, you should try to avoid shots that suffer from the same. A shot, for example, with a lot of red and a few other colors works well, because the reds hold the composition together and the other colors add balance.

Bold color can create an interesting composition; check out the color insert in the middle of this book to see a full-color version of this photo.

You can use saturated colors to aid your composition. In addition, contrasting colors can work well together, setting one another off. For example, instead of photographing a red rose with the sky in the background, try to frame it so the green leaves of other flowers form a background. The contrast of the red and green colors makes your photograph vivid. Monochromatic colors also work well as compositional tools. A stand of green trees in a forest or a pool of blue water with a child floating in an inner tube are good examples. If you fill your frame totally with sand dunes, all the same color, the lines and shapes of the dunes jump out at you, making an interesting composition.

Color can also be used to set the mood in a photograph. The subtle colors at dawn or dusk help you feel as if you are there, or involved in the photo. An image featuring objects that are predominantly red exudes energy and excitement. An image with pastel blue or green tones makes you feel cool and calm. *Lack* of color also can help compose an image. Imagine, if you will, a foggy harbor, devoid of all color except the gray mist. A lone red boat floats at the dock. The red boat adds interest and brings a little life to the image. Another good example is a snow-covered field with just a hint of color from a child in a snowsuit.

Contrast

Contrast can be achieved in many ways in a photograph. Color can be used to create contrast, or contrast can be created by the use of lighting. Deep shadows and well-lit areas can create wonderful contrasts in an image. Textured objects, when put on or adjacent to a smooth background, can set up image contrast—for example, a beautifully detailed piece of tree bark with an out-of-focus soft background.

Strong light and shadows can create an interesting composition.

Negative and Positive Space: The Final Frontier

The space that your object takes up in your frame is called *positive space*. The space that is not used, such as the background, is called *negative space*. The positive and negative space in a photograph work together to reinforce each other. Imagine you are taking a picture of a tree branch with a blue sky in the background. If you look at the pattern formed by the interweaving branches, you see that the blue sky plays an important part of the image, supporting the pattern. The sky is as important to the composition of the image as the tree branches are.

In the collage image of a lamp in the following figure, the spaces between the lamp structures (that is, the negative spaces), which are colored, begin to form an image all their own. The contrasting colors also help support the image.

The colored background space works as negative space to help "set up" the lamp parts in the positive space. Both are compositional elements.

Movement

One of the most important attributes of a modern camera is that it can freeze motion. Speeding cars, children on bicycles, and kites flying through the air can be frozen in time. Stop-action photographs can hold a viewer's attention for quite a while.

High-Speed Breakthroughs

Early photographs by Edward Moybridge were a massive study on movement. He would shoot a series of photographs of a person jumping using, what was then, a high-speed camera. His series on animal locomotion was used to prove a bet about whether a horse has all four feet off the ground when galloping. Much later, Doctor Harold "Doc" Edgerton of the Massachusetts Institute of Technology (we Bostoners call it MIT) made many studies of high-speed movement, such as the famous shot of a bullet being shot through a playing card.

Speed doesn't always need to be represented by stop action. A little blurring of an object is just as effective, if not more, to show how quickly an object is moving. Slow down your shutter speed to help create the illusion of movement. Alternatively, if you have an automatic camera, you might try putting neutral density filters over your lens to trick your meter into slowing down the shutter speed. Another good way to show speed in a photograph is to employ a little trick I call "action panning" (also called a "drag-shutter effect").

Panning the camera helps create the illusion of action.

Action Panning

To create the illusion of movement through action panning, begin by setting your shutter speed at about 1/30 of a second or so. (The exact speed isn't important, but it will alter the results of the effect.) To enhance the effect, use a telephoto lens. (Note: This technique works best when your camera is in a horizontal mode.) As your subject, let's say it's a race car, comes into frame, start panning your camera in the same direction in which the car is traveling, and hit your shutter while continuing to move the camera.

Your results should be a combination of stop action and motion blur. The background is almost all blur, because it is put into motion by your camera motion. The car, however, which remained relatively in the same spot in your frame, has a bit of stop motion effect to it, but not completely.

This technique takes a little practice to master; it has no set rules as to which shutter speed to use, how fast to pan the camera, or when to press the shutter. Practice and have fun!

Viewpoint: Low, Different, or Political

The point of view (or POV) that you use to photograph your subject can greatly add to its visual appeal. If you can avoid it (and you can), don't shoot an object straight on; doing so can make your shots boring. Instead, look at your subject from different angles. Will shooting partially from the side enhance the image? Will a total side view look even better? Shoot from a low angle looking up, or a high angle looking down. If you are shooting a scenic view, consider where you are going to put your horizon line. Consider using your wide-angle lens to create an interesting distortion.

Of course, you should be careful not to go overboard. If your point of view distracts too much from your subject, your photograph won't work. Don't let your fancy footwork rob from your subject its reason for being photographed in the first place. Confusing your viewer because you fell in love with a point of view will not help your image.

There are no hard and fast rules about point of view; just try to remember the composition guide and place your interest point on the hot spot.

Explore different points of view to make your subject look interesting.

Caution!

Your safety should always be a prime concern when taking photographs. Years ago, I was photographing a high school basketball game. I was intent on following the action through my viewfinder. As the ball got bigger and bigger in my viewfinder, I got more excited about what a great shot I was going to get. Finally, reality—and the ball—struck me! There is no feeling like having your camera smashed into your face.

So be careful when taking photographs. Don't hide behind your camera, thinking it is a special magic shield. Many professional photojournalists have been injured and a few have died because they forgot they were mortal. Watch where you are stepping when you are taking photographs. Don't go out on a limb, literally, to get a great shot. Think safety!

Perspective

Many photographs suffer from a lack of dimension. They look flat and unrealistic. Adding an element in your photograph that creates perspective can often help. Usually, featuring two lines that start out separate but converge somewhere in the photo (the point where the lines meet is called the *vanishing point*) helps create the illusion of perspective and depth. The human brain knows that when two lines that are normally parallel meet, the vanishing point is in the distance. A good example of this is a railroad track or highway, but look for roof lines, fences, and even power lines to help create perspective.

Perspective caused by receding lines of railroad track add depth to a shot.

Another way to create perspective in your photograph, especially if a railroad track or a road is not handy, is to twist your object or shoot it slightly from the side. As you can see from the following photograph, the objects not only show their size and shape, but as the images recede into the background, they create depth.

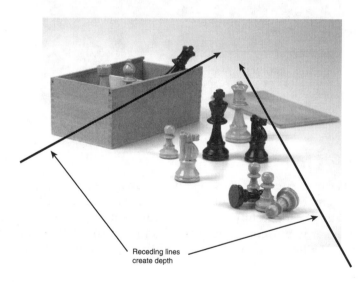

Receding lines create depth

Receding lines created by the side of the box and the chess pieces add perspective and depth to the photo.

145

Foreground/Background

If you have a familiar object in your foreground and another in your background, you can create a sense of depth. For example, let's say you have two adults in your photograph. The adult closer to your camera appears bigger in your image, and the adult in the background appears smaller. Your brain certainly knows about this phenomenon and associates depth into your photograph.

Overlapping images also help create depth in your photograph. Say you photographed your cat—okay, anybody's cat. Directly behind the cat, but in the distance, is a sofa. In the photograph, the sofa looks smaller than the cat. The viewer's brain, when looking at the photo, associates distance in the shot, because it knows that the cat can't possibly be larger than the sofa. (Although I have seen a few cats that are as big as chairs!)

The field and goal net add depth to the photograph.

Line and Imaginary Line

An object or series of objects can create a line or visual path through a photograph. This helps engage the viewer and deliver the photograph's message. You can also use an imaginary line to create interest and help your composition. Sometimes objects in your photography can be used as strong compositional tools to lead the eye toward your subject. These real or *regular* lines can be as obvious as the pipes in the following photograph.

Old pipes add direction and line, drawing your eye toward buildings in the background.

Line as element
of design

Let's use our mind's eye again to create a few examples. Say you have a photo with a child pointing up in the air and crying. Above the child, a balloon sails away into the sky. With this photograph, you have told your viewer that the child is upset by the escaping balloon, but you have also created an interesting visual. The viewer's eye follows the imaginary line between the child's outstretched arm and the balloon. This is a successful image. Congratulations!

In another mind's-eye shot, a dog stares at a spot on the floor with great intensity. In the photograph, a tiny spot can be seen just beyond the dog's nose. Could it be an ant or a tiny morsel of food? Whatever it is, the viewer's eye travels back and forth from the dog's nose to the spot on the floor.

Try to keep the imaginary line contained in the image; that is, do not offer an "end point" to the imaginary line that exists outside of the composition. If the dog was intently staring at something outside of the frame, the viewer's eye follows. After the eye leaves the image, it probably won't come back.

Watch Your Background

Distracting objects always find their way into your shot, but that shouldn't give you the right to have tunnel vision! Don't get so involved in your subject that you forget to look at what else is in your viewfinder. The quickest way to ruin a photograph is to have a distracting background.

A messy desk is the sign of a brilliant mind!

Sometimes it is unavoidable—you cannot prevent someone from walking through your photo...or can you? If I have a friend with me when I'm taking a photograph in a public place, I ask my friend to be sure no one walks in front of me while I'm taking the shot.

Look around the area you're about to shoot, and pick up any stray pieces of paper or litter. A white piece of paper can be a distracting object in your shot. (Besides, people will think you are really cool if you pick up litter!) Look in the background behind your subject; remove stray coffee cups and dinner plates. Don't photograph someone with the company bulletin board behind her. You are in control of your photograph; take the time to look at what is going on in your image before you hit the shutter.

The most criminal act you can do when taking someone's picture is to have something behind them appear to be growing out of their head! Watch your background. Be sure no trees, poles, books, door trim, and so on, are lined up behind your subject's head. Watch out for power and telephone lines when photographing outdoors. Sometimes you can change your point of view to avoid a power line, and sometimes you can't. Of course, with a little bit of digital imaging, you can erase those power lines—but it still takes time and effort to do so.

Texture

Texture can be a wonderful aid to composition. An image made completely of a textured object, such as an old piece of weathered wood, can be wonderful. Of course, you should be sure to balance a textured object with something else in the frame that has no texture. Even a smooth background works to balance your subject. Take the time to explore the textures of wood, stone, paper, and even water. By exploring the nature of these objects, you can learn much about yourself and how you view your world.

Texture can also be created by patterns. The pattern in the weave found in cloth is an example of texture. The small ripples in a pool of water, the cells in a honeycomb, and even the patterns in clouds, are all wonderful forms of texture.

An intricate pattern of colors can form texture; for example, the delicate purples and yellows of a field of wildflowers can create a wonderful blanket of color and texture. Take a good close look at an old piece of painted wood. Find a piece that might have been painted a few different colors over the years, and you will discover wonderful textures.

Colored flowers create a wonderful repeating texture.

You can use your texture as a background element or in the foreground. It can be the entire subject photograph, such as a beautifully weathered old tree stump, or it can be used as a background, such as a piece of crumpled newspaper with a delicate flower or piece of pottery in its center.

Scale

In a portrait or even a landscape, the scale of the objects is not important. We know how big the average person is. With a few visual clues, such as a tree, we can generally get an idea of how large our landscape is.

Many still-life photographs, however, can suffer from a lack of scale. If there are no visual clues to help identify the size of an object, the image can become confusing. For example, in the following photo of the nuts and bolts, we would have no clue as to their size without the pen being in the shot. Even if we used a wrench or a screwdriver as a scale reference, the size of the bolt might still be in question.

The pen helps clarify the size of the bolts in the shot.

The Least You Need to Know

➤ To keep your viewer interested, create a story with your composition.

➤ Balance the objects in your photo.

➤ Don't place your subject in the center of the frame.

➤ Draw your viewer's eye into the shot using "line" and perspective as composition tools.

➤ Color and texture can also be used as composition tools.

Lighting: It Makes or Breaks a Shot!

Now that you can create beautifully composed images, you need to start thinking about lighting. Lighting is as important to your image as the composition, and can add mood, create depth, and emphasize form.

Using Available Light

Using available light, such as sunlight, is often the easiest way to take a photograph. The light is believable and natural.

The time of day influences the angle of the light. In the morning and just before sunset, the sun is low on the horizon, and casts a beautiful sidelight on your subject or scene. At "high noon," the sun is well overhead; the shadows it casts are short, but intense. At 3:00 in the afternoon, the light is much more angled and casts very different shadows (go look for yourself!).

The *color* of light can also be affected by the time of day, and even the season. During most of the day, when the sun is high in the sky, the light is neutral. When the sun is low on the horizon, especially during the summer months, it picks up a warm yellow tone. This can be dramatic and beautiful.

Weather, too, affects light. Whereas a clear day proffers brilliant, intense light, an overcast day tenders soft, diffused light. In some situations, this can be pleasing; other times, it takes away your shadow detail and makes your images look flat.

Carry a Compass!

There is nothing worse than showing up to take a picture and finding the building you want to shoot completely in shadow; that's why most professional location photographers carry a compass in their camera bag. After all, we all know that the sun rises in the east and sets in the west. By paying attention to what direction the camera will be facing and what time of day the shoot will occur, a photographer can predict where the sun will be and how the lighting will look in a scene. If you miss a shot because the sun is in the wrong place, figure out a good time to come back and grab a quick shot.

Backlighting

The general rule to using sunlight as a light source is to try to position your body so that the sun is behind you (the photographer), or over your shoulder. That way, the light falls on the front of your subject. Of course, you can't always depend on the light being exactly where you need it. Many times, it comes from behind your subject, casting it in shadow. This is called *backlighting*.

When an exposure meter reads a scene, it expects to find bright areas and shadow areas. The meter assumes that if all these areas were totaled up, the average light would be a middle gray. So when a meter detects a bright area behind your subject, it shuts down your aperture to compensate in an attempt to render an average exposure. Unfortunately, that leaves your subject in the dark. What's a meter photographer to do?

More Backlighting

A bright area behind your subject, such as a white wall or pool of light, also creates backlighting. You should be aware of these types of light sources in addition to that great bright orb in the sky.

Well, if your camera has an exposure override, allowing you to open up the aperture or slow down the shutter, you can easily correct for this. Give your subject a few more *stops* of light, and your image will be properly exposed. Many consumer cameras

now come with a backlight feature in their menu. As an alternative, many cameras enable you to spot read and lock in an exposure. Spot reading allows you to gather a reading in a smaller area; you could, for example, measure only the shadow area, and then lock in the exposure settings. The camera then automatically opens the aperture and ignores the backlighting.

Filling with Cards

The only drawback to overriding backlighting by adjusting your exposure for the shadows is that the brighter areas in the image will be overexposed. One way to avoid this overexposure is to add some light to your subject by *filling* the shadow area with reflected available light. A large white card or a white bed sheet can be used to reflect the light back at the subject.

Nighty Night!

Shooting photographs at night is not as hard as it used to be. With your fancy preview LCD screen, you have a good idea of what your exposure should be. When shooting at night, definitely use a tripod; also use a cable release or fire the camera using the self-timer.

When photographing at night, try using various shutter speeds. You can get a nice effect from the streaks of lights from car taillights if you use slower shutter speeds. If you are trying to photograph fireworks, try varying your shutter speed to capture different types of bursts. Some cameras might even enable you

Using a Fill Flash

Another way to avoid overexposing the bright areas in your backlit image is to leave your settings alone, but use a *fill flash*. You'll learn more about this technique later in this chapter, in the "Fill Flash" section.

to hold the shutter open as long as you like; this is called a *bulb* setting. With the shutter left open, you can record as many firework explosions on one frame as you want. Of course, you can always manipulate your images by using image-editing software to make your own fireworks!

Flash

Gone are the days of flashbulbs and flashcubes. All consumer-level cameras, digital and film-based alike, come with built-in flash. These built-in flashes generally provide enough light to take a picture indoors, provided that the subject is within 10–12 feet of the camera. Built-in flashes will allow you to take photos in low-light situations, but will not render a natural lighting effect (the flash will usually look a bit harsh).

Don't expect that tiny little flash to light up the entire room; it is just not strong enough. In the same regard, don't expect a flash to even reach a subject that is more than 20 feet away from the camera. I always have to laugh when I watch a televised sports event and I see flashes going off in the stands—those flashes will never reach the field!

To use your flash effectively, do the following:

➤ Keep your subject 10–15 feet from the camera.

➤ Light from a flash does not spread well. This is called *fall off*. Keep your subjects in an area no wider than 6–8 feet.

➤ Keep your flash higher than your lens. Don't have it lighting from an angle lower than the lens, or pointing up.

➤ Avoid cameras with tiny flashes or flashes mounted very close to the lens.

Warm It Up!

You might notice that electronic flashes throw a cool or slightly blue light. This is because the color temperature of a flash is about 6500° Kelvin. Many professional photographers will tape a slightly yellow (05Y) filter over their flashes; this will help warm up the color of the flash and cast a more naturally colored light.

Fill Flash

Some cameras have a "fill flash" setting, which enables you to add light to your image without affecting your exposure settings. This is because your meter is working with the available light, and not accounting for the light that will be provided by the flash. A fill flash simply adds lighting to the backlit (shadowed) areas, *opening* them up. You can also use the fill flash in normal sunlight to fill in (and, as a result, soften) the shadows on your subject. Don't be surprised if your subject seems to pop out a bit

when you use a fill flash; the flash might be just a bit brighter than the available light. Of course, all this works only if your subject is within a reasonable distance from you, the photographer.

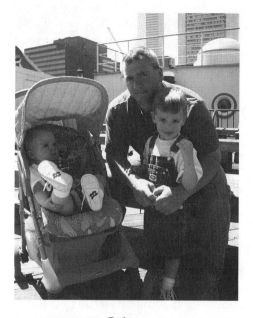

Before

Fill flash helps overcome backlighting.

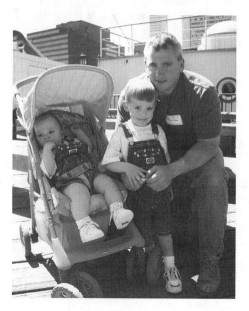

After

155

Extra Batteries

I almost always use a flash when photographing outdoors, especially when photographing people. Be aware, however, that this practice drains your camera batteries a lot faster than normal. Be prepared! Carry extra batteries.

Bounce Flash

Many times, using an on-camera flash can make your subjects look like deer in headlights. One way to correct for this is to bounce your flash off a wall or ceiling (this might not be possible with some low-end cameras). If you can point your flash at the ceiling or a wall and still keep your lens pointed in the right direction, you can greatly soften the output of your flash. When the light bounces off the ceiling, it both diffuses and lights your subject more from above.

Using an Extra Flash

One way to add more flash power to your exposure is to get an extra flash. Standalone portable flashes are not very expensive—you might already have one for your old film-based camera. You can preposition your second flash so that it is aimed at your subject, or set it up so that it bounces off the ceiling to provide a nice, soft fill light.

Diminished Output

Remember that when you are bouncing the flash off a wall or ceiling, you are sending the light on a far longer journey. Its apparent output might be greatly diminished.

Your flash needs to have a *slave eye* on it so that it knows when to flash. A slave eye detects the on-camera flash going off, setting off the auxiliary flash at the same time. (As an alternative, many professional photographers trigger the slave flash via a radio signal to prevent the slave flash from activating when someone else in the room takes a picture with a flash.) You can buy a slave eye for your flash if it does not have one built in.

Be sure to keep track of where your additional flash is and where it's pointed. You don't want to end up photographing your flash as it goes off, or having it send its light directly into your lens. Also, don't be fooled into thinking that the second flash must be close to your camera! When I am shooting at a party or during a family event, I generally carry a spring-loaded clamp so I can rig a second flash up somewhere high in the room.

Get a Bracket!

To avoid red eye and reduce harsh shadows, you should place your flash as far away from your lens as possible. To aid in this, many photographers mount a second flash on a *flash bracket*, which is basically an L-shaped handle that attaches to your camera. The bottom of the L attaches to the base of your camera, and the leg of the L holds the auxiliary flash over the camera and to the side. You can aim your flash at the ceiling to diffuse the light, or you can aim it directly at the subject. If your camera has a PC (patch cord) socket, you might think about blocking the light from the on-camera flash with some opaque tape and using only the bracket-mounted flash as a light source.

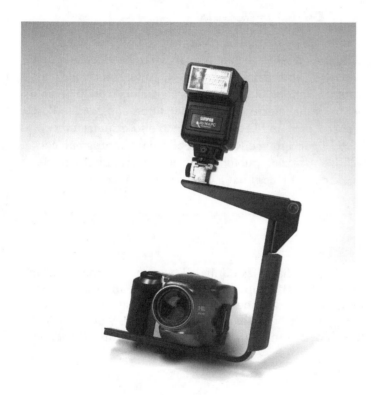

A flash bracket helps keep the flash away from the lens. Note that the bracket can swivel so that the flash can be reoriented when the camera moves from horizontal or vertical positions.

For the flash to operate, it must be connected to the camera body through a *PC* (*patch cord*) socket. That way, the flash goes off at the same time as the shutter. Counting on an optical slave is not a good idea, because the sensor will be behind or above your built-in flash and might not detect when the built in flash goes off.

Diffusion Material

Because most auxiliary flashes are powerful compared to the tiny on-camera flash, consider putting diffusion material, such as a small white handkerchief or a piece of cheesecloth, directly on your flash. Alternatively, go high-tech and buy some plastic diffusion material, lighting filters, or gels at a camera store or even a theater supply store. The major manufacturers of lighting filters and gels are Rosco Filters Co. (`http://www.rosco.com`) and Lee Filters. Rosco also manufactures wonderful set paints. Another good source for almost all things photographic is *Photo District News*, which is a magazine published for professional photographers. Their Web site (`http://www.pdn-pix.com`) has a wonderful resource section.

Adding Lights

If you don't want to be securing auxiliary flash units all over a room, there is a simpler way: Turn on a few lights! Try setting up a few clip-on lights and using brighter bulbs in some of the lamps and fixtures in the room. Reflectors can be used to concentrate and focus the light; typically bowl-shaped metal reflectors work well. The shape and size of the reflectors determine how wide a beam of light is *thrown* and how *hard* the light will be.

Color of Light

We've all heard the phrases *white hot* and *red hot*, and we've all seen heated metals glow and emit light. Many years ago, a system was devised to determine what *color* light was using during these observations. A piece of metal was heated and observed under daylight at noon. As the metal changed color, its temperature (measured in Kelvin) was taken, and the color of the glow was noted. It was observed that the hotter the metal got, the closer the color came to white. White hot metal, when observed under daylight, was measured at 5,500° Kelvin; interestingly, average daylight at noon is rated the same. We now use the Kelvin scale to describe the color temperature of light (see Table 9.1).

Soft Boxes

Commercial photographers often use soft boxes to produce an even, diffused source of light. A *soft box* is a box made of flameproof, lightweight material, the front of which is translucent. The light source is mounted inside the soft box, so the light shines through the diffusion material.

If you don't want to buy a soft box (and I wouldn't blame you, they can be expensive), you can rig a simple substitute. Hang a white cloth sheet from a stand or a clothesline, and shine your light source through the sheet in the direction of your subject. Although this method doesn't pass as much light as a professional soft box, it delivers a soft, diffuse light. Be careful not to burn or overheat the cloth; keep your light source a safe distance from the cloth.

Table 9.1 Color Temperature of Light Sources

Source	Color Temperature
Candles	1,950° K (how romantic)
Dawn	2,000° K (also romantic)
Household incandescent	2,800° K
Fluorescent tube	3,000° K (yucky color!)
Photo incandescent	3,400° K (sold at camera stores)
Noon sunlight	5,000–5,500° K
Sunny day with some clouds	6,500° K
"Incredible" blue sky	11,000–18,000° K (wear sun block!)

If you look at different light sources, such as a standard light bulb or sunlight, you will notice that they are different colors. A standard tungsten light bulb, such as a household light bulb, burns at about 2,700–2,900° Kelvin. In relation to sunlight, this appears yellowish. Tungsten photographic lighting equipment "burns" at 3,400° Kelvin; daylight-rated photographic light bulbs burn at 5,500° Kelvin.

When your camera detects light falling on a subject, it must determine the color of the light source. Most cameras (or their software) automatically adjust for the correct color temperature; this is called *color balance*. If your camera (or its software) does not

Mixing Your Lighting

Be careful when adding light to your subject. Use similar types of sources in the same environment. If you mix lighting, such as using a flash (which is 5,500°) and tungsten lights, you end up with a strange and unwanted color cast. Your camera adjusts for one of the sources or the other. If it decides to average the color temperature, you will see blue and yellow light in your image.

adjust for color temperature, the images carry a color cast (an overall tint of color). Imagine your camera is set to work only at 5,500° Kelvin. If you brought your camera inside to photograph under household lighting, everything would have an unpleasant yellow cast. Alternatively, if your camera were set to see tungsten lighting, then all your outdoor shots would look very blue. If you want proper, or neutral, colors in your pictures, be sure your camera is set for the color temperature of the main light source.

Of course, you might decide not to correct for the light temperature. For instance, if you were to take a moody candlelit picture, it would be a shame if the warm light of the candles were overcorrected to a neutral color. If you can turn off the color balance correction, try to do so. If you are setting the color balance using software, try leaving it off. Experiment and practice; remember, you are not shooting film and you have nothing to lose.

Lighting Setups: You Are a Pro Now!

Whether you are setting up lighting for a portrait or a product shot, it is easy to control your lighting. Start off by deciding what the important part of your photograph is and then decide how you want to light it. Try the following:

1. Add the first light, which is called a *key light*. The key light delivers the main and brightest light. It can come from directly in front of the subject, but it adds more dimension if it comes from the side. As you can see in the following figure, a key light casts a harsh shadow.

A key light casts a strong and abrupt shadow.

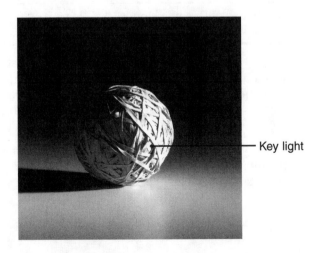

Key light

2. Before adding another light, see what a fill card will do. Place a white card opposite the key light. It bounces light back onto the object, and fills in the harsh shadows.

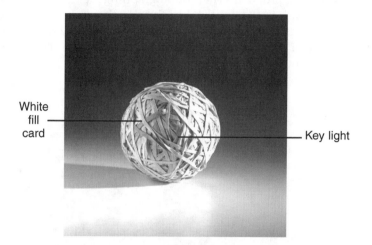

White
fill
card

Key light

Use a fill card to fill in the harsh shadows.

3. If you need more light to fill your shadow, you can replace the fill card with another light source (I'll call this a *fill light*). To keep some of the shadow detail, this light should be dimmer than the key light. If the key light and fill light are the same intensity, move the fill light farther away from the subject, or try diffusing it. In the following photograph, note the shadow thrown by the fill light to the right of the ball.

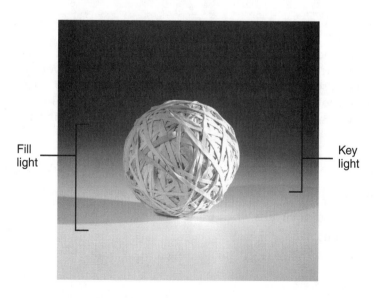

Fill
light

Key
light

A fill light can throw a secondary shadow. This can create an unnatural lighting situation.

161

4. Product shots might need a top light, which should be placed above the object. You can place the light slightly behind or in front of the subject, depending on the effect you want to achieve. This light also should be diffused—be careful not to cast a heavy shadow on the product! When photographing a person (or when photographing an object that is very textured, like the one shown here), using a hair light can add a nice effect. Place the hair light above and behind the person; it picks up the texture of the hair and adds some nice highlights. Be careful not to shine the light into your lens.

Adding a top fill and hair light really lights up this image!

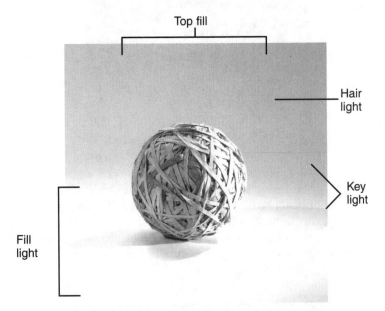

Practice your lighting techniques! Try out different types of light sources, and experiment with different placements. If you really want to get fancy, try coloring your light sources. Red lights add a sense of action to your shot, whereas blue light often gives the feeling of calm or coolness. Experiment with different colors and color combinations to get the mood you want. Creative lighting can produce exciting and pleasing results.

Lighting Safety Tips

As with all things in life, you should consider the safety hazards of using lighting:

➤ Don't overload your electrical circuits when using lighting.

➤ Use heavy extension cords.

➤ Place your electrical cords carefully to avoid creating a trip hazard.

➤ Weigh down your light stands so they don't tip over. You can make inexpensive weights by filling one-gallon plastic bottles with sand.

➤ Be careful of the heat the lamps produce. You can easily burn your subject.

➤ Be careful when using colored gels on your lights. If they get too hot, they might melt. Also, and this is extremely important, use only photographic gels or theater gels on your lights. They are designed to be used near high-temperature lighting.

➤ Do not move a light when it is on! Light bulbs are very fragile when they are hot—especially when lit. They might shatter or explode when moved. Turn lights off before you move them!

Forgot Your Tripod?

If you have forgotten your tripod and find yourself in need, here is a good trick: Hold your camera to your eye, and relax your arms and body. If you stiffly brace yourself, you are going to shake. After you take several deep breaths, exhale slowly. At the end of the exhale, trip the shutter. This not only reduces shake in your body, it will calm you down, also. If you find this technique helpful, you might consider signing up for a yoga class!

Stand Still: Working with a Tripod

When your camera's shutter speed falls below 1/60 of a second, you will not be able to hold it without shaking it—especially if you drink coffee! In a low-light situation, such as with an interior, you can be sure you'll need a tripod.

When you buy a tripod, be sure to get a sturdy one. Better tripods will have a Teflon-like surface on the legs to aid them in movement. The taller the tripod and/or the more compact it is, the more you will pay for it. Pay close attention to the pan head, which attaches your camera to the tripod—it should be sturdy and have smooth movements.

Most professional cameras will have a screw-like socket to attach a cable release. A cable release, which is a long spring-loaded cable, allows you to trip the shutter without shaking the camera (after all, it doesn't do you much good to put your camera on a tripod and then shake it when tripping the shutter). If your camera doesn't have a cable release socket, use your self-timer! Set the timer, trip it, and your camera takes the photograph vibration free.

The Least You Need to Know

➤ Use available light for your basic exposure.

➤ Don't let your meter be fooled by bright or dark backgrounds.

➤ Use a flash to add light to your photos.

➤ Use your flash as an indirect source of light.

➤ Use reflector cards to fill in your shadows.

➤ Use additional light sources to add creativity to your images.

➤ All light sources have their own color!

Resolution: Is Bigger Better?

We all remember *Goldilocks and the Three Bears*. One bed was too soft, one bed was too hard, and one bed was just right. Resolution behaves a lot like our friend Goldie. Too little resolution causes your images to lack detail; too much resolution clogs up your computer and printer and robs you of speed; and the proper resolution is just right.

Image Resolution/Monitor Resolution

Your camera can produce images at various resolutions. As a general rule, the larger your file is, the more you can do with it. If your file size is too small, you won't be able to reproduce large images and still have detail. The drawback to large images is that they take up a lot of storage space on your camera's onboard hard drive.

The resolution of your monitor is measured in pixels, just like the resolution of your images. Monitors can display your images at various resolutions, which affects how those images look onscreen (however, it doesn't affect the resolution of the images themselves).

Demo: Calibrating Your Image Resolution and Monitor Resolution

Both the screen resolution and the size of an image affect how that image is displayed on the monitor, but don't take my word for it! Humor me by performing the following steps, which illustrate how your monitor resolution and image resolution work together:

1. Click the **Start** button, click **Settings**, and choose **Control Panel**.

2. Double-click the **Display** icon (**Monitors and Sound CP** on a Mac).

3. Click the **Settings** tab, and look for the **Screen area** slider at the bottom of the panel. Drag the slider to set your screen resolution at 640×480 pixels.

Changing the screen resolution changes how the onscreen image is displayed.

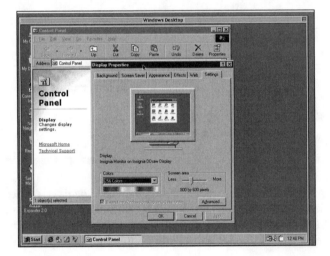

4. In PhotoDeluxe, open the **File** menu and choose **New** (alternatively, press **Ctrl+N**, or ⌘+**N** on the Mac).

5. In the New dialog box, shown in the following figure, type **9.4** in the **Width** field (don't worry about adjusting the **Height** field), and **72** in the **Resolution** field. (You'll understand why you're entering those particular numbers in just a moment.) Be sure that **inches** is the selected measurement for the width and height (note that you can change this to **pixels**, **centimeters**, **points**, **picas**, or **columns**), and that **pixels/inch** is selected for resolution. Click **OK**.

Select the width and resolution in the New dialog box.

Look! The image's window fills the width of your screen when viewed at 100%. So how did I know to enter 9.4 in the **Width** field in step 5 to make the image fill the whole screen? Here's a hint: Your monitor is set up to *display* images at 72ppi (pixels per inch). Give up? Okay. Divide 640 pixels (remember that you set your monitor's screen resolution, or the total number of pixels available on your screen, to 640×480 in step 3) by 72ppi, and you get 9.4 inches!

So what happens if the image is 9.4 inches at 100ppi instead of 72ppi? Well, the image will no longer fit on the screen at 100%—you're out of pixels! You can display it at 100% and scroll the screen to view the image in its entirety, or you can increase the screen resolution. If you increase the resolution to 1,024×768 (or thereabouts), you will again be able to see the image at 100%—with a little screen to spare. (9.4 inches×100ppi = 940 pixels to display. We set the screen to be 1,024 pixels wide, so we can see the entire image.)

To see the entire image onscreen without changing the resolution, begin by specifying that the screen display only some of the total pixels available. So, instead of specifying that you want to see 100% of the pixels in the image, you can tell your software (in this case, PhotoDeluxe) to show a smaller percentage of pixels. For example, if you choose 25%, you'll see only one in four of the pixels in the image (thus losing some detail), but you won't have to use the scrollbars to view the image in its entirety.

Just as you can zoom out to view more of the image on your screen (thus making the image appear smaller), you can zoom in to make the image appear larger to view more of its detail, as shown in the following figure.

More Pixels, Please!

To keep things simple, just worry about the width of the image, and likewise the width of the screen. Don't worry about adjusting the height of the image.

Opening Images in PhotoDeluxe

By the way, when you first open an image in PhotoDeluxe, it opens the image at the largest zoom size that fits, in full, on the screen.

*You can zoom in and out
to see the detail of your
image.*

Printer Resolution

Printers usually have a fixed resolution at which they best reproduce an image. For most laser and dye-sublimation printers, this is usually 300dpi (dots per inch). So what happened to the ppiI (pixels per inch)? Printers don't print pixels; instead, they lay down tiny dots of ink or dye to produce an image. The printer should, at the very least, print one dot for every pixel.

To get the best image reproduction from your printer, you should maximize your image size. Also, the resolution of your image should be the same as your printer resolution, if you can swing it. If your printer has a resolution of 300dpi, then your images should have a resolution of 300ppi (pixels per inch). Note, however, that this need not be the same as your monitor's screen resolution (probably 640×480 pixels), which is why the printed image will not be the same size (in inches) as it was on your screen.

If your image is too small or has less resolution than your printer, one of two things will happen:

➤ Your printer might just leave a space between each dot when it prints. As a result, your image will lack detail and sharpness.

➤ Your printer might interpolate information to fill in the gaps between the pixels. As we know, interpolated information is not as good as original information. Your images might still not look sharp, and might lack detail.

The moral of this story: If you want great detail and print quality, start out with enough image data.

The Inkjet Exception

There, on the side of the box that contains a shiny new inkjet printer, is a label proclaiming, "This printer capable of 1200dpi!" Wow! That's a lot better than the 300dpi quality of my laser printer!

Well—it is, but it isn't.

Inkjet printers can reproduce a very tiny dot, much smaller than the dots that laser and dye-sub printers can produce. Also, inkjet printers can move their inkjet heads in very fine increments. By using this technology, the inkjet printer can lay down many dots when printing. Instead of printing one dot for each pixel as a laser printer would, an inkjet printer can lay down two, three, or even four! That means your 300ppi file can be printed at 1200dpi, because the printer lays down four dots for each pixel. The benefits to this can be finer detail and better color blending. Don't confuse this with interpolation, however. The printer is not making up information to go between the missing pixels. Instead, it is repeating the information it already has. That is, the printer is printing your 300dpi file at the same resolution, except it is using more dots to do it.

A high-end laser printer will produce as good an image at 300dpi as a 1200dpi ink jet. A laser can produce a very tiny dot, but because of the way the toner is spread to the paper, the dot will appear to be bigger. Because the dots are bigger, they might overlap or blend into one another. This will render a natural color effect.

You will need to do a side-by-side comparison to decide which printer gives you the more pleasing result. It is almost like comparing apples and oranges; each printer has its pros and cons. It is very difficult to say that a 1200dpi inkjet printer produces a better print as compared to a 300dpi color laser. But the point is that a 1200dpi inkjet is not four times better than a 300dpi laser printer.

In any case, if you plan to use your printer at a high dpi resolution, be sure you are using good-quality paper. Also, remember that it takes a lot longer for your printer to cough up a print. You might want to proof your image out at a lower resolution before you go the high-resolution route.

How Big a File Do You Need?

With small and lower-end digital cameras, you will probably not run into the problem of having too large a file size. Again, whatever size you decide to make your print, the dimensions of the print and its resolution should match the printer's settings.

If your image *is* too big, however, your printer will throw away information—think of this as *reverse interpolation* or *downsizing*. You should make the image smaller before you ship it to your printer, but be sure you never resize the original image. Instead, copy it, and then resize the copy. You might find that you need to make a few "variations" of your print, depending on the printer and paper type.

If your printer gives its specifications in lpi (lines per inch) instead of dpi, fear not. To determine how much resolution you need, double the lpi required; the resulting number will be your dpi/ppi setting. For example, if your printer wants an image at 133lpi, your image should be 266ppi.

It's always a good idea to call a commercial printer and ask them at what line screen they will be printing. Line screen, "printer talk" for lpi, refers to the mask that is used by a printer when exposing the negative, which in turn will be used to make the printing plate. The lower the line screen, the "coarser" your image looks. The line screen is also determined by the type of paper you are using. A newsprint type of paper doesn't hold a lot of detail. A low lpi is used so that detail will not be "clogged" up as the ink soaks into the porous paper. Glossy paper holds detail much better because the ink won't soak into the paper as readily.

The Least You Need to Know

➤ Monitors display images at 72dpi. An image that has the same amount of pixels in it as the monitor can resolve will display at 100%.

➤ You need to have enough resolution in your images to print properly. A printer has a higher resolution than a monitor.

➤ The size of an image onscreen might differ from the size it prints out at, depending on the onscreen pixel ratio.

Compression

To reduce storage size, your images can be *compressed*. Compressing images enables you to store more on your camera's and computer's hard drive, but unfortunately, compression might (and often does) destroy information.

Getting Quality Images

The best image quality that you can have is from a noncompressed original image (what I call a *straight* image). If image quality is important to you, you should try to find a way to get your images from your camera without compressing them. Unfortunately, many (if not all) mid- to low-end cameras don't give you the opportunity to download your information before it has been compressed. How, then, can you be sure you end up with the best possible image file—especially for those once-in-a-lifetime shots?

Well, it's confusing. Determining what the quality of your image will be requires an understanding of image size, resolution, *and* compression—and each camera manufacturer describes its options differently:

➤ **Image size/resolution** Your camera might give you anywhere from two to five options on what size your finished image will be, usually presented in pixels (for example, 1152×864 pixels, 640×480 pixels, and so on). The lower the *resolution*, the smaller the *file size* and, consequently, the less *compression* required. If you simply intend to put your images on a Web site, you don't need a lot of resolution. If you intend to print your images, select the highest resolution available.

➤ **Compression** One would think (or at least I would) that the *quality* of the image would have to do with how much image information is available, but that's not what the manufacturers are talking about. Instead, your camera's quality setting represents how much the image is *compressed*. The more compression an image undergoes, the more quality is lost. If given the option, choose the highest quality possible.

Some cameras do not give you the option to pick the resolution and compression rates; instead, you'll see Good, Bad, and Ugly settings, which determine the compression and resolution at the same time. The camera either shoots at a low resolution and compresses less, or shoots at a high resolution and compresses more! The only way to get a clue as to what's going on is to look at the final image size. For example, suppose you applied the Good setting to one copy of an image, and applied the Bad setting to another copy of the same image. If both the images end up the same size, then you know that the compression rate was varied. If the images end up sized differently, then you know that the resolution was changed. As you can see, this type of blind quality control is not the most desirable.

Guess Again...

You might think that taking a smaller image and compressing it only slightly would give you a better image than taking a larger image and compressing it a lot, but that's not true. The problem is that the smaller image has started out its life with less detail; the larger file, when uncompressed, still holds more resolution (it might, however, suffer from interpolation).

Lossy Versus Lossless Compression

Lossy and lossless might sound like Vegas streaks, but instead they refer to types of compression schemes:

➤ **Lossless compression** A compression scheme in which no information is lost during compression or retrieval (also called *run-length encoding*).

➤ **Lossy compression** A compression scheme that loses or throws away information in order to compress your file. Lossy compression relies on your brain and eye to "fill in" the information it threw away when you look at the file after it has been retrieved.

Lossless Compression

Instead of saving all the color information in your file pixel by pixel (which would offer no compression at all), lossless compression keeps track of the location of each pixel of color. For example, the compression process logs the color green, noting all the places in the photograph where that color is located, and then saves that information. So instead of saving 1,000 pixels of green, it saves one pixel of green and a directory of the locations in the photo where that color resides. This takes up a lot less space than saving each individual pixel and its location. When the file is uncompressed, the process happens in reverse. The compression scheme rebuilds the file using the colors it has stored and the directory that outlines where they should be located. There is very little visual difference between the original and the restored files. Because the "logging" process is not perfect, it cannot exactly reproduce the original file.

Using lossless compression is a safe way to save your files, but the drawback is that the compressed file doesn't end up being that much smaller than the original file.

Lossy Compression

Take a close look at any two objects that are adjacent to each other in a photograph—for example, a shiny red Porsche against a deep blue sky. Now look at the edge where the car ends and the sky begins. Notice how the pixels begin to *tween*, or blend from red to blue? This tween information is exactly the information that lossy compression software is going to chuck. It relies on your brain to detect where there should be tween information and to put it in for you when you look at the photo. One additional disadvantage of using lossy compression is that every time you resave an image, you lose even more information. Eventually, your image is going to look like a pile of mush.

The benefit of using lossy compression is that you can compress images to very small sizes. This aspect comes in especially handy when you are sending images via email or posting them to a Web site (besides, Web site images usually are so small that most of the detail is lost anyway). The smaller size greatly speeds download time.

Archiving Programs

After a while, you will find your hard drive brimming with hundreds of images you just can't throw away. You will need to back up your hard drive onto portable disks, such as a floppy or zip disks. Simply copying files off your hard drive onto a disk is an easy and quick way to store images and files. The problem with this is that you will need many disks to back up all your files. What do you do?

Archiving programs are designed to help solve storage problems. These programs will help you store your files and keep track of them. The archiving program will compress your files, without losing any data, so you will use far fewer disks than if you were just copying them onto a disk. The programs will also keep track of your files

creating catalogs or disk file directories. Some programs will simply compress your files and offer simple file directories. More elaborate programs will create backup logs and might offer file histories.

PKZip/WinZip

PKZip (used primarily on DOS platforms) and WinZip (used on Windows platforms), both of which can be found as shareware and as commercial programs, are lossless compression programs. PKZip and WinZip (found at `www.winzip.com`) can reduce image files about 20%–30%; text documents (such as Word documents) and computer program files compress up to 60%.

What's Shareware?

Shareware programs are developed by private individuals or small companies, usually to help fill the gaps left by large software companies. These programs are offered at a low cost or free, and are usually downloadable from user group bulletin boards or Web sites. If a fee is involved, it is usually small—$25–$50—and generally goes to the programmer to help defray his costs in operating his Web site or developing the program code (although some shareware programmers derive their sole income from developing shareware programs).

Not only can PKZip and WinZip compress many files at the same time, they can *archive* the image files into one single file. You can usually tell when a file has been zipped, because it has the extension **.zip** in its filename (as in **File.zip**).

WinZip compressed these files with an average savings of 35%.

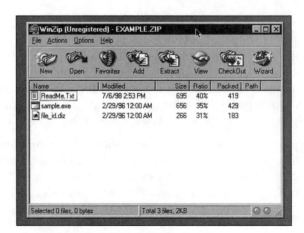

To restore an archived file back to its original form, run the file back through the zip program. Typically, you will use a program such as Un-Zip, or something similar sounding, to restore the file. Usually this requires little more than dragging and dropping the file onto the archiving programs icon. Zip files can also be archived as self-extracting archive (SEA) files, which do not require the use of the un-zip program to be unpacked. SEA files might be a bit larger than ZIP files, because they contain a small amount of computer code to run the extraction. SEA files are useful if the computer that is doing the unpacking does not have the zip program installed on it.

StuffIt

StuffIt, which is manufactured and sold by Aladdin (**www.aladdinsys.com**), also employs a lossless compression scheme; however, this scheme has been developed to work on Macintosh platforms (although Aladdin also provides an expander program for Windows platforms). StuffIt works similarly to PKZip and WinZip, except that files are compressed and labeled with an **.sit** (StuffIt) extension. StuffIt compresses an image file about 25%–30%, and a document or code file up to 60%–70%. In addition, StuffIt can archive many files into one group folder.

StuffIt also supports a self-extracting format, SEA; as mentioned previously, SEA files are larger than SIT files because they also contain the code needed to perform the extraction. Note: Because SEA files generated by StuffIt can be opened only on a Macintosh, it's a good idea to save your files as SIT files so that they can be read by both Macintosh and Windows machines (besides, the files will be smaller).

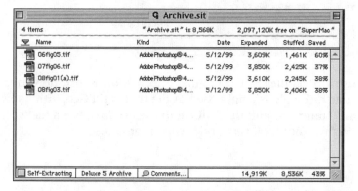

StuffIt saved 43% with lossless compression.

File Formats: Acrimonious Acronyms

So many file formats are available that it is often confusing to figure out what they all do. Some formats are specific to a program or manufacturer, although others indicate industry standards. We will look at only those formats that relate to pixel-based images.

Some formats are used to compress images, others are used to reduce color information, and still more have been developed specifically for Web usage. Not every format can be read by every computer (some formats can be read by Macs only, and others only by PCs). Let's take a few minutes here to look at some important image formats.

JPEG

JPEG (short for Joint Photographic Experts Group and pronounced *jay-peg*) files are lossy compressed files. The JPEG format can be read by all computer platforms; because JPEG files are small in size and extremely portable, they are an excellent (and the preferred) way to deliver images over the Web.

When you save a file in your photo-editing software, you are given the option to save your file in the JPEG format. If you do, you are then asked how much compression you want applied; play around to find out how much compression you need. When you want to reopen the file (no matter what program you use), the image is automatically restored.

JPEG is the primary lossy compression format used.

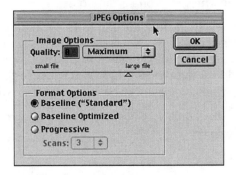

The disadvantage of using JPEG files is that original information is lost; how much is lost depends on how much the file is compressed. A file that is JPEGed with a low rate of loss (high quality) might be almost identical to the original, but a file with a large amount of JPEGing will not look very good when reproduced.

TIFF

TIFF, which stands for *Tagged Image File Format*, is one of the most universal formats for pixel-based images, and can be opened on Macintosh and Windows-based machines. Although TIFF uses a lossless compression scheme, TIFF files retain their original file size and offer no standard compression. TIFF images are not welcome on the Web, because they are large, bulky, and slow to open.

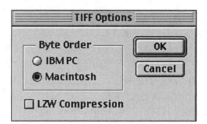

TIFF files must be saved in a byte order specific to the platform that will read them.

To compress a TIFF file, you must save it using the optional LZW compression scheme. However, most people do not take advantage of the LZW compression, because the compression it affords is minimal. (I once tried to use the LZW compression algorithm, and it took forever and a day to close the file. I don't know how long it took to open the file, because I got tired of waiting and opened the original file and threw out the LZW file.)

Byte Order

Both Windows and Mac platforms save files differently from each other. They differ in how they order, or arrange, the data bits in a file. Using a platform-specific byte order is an efficient way to store data.

GIF

GIF, short for *Graphic Interchange Format*, was developed by CompuServe as a compressed graphic format. GIF files are still widely used on the Web. Because the LZW compression algorithm, which is incorporated in the GIF format, was designed mainly to handle text formats, GIF files support only 8-bit color and best handle icons, text, and line drawings.

GIF files can be delivered over the Internet, and support interlaced graphics (which allow the image to displayed partially as the Web page downloads). An interlaced image file displays, for example, every eighth row or line of the image, and then fills in the other rows afterward. This way, the image can be seen quickly—although not in great detail until it is fully loaded. In addition, simple animation can be delivered via the Web using animated GIFs, which consist of a batch of GIF files that are delivered "flip-book" style.

EPS

EPS (*Encapsulated PostScript*) files can be huge, because they incorporate the PostScript language and the original file. *PostScript* was invented by Adobe as a language to tell printers how to print a file. A PostScript file tells any printer that supports the PostScript language how big a file is, which font or fonts it uses, and other information about the file. This enables the printer to print the file as it was intended to look.

EPS files contain a few lines of code in the *header* of the file that enables the images to be inserted into word-processing and other documents. This makes EPS files portable, but also large and slow to work with. This slowness is compounded by the fact that the image-processing program must process the PostScript instructions in addition to the image, which slows the computer quite a bit. For these reasons, EPS files are not a great format for the Web.

PDF

PDF (*Portable Document Format*) is a modern version of the EPS format. Like the EPS format, PDF contains instructions for the printing device such as font, size, and color descriptions. The PDF file is not a single file, but an entire document that contains page-layout, image, and color-management information.

Using PDF files is an excellent way to distribute large documents, especially over the Internet. Because PDF *readers* are freely distributed by Adobe and other companies, many software programs are being distributed with PDF manuals instead of actual printed instructions. This allows software developers (and anyone else who needs to distribute manuals) to save a lot of money by not printing and shipping books.

To write a PDF file, you need a PDF *distiller* such as Adobe Acrobat, which allows the page layout to be *published* into PDF format. PDF files are very small, because many of the layout and type specifications are contained in code that *describes* the layout or file instead of containing the actual file.

FlashPIX

FlashPIX, developed by a group of software and imaging companies (including Kodak, Hewlett-Packard, Live Picture Inc., and Microsoft), is another modern file format, and is excellent for the Web. FlashPIX uses lossy compression to store the complete image and multiple lower-resolution versions of the file.

As the user calls for an image at a specific resolution, the FlashPIX format delivers the specific resolution to fill the section of the screen called for. Remember, when you enlarge an image, you will be filling the entire screen; you don't need to load file information into RAM that will not appear on the screen. If the user calls for a higher or lower resolution, that file is quickly *swapped* in. This allows for a very speedy change in onscreen resolution. Also, because only the information needed for the specific resolution is loaded into the computer's RAM, more RAM is left over for other duties. For example, instead of loading all 20MB of information for an image that requires only 100KB to display the image, FlashPIX enables you to download only the 100KB you need; thus, much less RAM is used. Also, a FlashPIX image can be downloaded into a Web page at a low resolution, with a more detailed version of the image ready and waiting to be loaded into RAM if needed. This decreases the download time and increases image detail.

BMP

BMP files are a standard bitmap file format used by Windows. You will see these files associated with Windows programs. BMP files offer out-of-date compression schemes and do not resize well. Don't use the BMP format if you can avoid it.

PICT

PICT-formatted images, which work similarly to TIFF files, can be read only by Macintosh computer programs. PICT files are lossless, and can be compressed by programs such as StuffIt.

Because PICT files cannot be used on Windows or DOS machines, it is better to store files in the TIFF format if you can. If you find a Macintosh program that lets you save files in the PICT format only, you can reopen the file and resave it as a TIFF file.

So Many Choices!

If you are storing finished images and you are pressed for space, use the JPEG format. Make a copy of the original image and try a few different compression ratios until you find the right file size you need. Unfortunately, you can't predict the file size beforehand.

If you can afford the storage space, save your files in a lossless format such as StuffIt, PKZip, or WinZip. If you plan on storing a lot of images, it might pay to purchase a CD recorder and store your images on recordable CDs (CD-R). CD-R disks are inexpensive.

TIFF and PICT formats are great formats in which to store your images if you plan to do more work on them. They are lossless, but not compressed. They also open quickly. If you plan to store your images later, you can compress the files with StuffIt or PKZip. Your system determines which programs to use. TIFF files are the most universal, and are a safe bet. They can be opened on a Mac or *Wintel* machine.

.tif Versus .tiff

With some files, you see a `.tif` file extension instead of the `.tiff` extension, but fear not; these files are indeed TIFF files. In the olden days, before Windows, DOS machines allowed only three-letter extensions, such as `.tif`, `.doc`, or `.let`.

If you have an image that will be placed on a Web site, JPEGs are the way to go. Also, if you plan to deliver your image via a modem and it will be viewed on a monitor only, go JPEG! JPEG files can be made very small and can also be *interlaced*, meaning that they will open on a Web page at a low resolution at first, and then "fill in" their resolution as the remainder of the file is downloaded. The benefit is that the Web viewer can get an idea (albeit a bit blurry) of what the image will look like, and not feel frustrated waiting (and looking at nothing) while the image downloads. If the viewer is not interested in the image, he can move on to something else. This speeds Web pages along.

GIF files are an excellent format for logos, line art, and solid-color images. They are quick, can be compressed, and can be interlaced. Do not use a GIF format to save or deliver an image unless it is part of a logo.

The Least You Need to Know

➤ You can compress your files to save space.

➤ Lossless compression does not change the file; lossy compression throws away some information. The files will be changed in appearance.

➤ There are many file formats, some specific to each platform.

Part 4
Let's See It: Imaging Techniques

You can manipulate exposure, shutter speed, and focal length to draw attention to your subject and add life to your images. Your point of view and use of lighting can create mood or just add detail to your subject. And when you download your images from your camera to your computer, you can enhance and manipulate your images in ways you've never dreamed! Digital information is flexible and can be transformed into beautiful images that sing with clarity and glow with color.

Scratches, errant telephone wires, and missing teeth can be fixed. Perspective can be controlled, color can be enhanced, and images can be sharpened or blurred. You can combine elements from many photos to create a brave new world. Images that existed only in your imagination now can come to life on your screen and in print.

Don't be afraid to experiment. Creativity and exploration are the key elements in making great photographs. Accidents happen—and wondrous results might occur!

Go Get It: Downloading Your Images

In This Chapter

➤ Download images via the manufacturer's software

➤ Download images using PhotoDeluxe

➤ Download images directly from a removable disk

➤ Getting images off CDs

You have been running around all day. Your pockets are brimming with hard drive cards, stuffed with wonderful images. Your friends are driving you crazy asking for prints. You have all these fancy and wonderful toys at your ready.

The Fine Print...

The demonstrations that follow do not in any way reflect an endorsement of any one product. I've picked software that I hope is readily available and will have a common interface and functionality. I've also tried to review software that I think will be fun to use and add enjoyment and creativity to your photographic experience. But as always, my advice to you is to get out there and experiment!

Different Setup?

It would be impossible—not to mention boring—to cover the details of using each individual camera and software package on the market. Fortunately, in the process of reviewing cameras and software packages, I found many similarities in the ways cameras operate and the ways software is formatted—many programs work the same way, even though their interfaces look different.

If I happen to be demonstrating how to use the exact type of camera and software you are using, you're in luck. If, however, I am not using your specific setup, just try to understand the basics of what we're trying to accomplish, and apply it to your situation. When all else fails, read the instruction book that came with your camera. Believe it or not, some of the instructions actually work. Also, don't be afraid of making mistakes; you won't learn otherwise.

Hooking Up the Camera

Before you download images from your camera to your computer, no matter what type of software you are using, you must connect the two. Following is a general procedure for hooking up a camera; most cameras and cables work in the same way. Check your instruction manual before connecting any cable just to be safe.

Cable Hints

Don't shove a cable into a port. If it doesn't fit easily, be sure you have the right cable. Before you connect any cables, inspect them. Check to see whether your cable has any bent pins or foreign objects stuck in the connections.

1. Turn off your computer and camera. It's not a good idea to connect equipment when it's "hot."

2. If you're using a Windows machine, find the serial port on the back of your computer. You might find one or two ports; they are labeled *COM1* (port 1) and *COM2* (port 2). Line up the serial connector on the cable, insert it into COM1, and tighten it down with the screws.

If you're using a Macintosh, locate either the modem port or the printer port on the back of your Mac. You can connect to either port—your choice! If you are using a camera and computer with USB ports, just connect them using any USB port on the computer and the USB connection on the camera body.

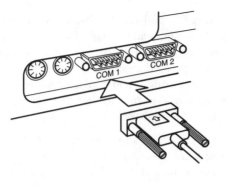

Connecting to a Windows machine is easy.

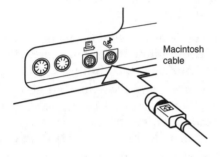

Connecting to a Macintosh is just as easy.

3. Find the other end of your cable. Take a look at the pin setup, and check the sockets on the camera to help you align the cable properly. Gently insert the cable into the serial socket on the camera.

Downloading via the Camera Manufacturer's Software

Every camera will have a different way to connect to the computer. Many will have more than one way to access the onboard photos. Many camera manufacturers include their own proprietary software or some variation or adaptation of canned software that has been designed specifically to work with their cameras. I'll call this software *OEM* (original equipment manufacturer) *software* (it might or might not have been developed by the manufacturer, but they like us to think it was, so we will). This does not include brand-specific software such as Adobe PhotoDeluxe or Photoshop, although they also might have been supplied with your camera.

Before you start, be sure you have the correct version of software for your operating system. Nothing is more frustrating than trying to shove a square peg into a round hole! Also, and this is really important, *back up your hard drive* in case something goes awry during the process of loading new software. Follow the instructions in your software manual *exactly*. After you've finished backing up your machine, go ahead and install the software that came with your camera (refer to relevant documentation that came with the camera as needed).

185

PC or Mac?

Many software packages distributed with cameras work on both Windows machines and Macintoshes; I have chosen to work with programs that work on both platforms, and that have only minor interface differences. I will note any important differences as we go.

Quick Tour

If you are using Windows 95 or 98, you will see the Quick Tour Screen. Skip the tour for now, and close the window.

Click the View picture button to start the downloading process.

I am using Image Expert, which is supplied with the Epson Photo PC 750Z. Image Expert allows users to preview images on the camera, to select certain images to be downloaded individually, and/or to download all the images at once. You can store your images in a photo album, and perform simple editing for color, contrast, and brightness.

After your camera is hooked up to your computer, you can begin transferring images (assuming, of course, that you've already installed the downloading software, as mentioned earlier). Follow these steps to transfer images:

1. If you're using Windows 95 or 98, click the **Start** button, choose **Programs**, select **Photo PC750Z**, and click **Image Expert**.

 If you're using a Macintosh, find the Photo PC 750Z folder on your hard disk, double–click **Image Expert** to open the Image Expert folder, and then double-click the **Image Expert** icon.

2. You should see the window shown in the following figure. Click the **View Pictures in the Camera** button.

3. A window displaying a "filmstrip" of your images appears, as shown here. Click **Get All** to transfer all the images to your hard drive; alternatively, click an individual image (or multiple images) to select it, and click **Get Selected** (the **Get All** button will change to **Get Selected** when only some of the images are selected).

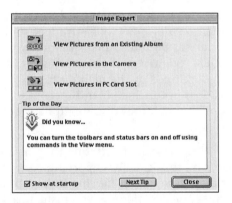

4. After you choose your images, Image Expert automatically creates an album (folder) for your pictures with the current date as its name. You can change the title if you like by overwriting the title, or you can choose an existing album and add the images to it.

You can choose to download all your images by clicking "Get All" or by clicking on the individual images, select just a few.

After you have chosen all your images, click OK to start downloading to your album.

5. Click **Open** (**OK** on the Mac) to begin transferring your pictures; the progress of the transfer is indicated in the progress window that appears. Note: This might take a while. Go get a cup of coffee, walk the family pet, or visit with your family.

The progress bar can give you a good idea of how long it will take to download your images. This is a good time to take a stretch!

187

6. When the transfer is finished, close the filmstrip window.

7. A message appears asking whether you want to delete all the images on your camera. If you want to make room for more images, delete the images by clicking **Yes.** If you are a chicken like me, wait until you are sure they really exist on your computer by checking your directory!

Be sure your images have transferred to your computer before you delete them. Check your directory!

8. You can double-click an image to open it.

When you double-click on one of the images in the album, it will open on your screen.

9. I suggest you save a copy of the image before you begin to "play" with it, preferably using another name. This way, if you really mess up, you will have a backup of the original image. To save your image, just click the **Save** button. To save a duplicate of your image, open the File menu, choose Save As, and save the file with a different name such as ***Filename_copy.tif***, or ***Filename2.tif***.

Before you start to make changes to your image, make a copy of it and then save it.

10. You might want to rotate the image using the drop-down menu or the **Rotate** menu button if you took your image in a "vertical" mode.

11. With the image still active or selected, open the **Image** menu and select **Corrections**. A screen appears that allows you to make various corrections to color, contrast, and the like. I won't go through these corrections here, but do note that the screen is split so that you can see the effects of the corrections before you apply them.

Color corrections and image enhancements can easily be made using the Image Corrections menu.

Downloading via Image-Editing Software

As we discussed previously, many cameras come with their own software. These imaging programs, on average, do just enough to get by. They offer color correction, resizing, cropping, and the like, but with few options. If you want to do more with your images, you need to use different image-editing software.

Adobe PhotoDeluxe is one imaging program that is written for non–photo professionals. It can handle all the basic photo imaging, and much more. I will be using Adobe PhotoDeluxe for most of my demonstrations; it is widely distributed and bundled with many cameras at no cost. In fact, PhotoDeluxe can be found on the CD that comes with this book. This will allow you to follow along with the demonstrations

and also make images on your own. Also, it works much like its big sibling, Adobe Photoshop, featuring many of the same options and features.

The TWAIN! The TWAIN!

TWAIN drivers allow software, especially image-editing programs, to communicate directly with the camera, and are distributed with many cameras and scanners by their manufacturers. The TWAIN driver is installed into your imaging software when you install your camera software onto your system. A camera that can use a TWAIN driver is called *TWAIN compliant*. TWAIN drivers are written in a universal language and can be used by most computer platforms and operating systems (OSes). You will almost always find the TWAIN access option in the **File** menu; depending on the imaging software, you need to select either **Acquire** or **Import** to download the image via the TWAIN driver (you might also have to preselect the TWAIN device). You might not even realize you are using a TWAIN driver because many are transparent to the software you are using.

The real importance of TWAIN drivers is that they enable programs such as Adobe Photoshop and PhotoDeluxe to acquire and work with images from numerous types of cameras and scanners. Otherwise, every camera system would have to come with its own dedicated software. I know that would keep a lot of programmers happy, but it would drive folks like you and me crazy!

Photoshop

It's a good idea to get used to the Adobe way of doing things, because Adobe has a major share of the imaging and illustration market. As you get more serious about imaging, which I know you will, you will find Adobe Photoshop a natural step up from PhotoDeluxe.

*Click on the **Get Photo** button to begin to open your photo.*

Before you can download images using Adobe PhotoDeluxe, you must first install it on your system. This book's companion CD has installation instructions (for Macs and Windows) that are very easy to follow. Read the instructions thoroughly before you start to install the program. As always, be sure to back up your hard drive before adding any software; you won't be sorry!

After PhotoDeluxe is installed, you can get to work downloading images:

1. In Windows 95 or 98, open PhotoDeluxe by clicking the **Start** button, choosing **Programs**, selecting **PhotoDeluxe**, and clicking **Adobe PhotoDeluxe**.

 On a Mac, double-click the **Adobe PhotoDeluxe** folder in your hard drive window, and then click the **Adobe PhotoDeluxe** icon.

2. Click the **Get Photo** menu option in the left menu box.

3. The "clue cards" open on your screen. Be sure your camera is connected to the computer and is turned on, and then click the **Get Photo** tab.

4. In the row of options, click the **Cameras** button. Note: Don't confuse this button with the **Camera** icon above it. (Just so you know, you are activating the TWAIN driver at this time.)

5. You are presented with all the TWAIN camera drivers that are installed. Select your camera from the list (in this case, I'll select the Epson camera), and click **OK**.

The clue cards are designed to ease you through the image-acquire process.

When you click on the Camera button (below the Camera icon), you are telling PhotoDeluxe which TWAIN driver to use to acquire images.

The large field of green in this image helps to accent the tiny blue flowers. This is a great example of how a tiny bit of color can be used strikingly.

Compositional tools, such as line (the pipes in the foreground), help draw the viewer's eye into the photograph.

Use color and texture to create wonderful compositions.

Each element in this photo is on its own layer. The transparency between each image is accomplished by using the Erase tool with various opacity settings. This is a wonderful example of using layers effectively.

All TWAIN Drivers Are Not Alike

Remember: All TWAIN drivers are not alike. Each manufacturer builds its drivers a little differently from the rest. It's impossible to describe how to use every driver for how every camera works!

Most drivers follow a common course of action, but don't worry if your driver does not exactly follow my demonstration. Try to find buttons that perform similar tasks, and look for patterns in button operation. Use your intuition, follow your gut, experiment, and stay calm! You won't damage your software, camera, or files.

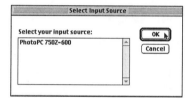

The Epson camera (PhotoPC 750Z-600) TWAIN driver is selected as the source for images.

6. Click the **Camera** icon (just above the **Camera** button you clicked in step 4).

7. The TWAIN driver activates, and leads you to the download interface. Click the **Select All** button or highlight individual images to select them, and then click the **Save to Folder** button.

8. Choose which folder you want to put the images in; you can create a new folder or use an existing one.

9. The software begins to download the images. This process takes a while; now's a good time to raid the refrigerator, visit with long-lost school chums, or put together that 10,000, piece monochromatic puzzle you've been waiting to get to.

10. When the file transfer is done, click the **Close** button to exit the download

The Download Interface

The download interface, which is specific to your camera, allows you to access many of your camera's functions, including the ability to adjust the camera's settings and defaults. Click one of the image thumbnails to see various options on the right side of the window; these options enable you to erase, view, get information on, and rotate your image, among other things.

interface and return to PhotoDeluxe. You can now open your images and begin to manipulate or improve them.

You can begin to acquire your images by clicking on individual images icons or the Select All button.

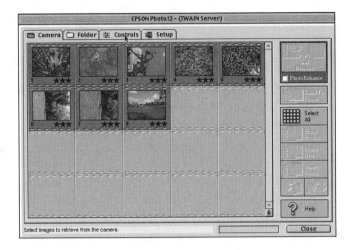

Downloading Directly from Disk

You do not have to directly download from your camera. If you have a pocket full of smart disks or compact discs, you might want to use an adapter of some sort—such as a floppy disk adapter or an external hard drive. That way, you can download images to your computer while you continue shooting with your camera. (Obviously, you need to have at least two disks to work this way.)

Many adapters are available for each type of removable storage disks. Some adapters are supplied by the camera manufacturers, and others are after-market devices. (Before you buy an adapter, be sure it will work with your system.) For this demonstration, I am using the FlashPath floppy disk adapter, which came with the Olympus 620 camera. This adapter allows you to download smart media cards via the floppy drive. Just follow these steps:

1. Follow the manufacturer's instructions to hook up the adapter. Install the adapter software driver, which is supplied with the adapter, by following the supplied instructions for your platform. In this example, the software driver is named *Read FlashPath*—simple and descriptive!

2. Open and start the software (click the **Start** button, choose **Programs**, and find the software in the list).

3. Open the **File** menu and choose **Import from FlashPath**.

4. You are asked to insert the adapter into your drive. Be sure the media card has been inserted in the adapter, and then insert the adapter into the drive.

Insert the FlashPath into your floppy drive when prompted to by the software driver, not before!

5. A screen appears that shows the name of your FlashPath card. (Don't be confused by a goofy filename that you don't recognize. The disk names are assigned during the disk-formatting process; you might or might not have a choice in naming the disks.) Click **Open**.

The FlashPath card might display a goofy name (which was assigned by the software). Don't worry about it here, just roll with it.

6. You should see a directory of all the image files on your card. If you want to select just one (or a few) file(s), select the image(s) and then click **Open**. Otherwise, click the **All Files** button.

All the images on your disk are shown on the directory at this point. Notice that they are all in the JPEG (JPG) format.

7. You are asked where you want to store the files on your hard drive; you can select an existing folder or create a new one. After you select your destination, click the **Select "FlashPath"** button.

I've selected the FlashPath folder to store my images. You could choose a different folder if you want.

8. The downloading process begins. Depending on how many files there are, you might want to find something to do to keep yourself entertained.

9. When the download is finished, the floppy adapter ejects. Go to the location on your hard drive and verify that your files are where you expect them to be. Congratulations!

Downloading from a Photo CD

Photo labs are now offering services that scan the negatives of the film you have sent in to be developed. They return your prints (hopefully) along with a CD with the images scanned on it. Images are also supplied on CDs by "stock houses." These disks have many images on them—usually there is a theme to the disk, such as "water" or "great skies." These stock photos can be used for backgrounds or elements in your shots—for example, if you went on vacation and the weather was terrible, you could paste in a great sky with puffy clouds into your shot. Only you will know the truth...!

Copyright Laws

Be careful concerning what you copy and where you get your images. If the image is not yours, it belongs to someone else! U.S. copyright laws are strict about people using someone else's images without their permission—and the penalties can be substantial.

As a rule, you can always take images and fool around with them for your own enjoyment. However, as soon as you publish an image featuring someone else's photo (or part of a photo), you have violated copyright law. Distributing a printed image or posting it on a Web site constitutes publication. (Okay, you can print out an image for your own enjoyment, and even show it to a few friends, but don't distribute it! To be safe, don't let it out of your hands.)

If you purchase a CD with images on it, read the *usage* rights. Find out how many times you can use the image, where you can use it, and for how long. Many CDs you can purchase grant unlimited usage.

With the Photo CD format, images are stored on the disk in various resolutions; when you choose which image you want, you are prompted as to which resolution you need. The benefits to this are twofold:

➤ You won't be taking up more room than you need to store images on your hard drive. This saves download time and the need to resize the image.

➤ Each image has been optimized for sharpness and size. You don't have to resize a larger image and then start the process of sharpening it and adjusting color and contrast.

In this demo, I'll use PhotoDeluxe to open images on a Photo CD. Follow these steps:

1. Insert a CD that holds images in the Photo CD format. (To help determine whether the images are being stored in this format, look for the Photo CD logo—it actually says "Photo CD" on it—on the disk label or CD case.)

2. Open PhotoDeluxe (refer to the section in this chapter titled "Downloading via Image-Editing Software" if you need help opening this program).

3. Click the **Get Photo** menu option in the left menu box.

To begin opening an image from a photo CD, start with the Get Photo menu option.

4. The "clue cards" open up on your screen. Be sure your camera is turned on and connected to the computer, and then click the **Get Photo** tab.

5. The tab expands, showing all the different ways to open files. Click the **Disc-CD** button, which is below the **Disc-CD** icon.

Click on the Get Photo clue card to continue the process of getting the CD image.

6. You are presented with a screen showing many different types of file formats. Scroll down until you find the **Kodak Digital Science Photo CD** option. Click to **select** it, and then click **OK**.

Choose the Kodak Digital Science file format to open up the CD's directory.

7. Click the **Disc-CD icon** (above the **Disc-CD** button that you clicked in step 5).

8. In the Open screen, highlight the **Photos** folder (not the **Photo_CD** folder) and click **Open**.

Highlight the Photos folder, not the Photo CD folder, and click Open to continue the process.

9. Select the resolution you want the image to have, and click **Open**. Remember: Don't be greedy! Use only as much resolution as you need.

This menu will allow you to choose the file size you need.

10. The next screen lists all the images on the CD. With a little luck, you might even see a small thumbnail image on the left side. Click an image in the list to select it, and then click **Open**.

When you find the file you want, highlight it and then click Open.

11. Your image opens on the PhotoDeluxe screen.

The process is now complete; your image is ready!

199

12. Save the image before working on it; if you don't and goof it up, you'll have to start the entire process over.

Just to be sure, save your image before you begin to work on it.

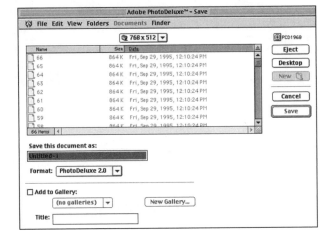

The Least You Need to Know

➤ You can download your images by using the software supplied by the camera manufacturer.

➤ You can also download your images by using a TWAIN driver and your imaging software.

➤ Your can transfer images from a Photo CD by using your imaging software.

Improving Your Images

In This Chapter

➤ Shape your image

➤ Understand brightness and contrast

➤ Use image color controls

➤ Learn about color modes

➤ Discover bit depth

➤ Control image sharpness, blur, and noise

One of the most important reasons to shoot pictures with a digital camera is the control it can give you over your images. You no longer have to settle for poor-quality photographs! With the use of imaging software, you can control and manipulate the color, contrast, size, and even the sharpness of your image.

Getting Started...

Before you get down to the business of improving your images, you should, of course, start PhotoDeluxe (refer to Chapter 12, "Go Get It: Downloading Your Images," if you're not sure how), and use the **Get Photo** menu to open the file `Phlox.tif` (included on the CD-ROM that accompanies this book). Also, you'll find it helpful if you make the menu bar visible before you continue. The **Long Menu** will list all of the PhotoDeluxe functions, such as Size, Tools, Orientation and so on, along the top of the screen. Having these functions listed above the image will let you access your tools and functions quickly. To make the **Long Menu** visible, open the **File** menu, choose **Preferences**, and select **Long Menu**. A menu bar should appear across the top of your screen, as shown here.

Untitled

You might have noticed that when you open images from the demo disk or your camera with PhotoDeluxe, they open with the name `Untitled.pdd`. Why?

Like other computer programs, PhotoDeluxe works more efficiently when the files it edits on are in its own *native* or *proprietary* format (in the case of PhotoDeluxe, that format is PDD). So when PhotoDeluxe opens a file in another format, such as TIFF or JPEG, it first makes a copy of the file, called `Untitled`, in the PDD format. The original file remains untouched, and any changes you apply from here on out do not affect the original.

After you apply a few effects to the image, you should save the file—but be sure you don't save it with the same name as your original file, or you will copy over it. If you plan to work on your file during another session, leave it in the PDD format (this is because the PDD format might or might not be readable by other programs). If you plan to store or open the image file in another program, save the file in a nonproprietary format, such as TIFF. (If you want to archive the image, you can choose a high-value JPEG or compress the file in WinZip or Stufflt.)

Note that instead of using the **Save As** command to save your image in a different file format, PhotoDeluxe requires you to *export* the image into the new format. To do so, open the **File** menu, choose **Send To** (or **Export**, depending on your version of PhotoDeluxe), and select **File Format**. A dialog box appears that enables you to name the file and save it in almost any format you can dream of.

Top Menu Bar Zoom Up Type Tool

Zoom Tool Undo Button Icon Menu Bar

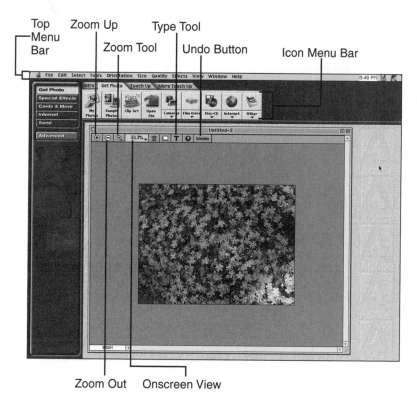

The menu bar appears at the top of the screen in the image frame.

Zoom Out Onscreen View

PhotoDeluxe

The explanations and demonstrations in this chapter continue to focus on the use of Adobe PhotoDeluxe. Adobe PhotoDeluxe is by no means the only photo-imaging software, but it is popular, easy to use, and distributed with many cameras.

Mac Versus Windows

In many instances, PhotoDeluxe's menus and controls are the same for Macintosh and Windows platforms. Note, however, that in certain instances, Macs use different keys from Windows to perform certain tasks. For example, Windows uses the **Ctrl** key and Macs use the **Command** key. Similarly, the **Enter** key on the PC keyboard performs the same function as the Mac's **Return** key.

Shaping Your Image

You can, within reason, increase the size of your images. If you resize too much, the image will start to degrade. In most cases, you can increase the size of your image 150%-200% and still retain good detail.

But why would you want to enlarge your image? Suppose you took a picture and just couldn't get close enough. Or you took a photo and you cropped the image down to make a nice composition. You can then take the image and increase the size so you can see the detail. Another good reason to increase the size of your images might be to use all those 8×10 frames your friends keep bringing over to the house (hint, hint!).

There are a few ways to resize your images, which we'll discuss as follows. The important thing to remember, and this is a constant through PhotoDeluxe, is that there are many ways to obtain the same results. You can resize your image and change the proportions of the image (Free Resize) or resize the image and keep the proportions frozen (Resize). Choose your options and have fun. If you save your images before you start a resize operation, you can have fun and experiment without worry.

Free Resize

The Free Resize feature allows you to resize an image and change its proportions at the same time.

To use the Free Resize feature, do the following:

1. Open the **Size** menu and choose **Free Resize**.
2. Small corner markers, or *handles*, appear in the corners and at the midpoint of the sides of your image.
3. When you move your cursor over these handles, the cursor changes into a *double arrow*. Drag the cursor, and the image handles follow.
4. Release the mouse button; the image's size and proportions are altered.

Change Your Mind?

If you've selected a feature that involves handles, such as Free Resize, but you do not want to continue, just press **Enter** or **Return**. The handles disappear, and you are back where you started.

Resize

The Resize feature (which you activate by opening the **Size** menu and choosing **Resize**) works similarly to the **Free Resize** command except for one important aspect: You cannot change the proportions of the image. You can make your image larger or smaller, but you cannot change its shape.

The Downside...

Anytime you make a change to an image in PhotoDeluxe (or just about any other pixel-based, image-processing program), you are *remapping* the pixels in the image. That is, you are changing the position (or color, or whatever) of the pixels. Each time the pixels are remapped, your software is interpolating where the pixels should go and what their values should be. Repeatedly remapping the pixels in an image can make the image look, well, terrible!

One way to avoid ending up with terrible images is to always work on a *copy* of the original image instead of the original itself. That way, if things fall apart, you can always cut your losses and start over with a new copy. Secondly, learn to use the **Undo** button (or its keyboard shortcut, **Ctrl+Z** on a PC or **Command+Z** on a Mac). Using this button enables you to *undo* your most recent change to the image. Note, however, that you can undo only the most recent change—if you make two mistakes in a row, you can undo only the second one. Finally, if you like the changes you've made to your image, save the image before you make a mistake! That way, you won't have to start all over if you mess up or do something you don't like. Remember: Save early and often!

When It Has to Be Bigger!

This you'll like. If you want to make your image larger than what you can see on the screen, you are in luck. I often get frustrated when working on a small monitor and want to make the image bigger but run out of monitor real estate. It is tough to drag the resize handle when you bump up against the edges of the monitor. Here is a good solution: Reduce the size of your image on the screen by reducing the pixel-to-screen ratio. You will find that ratio on the menu bar that is attached to the top of the photo "frame." For example, instead of seeing your image at 50%, reduce it to 25% or smaller and you will have more screen area to work with. Go ahead and resize your image until it looks good to you. You can then increase the pixel-to screen-ratio to see your detail.

Photo Size

As you can see in the following figure, there is an even more exact way to resize a photo. With the Photo Size feature, you can resize an image to exactly the size you want. The Photo Size feature is at the bottom of the **Size** drop-down menu. You will get a submenu in which you will be presented with your options.

Notice that, when the **Proportions** check box in the **Constrain** area is checked, you can resize your image but cannot change its proportions (notice also that the Width and Height entries are tied together). If you check the **Image Size** check box in the **Constrain** area, the **Resolution** field is also tied in—meaning that when you change the dimensions of the image, the resolution (dpi) increases or decreases accordingly (the file size doesn't change).

Use the Photo Size dialog box to get precise image dimensions.

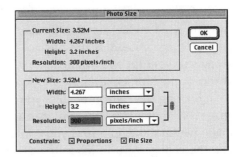

Canvas Size

If you need to add more area to your image, use the Canvas Size feature, which is much more precise than using the Free Resize or cropping tool. To use this feature, open the **Size** menu and choose **Canvas Size**. You will see a dialog box such as the one shown here. The square in the center represents your image as it exists now; type in new dimensions to increase the area consumed by your image. If you need to add area only to one side or just to the top or bottom of your image, this is the place to do it. Place your cursor on the gray square in the middle of the **Placement** area and drag the square to one side or the other. When you add canvas area after adjusting the **Placement** grid, the new canvas is added to the side, top, or bottom, depending on your choice.

The Canvas Size dialog box can also be used to reduce the canvas area of an image. If you need to make your image a precise size, type those dimensions into the dimension fields. The image is equally trimmed on all sides. If you want to trim your image on one side only, you can move the square in the **Placement** area accordingly. Type your dimensions in the fields as before, and click **OK**. You are warned that the canvas size is smaller than your image; if you're sure you want to proceed, click **Proceed** and the resize takes place.

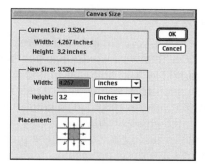

The Canvas Size dialog box lets you add image area to your photo.

Orientation

If you take an image with your camera in the vertical position, your image opens on its side. To rotate your image, open the **File** menu, choose **Orientation**, and select **Rotate** (**Right** or **Left**).

You can also flip an image along its axis by choosing **Flip Horizontal** or **Flip Vertical**. This concept has always confused me, so let me try to explain: Imagine an axis drawn though the image from right to left and top to bottom. When you flip an image horizontally, the image flips at the midpoint of the horizontal axis; flipping vertically works the same way except that it flips at the midpoint of the vertical axis. The best way to see what will happen is to open an image and experiment.

If you need to tweak your image just a bit to straighten it up, or you want to rotate it other than 90°, choose **Free Rotate** from the **Orientation** menu. Handles appear in the corners of the image. Using your cursor to drag and drop these handles, you can freely rotate the image any way you want. By the way, if you land your cursor inside the image or grab one of the handles on the edge of the image, you can move the image as if you were using the Free Resize tool. This comes in handy if you need to resize *and* rotate an image.

The Time Machine

I feel that I must warn you that the resize and rotate operations are very math intensive and take up a lot of computing time. To help speed things along, your CPU will transfer parts of your image to RAM while it chugs away. If you do not have a lot of RAM, you will notice that it will take a lot of time for these operations to be completed. You might make use of the time by getting on the phone and ordering more RAM from your computer vendor, or you can take a walk around the block a few times! If you know you will be waiting for your computer to resize an image, start the operation just before dinner and go enjoy your meal.

Use Undo

If you don't like where the image ends up, press **Ctrl + Z** (Windows) or **Command + Z** (Mac) instead of reapplying an orientation using the rotate handles. If you use the handles to nudge the image back and forth, you will tear up the image.

Trim

Many times, your image might size out to be just a bit wider than you would like. For example, it might be 5×7 1/2; and that might be a bit tough to shoehorn into a 5×7 picture frame. You also might find that just on the edge of your image is some unwanted element, like a part of someone's head or a wall. Trimming the edge of the photo is a great way to solve these problems.

To reshape or crop your image, do the following:

1. Open the **Size** menu and choose **Trim**.
2. Click the upper-left portion of your image, hold down the mouse button, and drag the cursor diagonally across the image to generate a cropping box.
3. Release your mouse button; a crosshair icon appears.
4. You can resize or change the shape of the crop box by grabbing one of the corner handles and moving it (the cursor changes into a double arrow).
5. When the crop box is the right size and in the right position, release the corner handle. Your cursor changes back into the crosshair.
6. Click your mouse button. Voilà! The crop is complete. If you don't like the crop, click the **Undo** button.

Perspective

The Perspective feature is a great tool to fix up images that have ungainly or incorrect perspectives. For example, if you photograph a tall building, the top of the building will look a lot smaller than the bottom. Also, the sides of the building will slope in toward the top. This is called *keystoning*. The Perspective feature can help you fix or control this effect.

The Perspective feature is found in the Size menu because it is a form of resizing. You are actually resizing the top of the image while the base stays "anchored." You will notice that, if you were to pull the left-side perspective handle, the right-side handle will mirror the action (and vice versa). Check out the following demo to get a good idea of how this operation works.

To use PhotoDeluxe's Perspective feature, do the following (I recommend using the **Tower.tif** file I've supplied on the CD-ROM to garner a better understanding of this tool):

1. Open the file **Tower.tif** from the CD-ROM accompanying this book.

2. Save the file as **Tower.wrk** (**File, Save As**). Even though this image is on the CD-ROM and you can't overwrite it, it is a good practice to save your image, with a slightly different name, to protect the original.

3. Open the **Size** menu and choose **Perspective**.

4. Handles appear in the corners of the image. Reduce the onscreen view so that the image appears smaller on your screen by pulling down the View percentage menu that is attached to the top of your image frame.

5. Grab the handle in the upper-right corner and pull it toward the right (see the following figure). You can pull the handles onto the unused portion of the PhotoDeluxe desktop.

Create an In Progress Folder

You might want to create a folder on your hard disk to keep all of your demo images or works in progress. I usually create a folder and name it **In Progress** for this purpose.

The Perspective feature helps build strong towers!

6. Release your mouse button. After a moment, the image's perspective is altered; in this case, the building looks shorter, but straightened up.

7. Undo your change; try pulling the handles again, but this time pull to the right and up. (You might have to go through this a few times until you find the correction effect you like.)

Congratulations! You just made a perspective correction normally accomplished by an expensive view camera!

Distort

Using PhotoDeluxe's Distort feature is a great way to correct an image that might not have been photographed "in square." If your camera were not perpendicular to a building or a product package, for example, one side of the building or box would slope toward the top more than the other. This can make an image look a bit strange. You can also use this technique to correct the perspective more to one side of the image than to the other side. Additionally, you can fill in with a color tone the whitespace that is created when you distort your image, or you can clone in some of the sky from the original image. (Usually, you end up cropping a portion of the newly distorted image and pasting it into another image; more about all that later on.)

Again, this feature is found in the Resize menu as it is a form of resizing. Think of it as resizing one side of the image more than the other.

To use PhotoDeluxe's Distort feature, do the following (I recommend using the **Tower.wrk** image from the preceding section to garner a better understanding of this tool):

1. While you have the **Tower.wrk** image open, open the **File** menu and choose **Distort**.

2. You will see the now-familiar handles. Grab the handle in the upper-left corner and pull it halfway down and toward the center of the image.

3. Grab the handle in the lower-left corner, and pull it halfway up and toward the center of the image.

4. Let the image process, and voilà! It is distorted.

The Distortion feature lets you get carried away.

From Darkness to Light

Many times, your images might not come out exactly as you intended. They may come out a bit too dark or flat-looking (lacking contrast). The following features are the perfect tools to help fix up your images and make them sparkle.

Instant Fix

Using the Instant Fix feature is a quick-and-easy way to correct the contrast and brightness of your image. It's not perfect, but it can get you a good part of the way there if you are in a hurry. To use this feature, do the following (I recommend using the **Phlox.tif** file I've supplied on the CD-ROM to gain a better understanding of this tool):

1. Open the file **Phlox.tif** from the CD-ROM accompanying this book.
2. Open the **Quality** menu and choose **Instant Fix**.
3. Watch carefully; you will see the image brighten a bit, and its contrast will change.

Wasn't that easy? Open up a few more images, either yours or mine, and try this a few more times to get the hang of it.

211

Brightness/Contrast

Notice the white flowers in the lower-right corner of the **Phlox.tif** image you corrected in the preceding task. Instant Fix saw these flowers and automatically brightened them to *absolute white*, which is the point in an image where there is no ink on the page—only paper shows. If you want the flowers (or anything else in the image) to be brighter or darker, you can use PhotoDeluxe's Brightness/Contrast option:

1. Open the **Quality** menu and choose **Brightness/Contrast** to view the **Brightness/Contrast** dialog box as shown here.

Brightness and contrast are the first tools to use to fix up your image quality.

Move the Dialog Box

Many times, the dialog box you need to use displays on the screen on top of your image, covering up a section of the image you want to see. To move it, click the dialog box's title bar, hold down the mouse button, and drag the dialog box anywhere on the screen you want.

2. Be sure the **Preview** check box is checked; that way, you'll be able to view your changes onscreen as you make them—without having to alter your image by actually applying them.

3. Drag the **Brightness** slider to the right until the field to the right of the slider reads **+30**. (Alternatively, you can type **30** in the number field to avoid using the slider.) The image brightens up nicely.

4. Drag the **Contrast** slider to the right to increase the contrast; the image becomes a little more "zippy" (again, you can type in the number field to avoid using the slider).

5. When you're satisfied with the image, click **OK**.

Viva Color!

As important as brightness and contrast are to your image's quality, color controls can help you make your image really come to life. You can make minor corrections or huge shifts. Follow your "inner eye" and enjoy!

Color Balance

There might be times when the color of your image is off a bit. For example, something might be reflecting color into your photograph (a brightly colored wall will add a *color cast* into your shot). If you refer back to the color temperature chart in Chapter 9, "Lighting: It Makes or Breaks a Shot!", (Figure 9.3), you can see that the lighting conditions also affect the true color of the image. Luckily, you're in control! You can easily adjust the color balance of your image:

1. Open the `Phlox.tif` image again (refer to the preceding two tasks if you're not sure which image this is).

2. Open the **Quality** menu and choose **Color Balance** to view a dialog box such as the one shown here.

3. Be sure the **Preview** check box is checked.

4. Three sliders control the color. If you move the sliders (one at a time, please, until you get the hang of it), the color in the image shifts respectively. For this demonstration, I have moved the **Yellow/Blue** slider toward blue to add a little more color to the flowers. I've also added a little green to the leaves by moving the **Magenta/Green** slider toward green.

Getting Tools to Work Together

After you have read Chapter 14, "Eeney, Meeny, Miney, Mo: Selections," come back to this demonstration. Isolate the white flower, and repeat the steps. You will begin to see how many of the tools in PhotoDeluxe can be used together.

Shortcut Keystrokes

Many dialog boxes, such as the **Brightness/Contrast** dialog box, have a **Cancel** button. When you click this button, the dialog box disappears and no changes take place. To start your correction over or to try another variation without going through the trouble of reopening the dialog box, press the **Alt** (**Option** on a Macintosh) key. The **Cancel** button changes into a **Reset** button. Click the **Reset** button to reset all the sliders to their original starting points.

213

Good color makes for a great image.

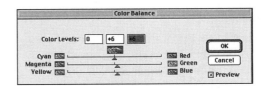

5. When you're satisfied with the image, click **OK**.

Hue/Saturation and Lightness

Hue (sometimes referred to as color) refers to *where* a color appears on those color triangles I showed you in Chapter 2. Saturation, on the other hand, refers to *how much* of a hue or color is present, or how intense a color is. Both the hue and saturation of an image can be manipulated, as can the lightness of an image:

1. With the **Phlox.tif** image open on your desktop, open the **Correction** menu and choose **Hue/Saturation** to open the Hue/Saturation dialog box shown here.

2. Be sure the **Preview** check box is checked.

3. Move the **Hue** slider either to the left or the right. Notice how the hue (color) of the image changes? If you move the slider a bit to the right, you change the hue of the flower petals from blue to pink. Check out how the other parts of the image change hue, also—you'll be able to avoid altering the hue of your entire image after you finish reading Chapter 14, "Eeney, Meeny, Miney, Mo: Selections," so don't fret.

4. Fiddle with the **Saturation** slider (if you really want to have some fun, slide it all the way to the right). If an image has been captured with diffused (soft) light, "upping" the saturation can liven it up.

Opposite Colors

Changing one color affects its opposite color (refer to the color chart in Chapter 2, "Pixel, Pixel, Little Star, How I Wonder What You Are!," to refresh your memory about color opposites). Adding more blue to an image is the same thing as taking yellow out of the image. Similarly, taking magenta out of an image is the same as adding more green.

Global Changes

Color shifts must be done carefully. Don't overcorrect your image. Unless you isolate areas in your image by selecting them (covered in the next chapter), your color correction *globally* affects your image. Although having wonderfully green leaves is great, do you really want to add green to all the other colors?

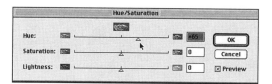

Good color saturation makes your images come to life—but don't go crazy!

5. Play around with the **Lightness** slider; notice that doing so produces an effect similar to adding white to the entire image (or black, if you move the slider to the left). Note that adding lightness adversely affects the contrast of your image, which is probably why I honestly can't remember using the **Lightness** feature more than once or twice in my entire career. Nonetheless, check the control out and put it in the bottom of your bag of tricks.

Oversaturation Woes

Be careful not to oversaturate an image. When an image is oversaturated, it might lose detail. And although a very saturated image might look great onscreen, you might have a difficult time printing it.

Variations

The Variations feature is a great tool to use when you first start out imaging. It is a quick, but crude, way to apply a variety of color corrections and hue/saturation mixes to an image. (With a little practice, however, you should be able to correct an image more quickly and precisely using the tools we discussed previously instead of with this one.) Here's what you do:

1. With the image that you want to correct on your desktop, open the **Quality** menu and choose **Variations** to open a screen with multiple small views of the image, as shown here.

2. Click the variation you like best; PhotoDeluxe moves the image you chose to the center spot, and generates even more variations based on the image you chose (the images in this round have finer changes and smaller variations in relation to one another). Continue choosing variations until you either go crazy or find one you like.

3. When you find the variation that you want to use, click **OK**. Your image will appear as your selection.

The Variations feature is useful if you have little time to correct an image, but you have to know when to stop!

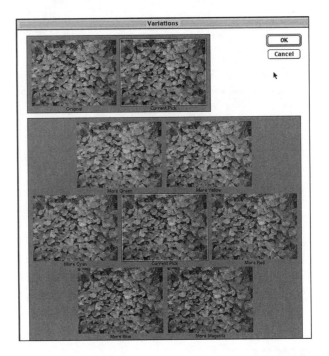

Negative

Open the **Effects** menu and choose **Negative** to invert your image to make it look like a photo negative. I use this control a lot in my commercial work to add interest, especially in faded backgrounds. You might consider this tool a gadget!

Other Color Worlds

Color can be described in many ways; one way to characterize color is to call it a *mode* (not *à la mode*). The most common color mode is the RGB (red-green-blue), which is the only mode PhotoDeluxe can use to handle images. Other commercial imaging programs, such as Photoshop, can handle color in various other modes—such as CMYK, LAB, HSB, grayscale, and index color—which allow the color to be manipulated or printed in different ways.

RGB

RGB is the most commonly found color world, or *color space*. We use this model because these are the colors our eyes and brain see and process. When you look around, these are the *spectra* of light commonly found—for example, you typically find blue skies, green leaves, and red berries. If there is no light—such as at night—you see no color; it is only when you add light, such as at dawn, that color becomes visible. This color model uses a process called *additive color*. (There

is no color unless it is added.) Your computer monitor works using this process—it starts out with a dark screen until light, provided by glowing phosphors, gives the screen color.

Under this model, colors in a spectrum change from one hue to another (you are probably familiar with color gradually shifting from red to orange to yellow to green, and so on around the color spectrum). Different combinations of red, green, and blue produce different colors. For example, you can combine red and blue, without green, to get purple. When red, green, and blue light combine at their fullest, white light is produced.

Entering a New Dimension...

This way of describing color is linear, or one-dimensional. When you add brightness or *tone* to a hue, however, you bring your color into a dimensional space! For example, imagine the color red placed on the base of this space—call this the X-axis. If you add white, or light, to red, it becomes pink; the pink, or brightness, can be described as being on the Y-axis (this axis can be thought of as vertical, if you want). If you move or blend colors and brightness, you will be moving along a lateral, or Z-axis.

This is not intended to be a technical explanation of color theory, but rather to show you the dimensionality of color. Many color models use spheres, pyramids, or cubes to describe the color space. (And you thought you would never use all that high school algebra!)

CMYK

If you start out with a nice bright piece of white paper, it is as if you are starting with totally *on* or fully reflecting light. You cannot add any more light or color to a piece of paper that is white. You can, however, cover up, or *subtract* from, the paper to produce color. This process is called *subtractive color*, and is used by the CMYK color model. With the CMYK model, which is used in color printing, cyan, magenta, yellow, and black are used in separate layers to produce color on a press.

You will notice this if you refer to the color model in Chapter 2, "Pixel, Pixel, Little Star, How I Wonder What You Are." It's of a Three-Color World (RGB) in which cyan, magenta, and yellow are opposite red, green, and blue, respectively. You also saw these colors interact in the color adjustment controls. Although cyan, magenta, and

yellow *are* primary colors, they do not produce black when added together (remember, *black* is the absence of all color). It is only when black (*K*) is added to the CMY model that you can reproduce black and darken other colors.

When you print an RGB image, your image is *separated* into CMYK on-the-fly. Depending on your setup, this might be done by the image-processing software or by the printer itself.

Running the Gamut

The *gamut* of a color world refers to how many colors the color world or device representing that world can reproduce. The RGB color world has a broad color gamut; if, however, you were to reproduce the image on your screen using a CMYK device, you would probably be disappointed by how many colors cannot be reproduced. The color gamut of the CMYK model and CMYK devices is much smaller than for an RGB device. I will get into this in more detail when we talk about printing in Part 5, "Output."

LAB

Both the RGB and CMYK models are based on how much light or ink it takes to produce a color on a specific device. On one type of printer, you might need 75% cyan, 50% magenta, 25% yellow, and 75% black to reproduce a color. On another printer, you might need 77% cyan, 48% magenta, 25% yellow, and 75% black to produce the same color. Different printers and different papers react in different ways to produce the same color. The same can be said of additive color devices; this is why, when given the same input information, monitors display the same image differently.

LAB color is a descriptive model based on a consistent set of references. In other words, the LAB color space takes the color-reproducing device (monitor or printer) out of the color equation. If the color can be described independently of the reproduction device, the consistency of the color can be preserved.

In the LAB color model, all the lightness, or detail, of the model is contained on the L (lightness) layer. If you were to look at this layer, it would look somewhat like a black-and-white image. The A and B layers contain the color information; the A layer describes the colors in a range from green to red, and the blue to yellow information is contained in the B layer.

HSB

The HSB model describes color based on hue (the wavelength, or color), saturation (how much of the color is present), and brightness (how much light is present). This might be familiar to you from the Hue/Saturation dialog box.

Grayscale

The grayscale color mode uses shades of gray, from black to white, to represent color. You should be familiar with this color mode, because it represents all black-and-white reproduced images. Your imaging software determines which colors are represented by which shade of gray.

What Is Bit Depth?

How Deep Is My Bit Depth?

Your computer presents information in binary digits or bits. Binary code presents data in ones and zeros, or off and on. Color can also be presented as binary information, with black an off bit and white an on bit. The bit depth I just described is one bit deep (you are dealing with only one bit, either off or on); in binary, this is represented as two to the first power.

Let's expand your color world and use two bits. You can describe each bit as being either off or on, representing four colors; that makes your bit depth two deep, or two to the second power. Each time you increase your bit depth (which increases exponentially), you double the number of available colors. Take a look at Table 13.1 to get an idea how increased bit depth enables you to reproduce color.

Table 13.1
Bit Depth and the Number of Available Colors

Bit Depth	Binary	Number of Colors
1	2^1	2
2	2^2	4
3	2^3	8
4	2^4	16
5	2^5	32
6	2^6	64
7	2^7	128
8	2^8	256
16	2^{16}	32,768 (enough?)
24	2^{24}	16,777,216 (so they say)
32	2^{32}	Billions and billions!

Remember that your camera or scanner, both of which are RGB devices, can capture color information on all three layers. If your camera is capable of 8-bit color per channel, it can reproduce 24 bits of color for each pixel (eight bits of information from each of three layers of RGB color). In Table 13.1, you see that your camera can describe over 16,000,000 colors. That's rich!

You might see a camera or scanner described as being able to capture color in 12-, 14-, or even 16-bit color. This is wonderful, except you have one small problem: Your printing device can reproduce color only in 8-bits-per-channel color. So, what good are all those extra bits? What do you do with all the leftovers—sweep them under the rug, or feed them to the dog?

Because you have all this additional capacity for color information, you can capture and carry a lot more image detail. Instead of having an image that has no information in it in an 8-bit color image, you carry a lot more information in the same area if it is captured in 12- or 16-bit color. To simplify the explanation, you can choose which of those extra bits you want to use when you reduce your image to 8-bit—this is done when you adjust for brightness and contrast. If you were able to view an 8-bit and 12-bit image side by side on your monitor, you would notice much more detail and color resolution in the 12-bit image. You would also be able to make much finer changes in the color, contrast, and brightness, as you'll learn to do next.

Index Color

Index color is not really a color mode, but it is a way of reproducing color. To reduce the amount of color in an image, colors can be indexed or remapped. (You might want to reduce the amount of colors to reduce the size of a file. This comes in handy when you want to place an image on a Web site, where the size of an image is crucial to its speed of transmission.)

To remap an image, a specific *palette* of colors is used. Let's say your palette has five colors of blue in it, but your image has 20. You can remap, or *index*, the first four blue colors in your image to the first blue color on your palette, and can continue to index all the remaining blue colors in the image in a similar manner. If you are crafty in how you pick the colors, the indexed image will look very close to the original image. Typically, an indexed file has 256 colors. (You can index a file with a smaller palette, but it will start to look funky.) Again, this comes in handy when delivering images via a Web site—especially animations—because the file sizes are significantly smaller.

On Oversharpening...

Try to avoid oversharpening your image—otherwise, it will look forced or overworked. It is better to leave an image a tad undersharpened than to take it too far. Of course, because all the sharpening filters affect the contrast of an image, you might do well to keep this in mind when adjusting your contrast as well (note: avoid applying any sharpening filters before making contrast adjustments).

A Sharper Image

You can vastly improve an image by sharpening it. Many times, a tweak to the image's sharpness helps overcome any inadequacies in a cameras lens or chip, or any incorrect focusing.

Take a look at an image that is out of focus, and compare it to one that is in focus. The in-focus image has more contrast. This is the key to PhotoDeluxe's Sharpening tool. When the sharpening filter is used, it creates the effect of increased contrast by creating a border between dark and light areas of the image. On the dark side of the border (I can't resist a *Star Wars* pun here), the pixels are darkened slightly, creating an edge. On the lighter side of the same border, the pixels are lightened a bit. This also creates an edge. The visual effect of this double edge is the illusion of contrast or sharpness; your eye is fooled into thinking the image is sharp.

Sharpen

To sharpen an image, open the **Quality** menu and choose **Sharpen** (alternatively, open the **Effects** menu, choose **Sharpen**, and select **Sharpen** again). You have no control over this filter; no dialog box appears. It does its thing, and it's all over. Note: You might want to undo and reapply the filter a few times so that you can see just how much sharpening has been done (it won't be much).

Sharpen More

> ### He Who Sharpens Last Sharpens Best
>
> Sharpening is always affected by the size of an image. If you plan to increase the size of your image, do so before applying any sharpening filters. Sharpening is always the last thing I do before I change a file from RGB to CMYK in preparation to print.

I bet you can't figure out what this filter does! This filter (open the **Effects** menu, choose **Sharpen**, and select **Sharpen More**) increases the contrast of the edges at the borders (again, you have no control over the degree of the sharpening effect; simply apply it and see what happens). This yields a sharper effect than just plain old Sharpen. (You guessed right!) Depending on your image, applying **Sharpen** twice might give the same effect as **Sharpen More**. If you're curious, try it out.

Sharpen Edges

Sharpen Edges (open the **Effects** menu, choose **Sharpen**, and select **Sharpen Edges**) looks at the border areas and applies the Sharpen filter only in areas that have a good deal of contrast. This filter is a bit more selective than the previous two, but you still do not have any control over the degree of the effect.

Unsharp Mask

You might think this is another one of my silly jokes, but I promise you that the Unsharp Mask (USM) filter is for real—and is very useful. USM acts like a combination of Sharpen, Sharpen More, and Sharpen Edges. This is the only sharpening filter over which you have any control, and the control you have is *very* powerful.

> ### Crunchies
>
> We professional types call the visible edges between the contrast areas *crunchies*; they look almost like the pixels have been piled up along the edges. I confess—I use USM almost all the time to sharpen my images. It offers the most control, and leaves little to no *crunchies* in the image.

To use this filter, do the following (I recommend using the image named **Greens.tif** on the CD-ROM that comes with this book, just for the sake of example):

1. Open the **Effects** menu, choose **Sharpen**, and select **Unsharp Mask**. You should see a dialog box such as the one shown here.

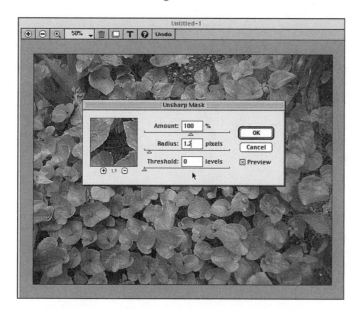

Unsharp mask gives you very sharp control.

2. Be sure the **Preview** check box is checked.

3. The **Amount** field determines how much contrast there is at the borders between the dark and light areas. The higher the value in the **Amount** field, the more contrast. This creates the major part of the sharpening effect.

4. The **Radius** field determines the number of pixels (or how far or wide from the border) to which the contrast is applied. This affects the width of the edge. A low (less than 1) radius lessens the effect of the **Amount** field.

5. The **Threshold** field describes how much contrast must be present in the areas between the borders before the sharpening will be applied. If a zero (0) value is present (or no difference in contrast), the sharpening always takes effect. If a value of 5 is found, there must be five *levels* of contrast present before the sharpening can occur. Think of the levels as a ratio of contrast between the pixels, such as a contrast of 1:2 or 1:5.

6. The small preview box on the left side of the dialog box shows you what the filter will look like on the image if applied. Notice that you can zoom into the image to get a better look at what you are doing by clicking the plus and minus buttons below the preview.

7. When you are satisfied with the effect, click **OK**.

In Table 13.2, I've given you some starting points for the settings to use with the USM filter. Remember, these are starting points, and this is not a "one-size-fits-all" filter. Different type of images with different contrast ranges and subject matters require varied USM settings. Experiment and check out your results.

Table 13.2 Suggested Starting Values for the Unsharp Mask Filter

Amount (%)	Radius (Pixels)	Threshold (Levels)
50	.7	0
75	.8-1	0
100	1-1.1	0
125	1.1-1.2	0
150	1.2	0
175	1.3	0
200	1.5	1
200+	It doesn't matter—you're oversharpening! Try applying 125 twice.	

File Size

A larger file can stand much more USM than a small file before any ill effects are visible.

It is difficult to say which filter to use on your image; all will work. USM works very well, but it takes some time, and a few rounds of experimenting to figure out the settings. Usually, a shot or two of plain old **Sharpen** works fine.

It's All a Blur

Blur filters are frequently used for correcting selected areas of an image. They can be used to correct stair-stepping at the edges of an image or to dissipate noise. It is interesting that PhotoDeluxe does not put these filters under the **Quality** menu.

Blur

To apply the Blur filter, open the **Effects** menu and choose **Blur.** Just like the Sharpen filter, the Blur filter offers no control over how much the image is blurred. When you apply it, the image appears to soften slightly.

Blur More

To apply the Blur More filter, open the **Effects** menu and choose **Blur More**. Not surprisingly, applying this filter renders a stronger effect than simply applying the Blur filter. Note: I would apply **Blur More** before I would apply the **Blur** filter twice.

Soften

The **Soften** filter is my Blur filter of choice, because it is controllable. (To be honest, I would not use the Blur or Blur More filter unless I was in a rush.) To apply this filter to an open image, do the following:

1. Open the **Effects** menu, choose **Blur**, and select **Soften** to view the dialog box shown here. Note that this dialog box is laid out similarly to the **Unsharp Mask** dialog box.

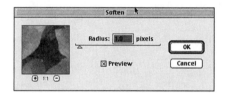

The Soften dialog box utilizes a slider control or a fill-in box, and offers a preview.

2. Be sure the **Preview** check box is checked.
3. As with any dialog box with a preview window, you can click your mouse anywhere on the image on your desktop to display that area in the Preview window. (Again, click the zoom buttons below the window to view more or less of the image area.)
4. Use the **Radius** slider to specify how much softening will occur.
5. When you are satisfied with the effect, click **OK**.

Despeckle

Many times, your camera introduces *noise* (unwanted color flecks or static), into your images, usually in the dark areas. The Despeckle filter helps eliminate some of the noise—it won't get it all, but it will clean up a good portion of it. To use this filter, do the following:

1. Open the image **Noise.tif** on the CD that accompanies this book.

Quiet! No more noise.

2. Open the **Effects** menu, choose **Noise**, and select **Despeckle**.

3. The Despeckle filter offers you no control; it does its thing, and that's that.

The Least You Need to Know

➤ One major benefit of digital photography is that it gives you control over your images. You no longer have to suffer with drugstore prints that are too dark or the wrong color.

➤ The techniques of image enhancement take time to learn. Applying the right filter or right amount of color control takes some expertise.

➤ Always work on a copy of your image rather than the original.

...PICK A TIGER BY THE TOE--

Eeney, Meeny, Miney, Mo: Selections

In This Chapter

➤ Using selections to improve your images

➤ Using selections to isolate image areas

➤ Using the freehand selection tools

➤ Using the Color wand to make selections

Without selection tools, image editing would be very difficult. The selection tools, which work hand in hand with other tools and filters, are the key to your ability to copy or remove pixels in your image; they allow you to protect areas from retouching or color correction. When you master the selection tools, you will begin to truly appreciate how much control you have over your images.

Getting Started

Before I go too far into describing how you make selections and why, let's find the tools themselves. As with many PhotoDeluxe operations, there is more than one way to get to the selection tools. One is to simply open the **Select** menu and choose **Selection Tools**; the menu expands to display the tools at your disposal.

A quicker way is to select the tool from the floating Selections palette (open this palette by opening the **View** menu and choosing **Show Selection**). The palette has a pull-down menu that allows you to select the tool you want to use. It also has additional buttons along the bottom. Keep this palette on your desktop any time you plan to edit your images; you'll use it almost constantly.

The selection palette.

Pull down the arrow in the right corner to see more selection tools.

Floating Palettes

Floating palettes are a great way to save time and keystrokes; they do, however, take up a small bit of your screen's real estate. You can drag the palette around your window by grabbing its title bar, and placing it anywhere on your screen you like. The beauty of a floating palette is that you can keep it close to the area where you are working; that way when you need a tool, you don't need to move your mouse too far to get it.

If you really want to get crazy, try using two monitors—a 21-incher for the image, and a second (possibly smaller) one for the various palettes you need to use (this one is usually called the *toolbox monitor*). That way, the tool palettes are always at the ready, but don't cover up the image.

Hiding Your Palette

For those of you who are working on a Macintosh (and you know who you are), you can easily hide your Palette without closing it. Simply double-click the title bar, and the window rolls up like a window shade. The title bar stays on the screen; click it to reveal the palette.

Why Use Selections?

There are plenty of reasons to use selection tools:

➤ Using a selection tool in your image enables you to move pixels. You can cut and paste a selection, moving it from place to place within an image or from one image into another. You can also *drag* a selection from one place in a photo to another. Say, for example, that you've selected a cloud. You can move the cloud to another location in your image, or you can copy and paste the cloud, creating an entire storm if you want. Talk about playing weatherman!

➤ After a selection is made on an area in a photo, it can be protected from any operation done to the rest of the image. It also can be isolated so that operations affect the selected areas only. This comes in handy if you need to apply a filter or a color correction to a specific area in a photo.

➤ A selection can also be used as a targeting device, allowing you to place an image that has been copied exactly where you want it. All you do is draw a selection in the place you want the new copy to land. When you drop the new copy into your image, it lands in your selection.

Leaving Your Palette Open

If you want to leave your floating palette in place for your next PhotoDeluxe session, simply leave it open when you shut down the program. The next time you start PhotoDeluxe, the floating palette appears, ready for use.

Imagine this scenario: You just took the most wonderful portrait of your entire extended family. Folks and relatives from all over the country gathered for this occasion. The sun was shining, and all was right in the world. To celebrate this happy occasion and to show off your new toys, you run inside to your computer and print out an image for everyone in the crowd. But there is one small problem: Your nephew, Pete the Pest, has his eyes closed!

No problem. Simply photograph Peter again, keeping him at the same distance and under the same type of light as in the original photograph. Then run back inside and download the photo of Pete's smiling face, open it, and select only his face. Then open the family portrait and select Pete's face (the one with his eyes closed). Now all you need to do is paste the new photo of Pete into the selection on the portrait. Because you selected the area on the portrait, Pete's face lands in the right place. You have to do some resizing and rotating of the pasted section, but you can do that with no problem.

Selection Tools

Lets take some time to look at the specific selection tools that PhotoDeluxe makes available to you. Although you can follow along by just reading, I suggest you cozy up to your computer and open up an image. Be sure the floating Selection tool palette is on your screen, and remember that you can access the various selection tools by using the pull-down menu on this palette. Are you comfortable? Let's begin.

Third-Party Tools

Many times, you can buy third-party filters or tools to make up for shortcomings in the software or for an easier way to do an operation. Many companies, such as Extensis Corporation (**http://www.exetemsis.com**), make filters that help make selections much easier.

Most of the time, you can download trial or demo versions from a company's Web site. This is great, because you can check out the filter to see whether it does all that it says it will. Also, you can check to see whether it works on your platform and with your software. Best of all, you can check to see whether you like the software in the first place.

Select All, None, and Invert

On the bottom of the Selection palette are three very useful buttons:

➤ **Select All** This button, you guessed it, selects the entire image. Go ahead; try it. An animated dashed line appears around the entire image. We professional types call these the dancing ants, and they indicate that an area has been selected.

Keyboard Shortcut

Another way to select the entire image is to press **Ctrl+A** (**Command+A** on the Mac). Always use keyboard commands whenever you can—your wrists will thank you!

➤ **None** If you want to drop any selection after it has been made or used, click the **None** button. (The keyboard shortcut command is **Ctrl+D** on a PC or **Command+D** on a Mac—think "D" for "drop," as in "dropping" a selection.) If you drop a selection by accident, you can always use the **Undo** command to get it back (whew!).

➤ **Invert** Click this button (or press **Ctrl+I** or **Command+I)** to select the opposite of what was originally selected. For example, if you are working on an image of a flower, and you want everything but the flower in the foreground to be slightly blurry, select the flower, invert the selection, and apply the Blur filter.

Fixed Selection Tools

Fixed selection tools are easiest and simplest of all the selection tools. They do not allow you to make a targeted selection but are very helpful when selecting large area to move, rotate, or resize the image.

Object Selection Tool

The most basic fixed-selection tool is the *Object Selection* tool, which you can use to select the entire object on the screen (or, if you are working in layers, the entire object on the active layer). Check out Chapter 19 to find out more about layers. In other words, when you click the image, a selection box is drawn around the entire frame. Indeed, you might notice that this looks a lot like the selection box you saw when you used the rotate/resize tools; it is the same box, complete with rotation icons and handles.

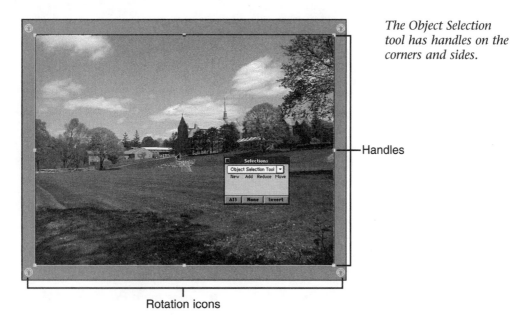

The Object Selection tool has handles on the corners and sides.

Handles

Rotation icons

If you grab the handles on the side, you can resize the width or height of the image (remember, if you don't like the effect, undo it by clicking the **Undo** button or pressing **Ctrl+Z/Command+Z**). If you grab a handle in the corner, you can proportionally resize the height and width simultaneously. The rotation icons can be used to rotate the image. To drop the selection, you can click the **None** button on the Selection palette, press **Ctrl+D/Command+D**, or press **Enter/Return**.

Rectangle Selection Tool

To use the Rectangle tool, click the top-left corner of the area you want to select, and then drag down and to the right. Change the direction of the drag to change the shape of the selection. When you release the mouse button, your selection is complete.

You can change the shape of the selection tool by dragging in different directions.

Rectangle selection ————

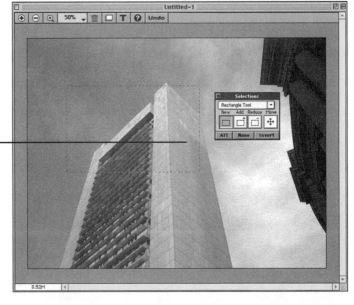

The Square Tool

The square tool works just like the rectangle tool, except for one important difference. Yup, it draws only squares.

Demo: Removing Color from Portions of Your Image

Have you ever seen an advertisement or a photograph that seems to be black and white but has color in selected areas? (Well, if you haven't, imagine you have or you'll mess up my demo.) I'll show you how it is done:

1. Open any image, and then choose **Square** from the Selection palette's drop-down list.

2. Using your mouse, drag to select a square area (about an inch or so) in the middle of your image.

Change Your Mind?

If you decide that an operation isn't going to work, but you've already started it, you can easily stop it by clicking the **Cancel** button in the palette. If no Cancel button is available to you, press **Ctrl+[period]**/ **Command+[period]** to stop the operation. This can save you a lot of waiting time, especially on time-consuming operations such as Rotate.

3. Click the **Invert** button in the Selection palette to select the area outside the box you just drew.

4. Open the **Quality** menu and choose **Hue/Saturation**.

5. Drag the **Saturation** slider all the way to the left to remove all the color from the image.

The image, except for the protected area, appears to be black and white; the area you protected when you drew the original square selection remains colorful!

The Oval Tool

Guess what? The Oval tool works just like the other regular selection tools, except it draws ovals. You can alter the shape of the oval, making it oblong or squat, by altering the direction you drag the cursor. To draw a perfect circle, hold down the **Shift** key as you drag to make a selection.

Freehand Selection Tools

Freehand selection tools allow you to draw a selection, well, freehand. There is no fixed shape to the tool. These tools are precise, enabling you to follow along a line or a shape easily.

Trace Tool

You can use the Trace tool to trace an object of an unusual shape. To use it, drag around the object you want to trace. Note: for a selection to work, it must be "closed," meaning that you must drag all the way around the object until you reach the starting point. If you fail to do so, the cursor "snaps" into place to connect the point where you released the mouse button to your starting point (it's probably best to close the selection by hand to avoid having the selection cross over itself when it snaps closed, as was the case with the unintentional figure-8 selection in the following image).

Drawing from the Center Out

You might have noticed that all the fixed selection tools draw across the screen in the direction of the cursor drag. If you hold down the **Alt** key (**Option** for the Mac), the selection grows outward from the center (the center being where your mouse was pointing when you clicked it to begin dragging).

Use the Trace tool to draw freehand selections.

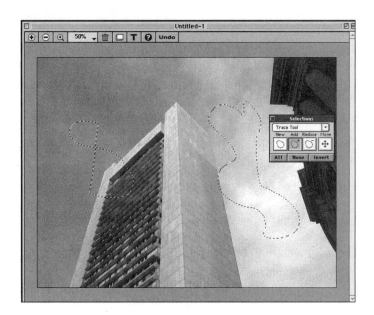

Drawing Straight Lines with the Trace Tool

Suppose you're tracing an image that contains both squiggly lines and straight ones. Drawing a perfectly straight line freehand is pretty hard; usually, your hand tremors ever so slightly, making the line that's supposed to be straight look squiggly.

Fortunately, PhotoDeluxe provides a way for you to trace perfectly straight lines, even while using the Trace tool. To do so, press and hold the mouse button, and then press and hold the **Alt** (**Option** on a Mac) key on your keyboard. Release the mouse button (keep pressing **Alt** or **Option**), and drag to trace the straight line. When the line is as long as you need it to be, click to *anchor* it. You can keep doing this as much as you want, adding section after section. When you finally release the **Alt** (**Option**) button, you are again able to draw "squiggly" lines.

Polygon Tool

The Polygon tool is another freehand selection tool, but unlike the Trace tool, which enables you to draw both squiggly and straight lines, the Polygon tool draws only straight segments. Try using the image **Tower.tif** (on the CD-ROM accompanying this book) to get a good handle on how this tool works:

1. After selecting **Polygon** from the drop-down list in the Selection palette, click the base of the tower on the right side, and click again at the top corner of the tower, directly above the base.

2. Keep clicking each corner of the building until you get to the base on the left side.

3. Double-click to close the selection across the base of the building.

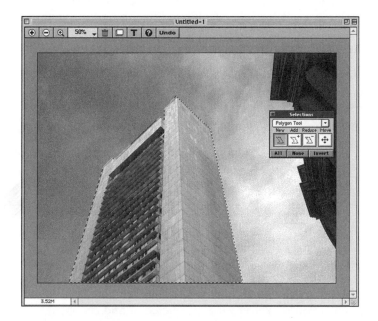

The Polygon tool lets you select straight line segments.

Selecting by Color

It is always easiest to let the computer do as much of the work for you as possible. Selecting by color is one way of letting your computer's "horsepower" do some of the work for you. Instead of drawing a complicated selection around a beautiful red rose, why not let the computer do it for you? By selecting the red color, your rose can easily be isolated from its green, leafy background. So easy and so simple!

The Color Wand

The Color Wand enables you to make selections based on similar colors or tones. This comes in handy when you want to choose large areas of color, such as when you

want to select the entire lawn or sky in a photograph. The downside of using this tool is that it can take a while for your computer to look at each pixel in an image and decide which pixels it wants to include.

Generally, but not always, the Color Wand won't jump "barriers." For example, if you click the Color Wand on a blue sky over a lake surrounded by tall pine trees, the tool probably will select only the sky and not the blue reflecting in the water. The pine trees act as a barrier between the lake and the sky. The *tolerance* of the tool determines whether the tool jumps the barrier.

Unfortunately, there is no Tolerance palette, nor does this option seem to be included on other floating selection menus (take note, Adobe!). So to adjust the tolerance of the Color Wand tool, you must adjust it via the Cursor Preferences dialog box. (The selection tools, and many other tools such as brushes, can be viewed onscreen in different ways. The Cursor Preferences dialog box enables you to choose how your cursor appears onscreen.) Try using the image **Tower.tif** (on the CD-ROM accompanying this book) to get a good handle on how this tool works:

1. Open the **File** menu, choose **Preferences**, and select **Cursors**.
2. A good starting number for the Color Wand's tolerance is 32; setting the tolerance at 32 means that the 32 colors closest to the pixel you clicked with the Color Wand will be selected.

Tolerance Values

If you set the tolerance too low, such as at 1, then the tool selects only those pixels that are exactly the same color as the one selected by the wand (lower tolerances can come in handy if you want to pick a specific color and change it, however). If you choose an excessively high tolerance, such as 255 (remember from Chapter 13, "Improving Your Images," that there are only 255 colors available in an image), then *all* the pixels in your image will be selected.

3. Click **OK**.
4. Click the sky in the upper-left corner of the image using the Color Wand tool from the Selection palette. In a moment, about one quarter of the image will be selected.

You can adjust the toler-
ance of the Color Wand
in the Cursors dialog box.

5. Click another section of the image using the Add Color Wand tool (the wand tool with the "+" sign next to it). This allows you to add to your first selection. Now, even more area will be selected. We'll cover the add and subtract buttons later in the chapter.

6. Keep doing this, adding on until you have most of the image selected.

7. Redo the entire demonstration, but this time select a higher tolerance for the Color Wand tool. You will notice that the sections you make are larger each time.

Undoing

Be careful to not select the edges of the building. If you do, you can use the **Undo** command, or click the **Reduce** button and remove the unwanted selections (I discuss using the Reduce button in just a moment).

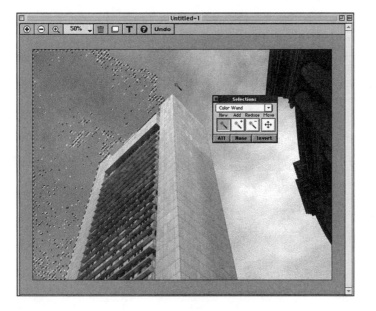

This is the Color Wand in
action.

Blinkers

At some point, you will be left with some small "blinkers," or blinking selections, in your image. (You'll know what they are when you see them!) You could try selecting these portions of the image with the wand (thus ruining your eyes), but the easier way to finish is to change tools. Choose the Add Trace tool (the trace tool with the "+" sign), and trace the blinkers to select them. Each time you make another selection, it adds to the selection you have already made. We'll cover the add and subtract buttons later in the chapter.

SmartSelect

The SmartSelect tool works by making selections based on contrasting pixels or edges. For example, the edges between the building and the sky in the following `Tower.tif` image have a good deal of contrast; with the SmartSelect tool, you could click at the bottom of the building, and then drag the mouse up the building (without holding down the mouse button) to draw a selection line up the edge.

The SmartSelect tool makes selections based on contrast found in an image, such as the edges of the building.

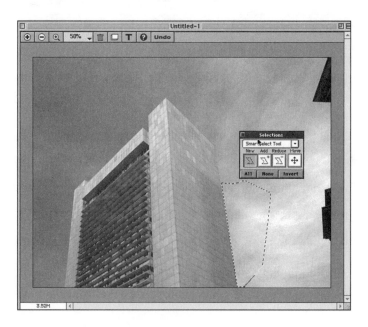

Notice that the SmartSelect tool has its own options in the floating Selections palette; use them to adjust the edge threshold (tolerance) and the width of the wand. (Hello, Adobe, this is the palette I was hoping to find with the Magic Wand tool!)

New, Add, Reduce, and Move

The Selection palette offers a few more nifty buttons:

➤ **New** This is the starting point for each selection tool.

➤ **Add** You can add to your existing selection; begin by clicking the **Add** button on the Selections palette. Draw another selection elsewhere in the image, or add onto the selection you originally made.

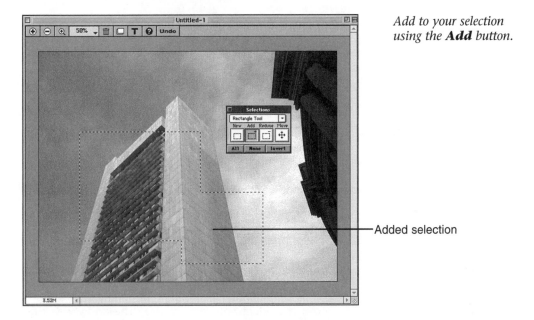

Add to your selection using the **Add** button.

Added selection

➤ **Reduce** Believe it or not, sometimes you will select too much. Luckily, you can click the **Reduce** button to, well, reduce the selection.

➤ **Move** When you click this button (or press **Ctrl+G/Command+G**), you can drag the selected area to another part of the image. (The white area you see where the image used to be in the following figure is the base or background of your image.)

You can move a selected area.

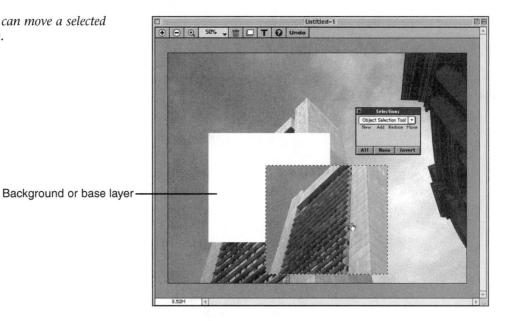

Background or base layer ————————

Moving the Selection Itself

If you want to move just the selection (but not the portion of the image within the selection, press and hold **Ctrl+Alt/Command+Option** while the selection is active, place the cursor *inside* the selection, and drag the selection to where you want it. If you want to move the selection precisely, press the arrow keys on your keyboard instead of dragging; each time you press the arrow key, you move the selection one pixel in the appropriate direction.

A Selection Saved Is a Selection Earned: Saving Selections

After all the work you have just done to make the most perfect selection, wouldn't it be nice if you could save it to use again? Even better, wouldn't it be nice to save a selection in progress—like if you hadn't finished working on a selection and you needed to close the file and do something else—like eat dinner?

In most high-end imaging software, such as Adobe Photoshop, you can save your selections. In fact, you can save many different selections. In PhotoDeluxe, however, you cannot save a selection—but there is a double-secret work-around, and I'll show you what it is:

1. After you've finished making the selection that you want to save, open the **View** menu and choose **Show Layers**.

2. Click the small triangle in the upper-left corner of the Layers dialog box and choose **New Layer**.

 In the dialog shown here, fill in the **Name** field with anything you like (I've typed `saved selection`) and click **OK** to create a new layer.

Duplicating Instead of Moving

To duplicate a portion of an image, press and hold the **Alt** (**Option** for the Mac) key as you drag the selection. The software automatically makes a duplicate of the image, meaning that you don't end up with a giant piece of white background.

Add, Reduce, and Move

The **Add**, **Reduce**, and **Move** buttons are available for most tools, and work in the same way.

So What's a Layer?

Layers are a wonderful way to stack picture elements in a photo one on top of another. In fact, Layers are one of the most powerful ways to manipulate an image. The elements stay independent of one another and can be moved, resized, or have filters applied to them. This is a wonderful way to add an element to a photograph or make a collage. See Chapter 19 for a much more detailed explanation of ways to use layers.

This figure shows the Tower image with the Selections and Layers palettes active, and the New Layer dialog box visible.

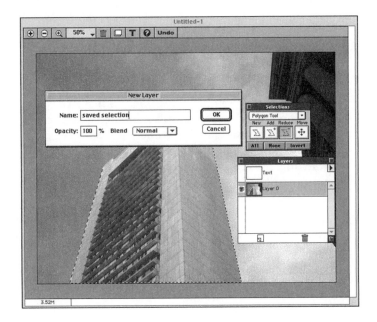

4. The new layer, saved selection (or whatever you called it), is listed in the Layers dialog box, and the entry is highlighted. This indicates that the layer is active and can be manipulated. Also, because your selection is still active (the ants are still dancing), anything you do with the selection affects the new layer.

The Polygon tool was used to select the tower.

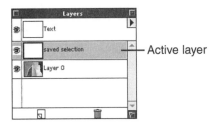

5. Open the **Effects** menu and choose **Selection Fill**.

6. The Selection Fill dialog box opens. Be sure the **Color** option button is selected.

7. Double-click the color box.

8. The Color Picker dialog box opens. When you place your cursor over the color tiles in this dialog box, the pointer changes to resemble an eyedropper. Maneuver the eyedropper until it is over a black square, and click. The color you clicked appears in the box in the upper-left corner of the dialog box; when you're sure it's the one you want, click **OK**.

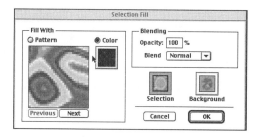

The selection is filled with black, using the Selection Fill menu.

9. Click **OK** in the Selection Fill dialog box.

10. Drop the selection by pressing **Ctrl+D/Command+D**.

11. The selection is filled in with black. (In reality, only the selection on the saved selection layer has been filled in. If you don't believe me, click **Layer 0** in the Layers dialog box.)

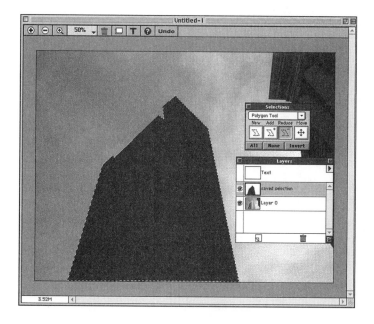

The Saved Selection layer (above the image layer) contains the black mask.

12. Save the file in a PhotoDeluxe file format (it is automatically saved that way unless you choose **Export**) and close it. I saved the file as **Mask demo.pdd**; you will find it on the CD included with this book.

13. Let's try using the selection you saved. Open the file you just saved and closed (**Mask demo.pdd in my case**), and open the Layers dialog box. Be sure the Saved Selection layer is active.

243

Don't Like Black?

Actually, any color works for this demo, but because upper-end programs use black and white to indicate selections, we'll keep up the tradition.

14. Using the Color Wand, click the black area on the layer to select it. The dancing ants appear. Look familiar?

15. With the selection still active, click **Layer 0** to make it active. The selection becomes active on Layer 0; you've successfully saved and reapplied it!

16. Just in case you need to convince yourself that it really worked, press the **Delete** key on your keyboard. The area inside the selection should disappear; you will see the white of the base layer.

You can save multiple layers in a file this way. The only drawback to this workaround is that your file size is larger than normal because you have the extra layer. Nothing is free, you know!

The Least You Need to Know

➤ Selections are an important part of enhancing your images.

➤ Using selections, you can duplicate and move elements, and protect certain elements while you color-correct others.

➤ You can select large areas of your image using fixed selection tools or select very fine detail and shapes using freehand selection tools.

➤ You can select areas using the Color Wand Tool to select a particular color or range of colors.

Color Me Beautiful: Adding Fills and Color

In This Chapter

➤ You will learn how to fill your selections

➤ A selection can be filled with color or texture

➤ Draw on your images using the brush, line, and erase tools

There are many ways to enhance your images. Here we will cover filling areas with color or pattern. You can lay down these in a strong bold way, blend one color to another, or subtly just add a tint.

For those of you who always wanted to paint and draw, you are in luck. PhotoDeluxe has tools that allow you to draw or brush color onto your photos. You can draw over a few faded pixels to beef them up or draw a smile on a face to add comic relief.

PhotoDeluxe offers a few different ways to add color to your image:

➤ Using fills, you can easily fill large areas of your images with colors or patterns. You can also use fill gradates that gradually move from dark to light, or even from one color to another.

➤ Using paint tools, you can draw on your image.

Fills

With Adobe PhotoDeluxe, you have two basic categories of fills at your disposal:

➤ Selection fills fill the selected portion of your image with a solid color or pattern.

➤ Gradient fills work similarly to selection fills, because they also fill in a selection. However, this type of fill fills the selection with two colors, fading one into the other.

You Can Fill More Than Just the Base Layer

You can apply these fills to layers as well as to the base images. Check out Chapter 19 to learn more about layers.

Selection Fills

To apply a selection fill, begin by selecting the portion of the image that you want to fill. Then open the **Effects** menu and choose **Selection Fill** to view the **Selection Fill** dialog box. As shown here, this dialog box is broken into two main parts:

➤ Fill With

➤ Blending

A selection is drawn in an image. The Selection Fill dialog box allows many options to be applied to the selection.

In addition, this dialog box enables you to specify whether the fill is applied to the selected area of the image (specify this by clicking the **Selection** button) or outside the selected area, in the background of the image (specify this by clicking the **Background** button).

Fill With

The **Fill With** area offers two options:

➤ Select the **Pattern** option button to fill your selection (or background, depending on which you've specified) with the displayed pattern (click the **Next** and **Previous** buttons to view available patterns, graciously provided to you by the folks at Adobe).

1. Open the image you want to copy the pattern from.

2. Using the rectangle tool (only the rectangle tool will work), select the area you want to use as your pattern.

3. Choose **Effects, Define Pattern**.

4. Select the area that you want to fill with the pattern.

5. Click the **Pattern** button and click **OK**.

If you want to save the pattern for later use, create a new file and fill the new file with the pattern and then save the file.

Making Your Own Patterns

You can make your own patterns, and set up your system so that your patterns appear in the **Pattern** window. (This effect can be used in Version 3 or the Business Version of PhotoDeluxe.)

➤ Select the **Color** option button to fill the selected area (or background—again, depending on which you've specified) in your image with color. Double-click the colored box to view a color picker, select the color you want, and click **OK**.

Blending

Use the **Blending** area of the Selection Fill dialog box to specify *how* the color or pattern you picked will be applied to the image:

➤ Use the **Opacity** field to specify how transparent the applied fill will appear. Choosing 100% means that the fill will be completely opaque. If you want the fill to resemble a tint rather than a robust color, try setting this field to 50%.

➤ Use the **Blend** drop-down list to specify how the fill will be applied. You have the following options:

 ➤ Select **Normal** to fill the selection so that it completely covers the base or layer below. Check Chapter 19 to learn more about Layers.

 ➤ Select **Color** to fill the selection so that the area below the selection keeps all its shadows and highlights. This is a good way to lay a color tone over an image while retaining the original image detail.

 ➤ Select **Lightness** to apply the fill color only to pixels that are lighter than the selected color. This would darken all the affected pixels. All pixels that are darker than the selected color will be left alone.

 ➤ Select **Darkness** to apply the fill color only to pixels darker than the selected color. This would effectively lighten all the pixels that are chosen.

 ➤ Both the **Overlay** and **Difference** options require a technical explanation that, when finished, would not help you understand what they do. Suffice it say that they both involve multiplying or comparing color information—they can, however, produce cool results. The best thing to do with these modes is to try them out.

Gradient Fill

Applying a gradient fill is similar to applying a selection fill; begin by selecting the portion of the image that you want to fill. Then open the **Effects** menu and choose **Gradient Fill** to view the Fill dialog box as shown here.

Use the Gradient Fill dialog box to fill your selection with a gradient color.

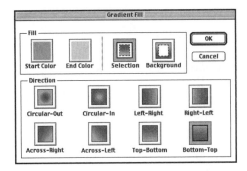

You will notice pretty quickly that this dialog box doesn't offer a blend mode or pattern options, but don't take that to mean it doesn't have plenty of bells and whistles:

➤ The **Fill** area has two color boxes. Double-clicking the first box, **Start**, opens a Color Picker dialog box that lets you pick the starting color of the blend; double-clicking the **End** box opens a Color Picker dialog box that lets you choose, yes, ladies and germs, the ending color of the blend. Both boxes work like traditional color pickers.

➤ The **Selection** and **Background** options work exactly like their namesakes in the **Selection Fill** dialog box (see their description in the section titled "Selection Fills").

➤ The **Direction** boxes describe how the color blend will be filled. As you can see, there are many options: You can fill from side to side, top to bottom, corner to corner, and even in a circular pattern.

Demo: Using Gradient Fills to Change the Weather

With the use of selection tools and fills, you can borrow the blue sky from one image and place it over the gray sky in another. People will think you always go on vacation during the best weather!

1. Open the file **Train sta.b4** on the CD-ROM that accompanies this book.

2. Using either the Color wand or Polygon selection tool, select the white sky area in the background. (Be careful not to select the edge of the roof over the pedestrian walkway beside the tracks.)

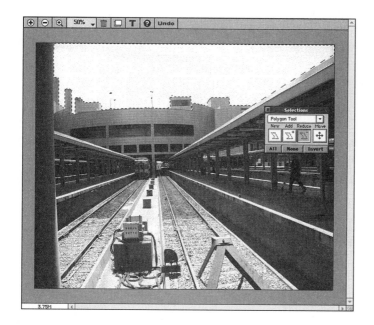

Use the color wand tool to make a selection in the sky area.

3. Open the image **School.tif** on the CD-ROM that accompanies this book. We are going to steal—er, I mean *borrow*—some sky!

4. Open the **Effects** menu and choose **Gradient Fill** to view the **Gradient Fill** dialog box.

5. Press **Ctrl+A/Command+A** to select the entire **School.tif** image (you'll see why in a moment).

6. Click the **Start Fill** box in the Gradient Fill dialog box to open a **Color Picker** dialog box.

Borrowing Skies

When you catalog your images, it's a good idea to make note which images have great cloud formations and wonderful skies.

7. Instead of using the color picker, place the eyedropper pointer at the very top of the sky in the **School.tif** image and click. The blue of the sky fills in as your **Start** color. Click OK in the start color picker to close the box.

8. Repeat steps 6 and 7, but this time click the **End Fill** box, and pick the color from the **School.tif** image at the horizon between the grass and the sky. (I picked my color from right between the two tall pine trees at the left of the main building.) Click OK to close the color picker.

9. After you have both your beginning and ending colors chosen, click the Cancel button on the Gradient Fill dialog. Then close the school image.

The color picker is used to grab some of the natural blue sky from the school photo.

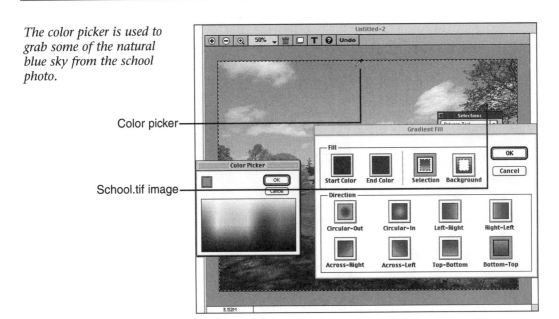

Color picker

School.tif image

10. The image of the train station should still be on your screen, with the sky selected. Open the **Effects** menu and choose **Gradient Fill** to open the Gradient Fill dialog box. Your beginning and ending colors should still be in the boxes.

11. The **Start Fill** and **End Fill** colors you chose in steps 7 and 8 should still be active; be sure the **Selection** option is active, and then click the **Top to Bottom** blend option.

The train station sky is selected and the Gradient Fill dialog box is ready and waiting.

Selected area

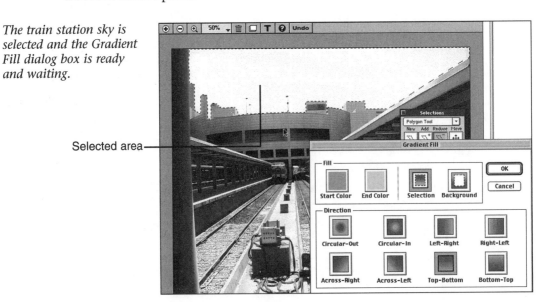

12. Hold onto your hat, and click the **OK** button. Voilà! Instant sky! Your image should look like the following figure; my final version, Station_final.pdd, is also included on the demo CD disk.

A beautiful blue sky as seen from Boston's South Station; only you know the truth!

Paint Tools

The painting tools are a lot of fun to use. You can use them to clean up or enhance part of your image or you can use them to draw on your photos. If you are using PhotoDeluxe to make business presentations, you can draw arrows or circle parts of your images to draw attention to a specific point. You could even draw on the walls and not get in trouble!

PhotoDeluxe offers a variety of paint tools for you to use, including the following:

➤ The Brush tool

➤ The Eraser tool

➤ The Line tool

Better Paint Options

Programs such as Adobe Photoshop, Adobe Illustrator, and Corel Quick-Draw offer more robust paint tools, including a very nice airbrush tool, and options than does Photo-Deluxe. Nonetheless, the tools that are included in PhotoDeluxe can be effectively used to add interest to your image.

The Brush Tool

The Brush tool acts and behaves just like a paintbrush. It is a very nice way to apply color in a freehand manner.

To use the Brush tool, begin by opening the **Tools** menu and choosing **Brush**. The Brushes floating palette, shown here, appears, enabling you to specify the brush's size and color.

The floating palette allows you to pick the brush's size and color.

Setting the Brush Size

The palette features three rows of circles that correspond to the shape of the brush's tip. The upper row has hard-edged tips, which render a precise stroke when the brush is dragged across the image. The middle and bottom rows of the palette show fuzzy tips, which render soft-edged strokes. The bottom row contains circles that are accompanied by numbers that indicate the tip size in pixels.

What About the Background Color Box?

You select a background color the same way as the foreground color, but you'll find that this option is seldom used except by a few effects filters, such as the Clouds filter.

Setting the Brush Color

In the lower-right corner of the floating palette, a color box indicates the color that the brush will draw. To change the color of the brush, double-click the color box to open a Color Picker dialog box. To select the foreground color (that is, the color your brush will use), click the **Foreground** box in the upper-left corner of the Color Picker dialog box, and then click the color you want. The color you clicked appears in the **Foreground** box. Click **OK** to close the **Color Picker** dialog box; the foreground color you selected appears in the lower-right corner of the **Brushes** palette.

Cursor Preferences

In programs such as Illustrator or Photoshop, the brush cursor takes on different "characters," such as a paintbrush, pencil, or airbrush. By default, the cursor for PhotoDeluxe's Brush tool is simply round. However, you can use the Cursor Preferences dialog box (open the **File** menu, choose **Preferences**, and select **Cursors**) to specify how you want your cursor to appear onscreen. This dialog box is divided into three sections; the section on the far left is for the painting tools—such as the Brush tool.

Choose the **Standard** option if you want your cursor to look like the tool's icon. For example, if you are using the Brush tool, the cursor looks like a little brush—making it easy for you to remember which tool you are using. If you choose the **Precise** option, your cursor resembles a small crosshair—making it easy for you to finely control the tool you're using. Finally, you can select **Brush Size** to make it so that your cursor reflects the size you've selected for the tool (I usually have this option selected).

The Color Picker dialog box lets you pick which color your brush will use.

As an Alternative...

You can also control the opacity of the brush tool by controlling the opacity of the layer on which you're drawing. See Chapter 18, "Layer Cake: Adding Elements," for more information on layers.

Setting the Brush Opacity

You can alter the opacity of the color drawn by the Brush tool, but for some reason, this setting does not appear on the Brushes palette (hey Adobe, what were you thinking?). Instead, you control the opacity of your brush by using the numeric keys on your keyboard. Think of each key (1–9) as a multiple of 10% of opacity. In other words, with the Brush tool on the screen, press 1 for 10% opacity, 5 for 50% opacity, 9 for 90% opacity, and so on; press 0 for full opacity. The downside? You'll never remember which setting you've chosen, and there's no way to find out. When in doubt, pick your opacity again. The following image shows some doodles using different opacities.

Drawing with the Brush Tool

Click and hold the mouse button, and drag the Brush tool across your image. Squiggle it. Do the loop-tee loop. Dab. Have fun. Remember, you can also use a selection to limit where you draw. To be safe, create a new layer before trying out an effect (you'll learn more about layers in Chapter 18).

You can control the opacity of your brush strokes.

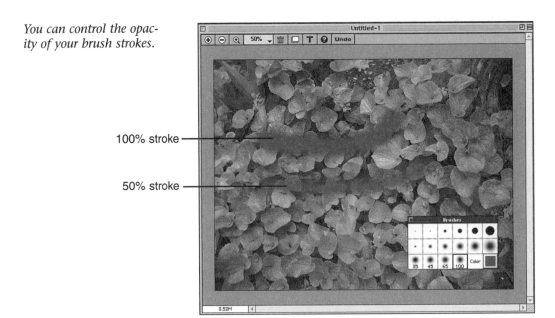

100% stroke

50% stroke

When Using Selections...

If you have a selection activated but hidden from yourself—for example, you might be zoomed in on a different section of your image—trying to use the Brush tool will be frustrating (remember, you can't draw outside a selected area). Zoom out of the image to find the selected area, or drop the selection (press **Ctrl+D/Command+D**) just to be sure.

The Eraser Tool

The Eraser tool erases the image from the photo. If you are on the "base layer" of an image, it erases to white—like paper underneath the image (see the following image). If you are on an upper layer, it erases the pixels on that layer, allowing pixels on submerged layers to show through.

Need a Straight Line?

If you need to draw a perfectly straight line, press and hold the **Shift** key while you draw.

The Eraser tool behaves exactly like the brush tool—almost. Like the Brush tool, you can specify the size of the eraser; unlike the Brush tool, no color selection need be made. You can use the numeric keys on the keyboard to set the opacity just as you did with the brush tool. To open the Eraser palette, open the **Tools** menu and choose **Eraser**.

The Line Tool

With the Line tool, you can draw a straight line in any direction. To open the **Line Tool Options** palette, open the **Tools** menu and choose **Line**; use the palette to pick the color and width of the line. As with the Brush tool, you can control the opacity of the line by using the numeric keys on your keyboard.

The Eraser tool exposes
the base layer of the
photo.

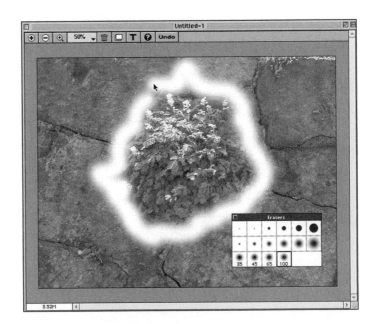

The line tool can draw
only straight lines.

100% opacity

50% opacity

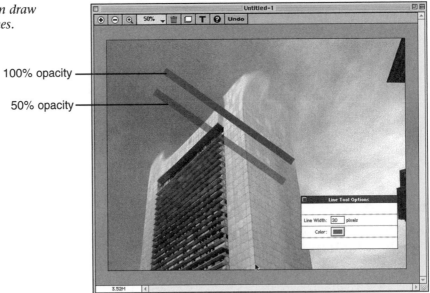

The Least You Need to Know

➤ You can fill a selection with color.

➤ You can gradate the color in a selection.

➤ You can draw on your image with the brush tool or create lines using the line tool.

➤ You can erase with the erase tool.

➤ All drawing tools have opacity controls.

The Clone Tool: The Ultimate Retouching Tool

In This Chapter

➤ Using the clone tool

➤ Retouching out unwanted elements

➤ Cloning from one photo into another

One of the most useful tools in the PhotoDeluxe arsenal is the Clone tool. This fairy-tale tool allows you to copy over "bad" pixels with "good" pixels, enabling you to remove scratches, dust, and other annoying maladies on your photos. This tool is so important and so beneficial to your photos that it deserves its own chapter. Its pro-grammer (mother?) would be so proud!

Getting Started

PhotoDeluxe's Clone tool is a descendant of Photoshop's Rubber Stamp tool, which is why the Clone tool's cursor looks like a rubber stamp. Although this icon is cute, it is annoying and gets in the way; the first thing you should do when using this tool is open the **Preferences** menu and change the icon so that it indicates the tool's brush size.

1. Open the Preferences menu (File, Preferences, Cursors).
2. Under the painting tools, choose the Brush Size radio button. Close the dialog box by clicking **OK**.

Save the Original!

Before you start a clone, save your original image in case you need to start over. As you go along, especially after you have a accomplished a difficult clone, save your image again—you'll be glad you did.

Demo: Removing Phone Lines Using the Clone Tool

Open the image **Old tree.tif** from the CD that accompanies this book, and notice that the telephone company decided to put phone lines across my image. How dare they?! No problem; using the Clone tool, you can easily hide those eyesores.

Do the following to use the Clone tool:

1. Open the **Tools** menu and choose **Clone**.
2. The Clone floating palette opens, enabling you to choose an applicator—or *brush*—size. To make things easy, situate the palette so that it's near the photo you just opened.

The Clone Palette

Like the painting tools you learned about in Chapter 15, "Color Me Beautiful: Adding Fills and Color," the Clone tool also uses a brush. The Clone palette features three rows of circles that correspond to the shape of the brush's tip. The upper row of the Clone palette features precise, hard-edged tips. The middle and bottom rows of the palette show fuzzy tips, which leave soft, feathered edges (these are the best brushes to use, because they help blend the clone into the photo). The bottom row contains circles that are accompanied by numbers that indicate the tip size in pixels.

The Clone palette allows you to pick a tool's size and its edge effect.

3. Rotate the photograph to the left, and perform any image correction you feel is necessary to make it look wonderful (**Orientation**, **Rotate Left**).
4. Zoom, using the zoom tool in the photo's menu bar, into the lower-left area of the image so that the phone lines fill your screen.

5. You get the paint for the Clone tool's brush by "sucking" the pixels that you want to clone from your image. Drag the colored area with the crosshair in its center (I call this the *clone source*) to the pixels you want to clone—in this case, to the blue sky above the phone line in the upper-left area of the image.

6. Click the 35-pixel soft brush on the Clone palette.

7. Click the phone line. The cloned pixels from the source cover the spot you clicked.

Crosshair Size

Note that the crosshair does not change in size when you select different brush sizes—its size is constant.

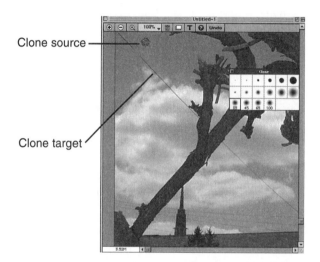

Clone source —

Clone target —

Check out my first few clicks.

What's with the Traveling Crosshair?

As you clone, you will notice a small crosshair that follows along with your Clone tool. This crosshair indicates the spot from which the Clone tool is picking up pixels, and stays in the same location in relation to the Clone tool that the original clone source was. If you find that you don't like the pixels being used as a source, change sources; the relation between the traveling crosshair and the brush also changes.

8. Continue clicking to cover up the line up to the cloud. Alternatively, drag your cursor along the phone line to quickly cover a large area. (This is an effective way to cover up a straight line.)

Mix It Up

When cloning, move the clone source around. Don't drag the cursor along if it is going to create a noticeable line. Try using different-size brushes. Clone from different spots—above and below the area you're cloning over. Dab at the spot you want to clone over. If your clone target area has grain in it, try to duplicate it. Try to match the source and target areas the best you can. In other words, mix it up and take your time—a poorly done clone is easy to spot.

Opacity

You can use your keyboard's numeral keys to control the opacity of the Clone tool. Press **1** for the lowest opacity, which renders almost no perceptible clone; press **9** for an almost fully opaque clone; press **0** for a fully opaque clone; press **5** for 50% opacity; and so on. Passing over an area a few times with 50% opacity can help beginners get a better feel for the tool. Also, it helps to soften edges from 100% opacity.

9. Move the clone source into the cloud area, and continue spotting away the phone line as it crosses through the cloud. Be careful about your source here—be sure you are picking source colors that are the same as the colors adjacent to what you are covering up. (Note: The effect of using a large brush with a soft edge is sometimes less noticeable than with a small brush.) In the area where the clouds and sky touch, choose a small brush and nibble away.

10. Note that in the area around the tree, there are a few more problem areas to take care of. For one, the phone line crosses through the V area where the branches split in the tree and exits on the other side of the trunk. If you were to use the Clone tool by itself, it would be difficult to avoid covering parts of the tree as you remove this problem. Instead, you should use selections to protect the areas you want to preserve; begin by opening the **View** menu and choosing **Show Selections** to view the **Selections** palette.

Be careful when you pick a source to clone from that it matches the intended target. Here I use an area of cloud to clone. Use different size brushes to nibble away at the clone.

11. Use whichever selection tool you feel is appropriate to draw a selection along the edge of the tree. I've used the Polygon tool to draw a selection inside the V area where the branches split, and I've also drawn a selection between the tree and the steeple. Note: Each time you use the selection tools, the Clone tool disengages.

12. After the tree has been "protected" by the selections, use the Clone tool to clone pieces of the sky over the problem areas.

13. Notice that below and down the trunk a bit, the church steeple touches the tree which bothers me a bit as far as the composition goes. Again, use selection tools to select the steeple, and then clone over it.

Inverting the Selection

Sometimes you might need to work on both sides of a selection (suppose, for example, you also wanted to make changes to the tree without affecting the sky). If so, you don't need to redraw the selection. Instead, inverse it by clicking the **Inverse** button on the Selections palette. You can then draw or paint against the selection from the "other side."

This almost-finished clone shows selections made to protect the tree trunk.

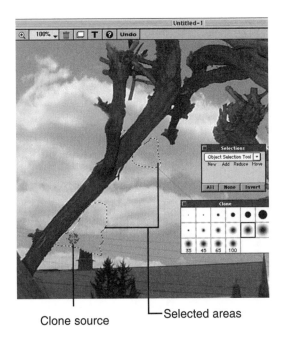

Clone source ⎯⎯⎯⎯ Selected areas

14. Finally, deactivate the selections, and then remove the rest of the phone lines (the ones from the right of the limb on out) using the techniques you just learned.

15. Save your image.

Don't Forget to Deactivate the Selections!

If you try to perform any operation outside an active selection, nothing happens!

Before You Save...

When you finish a clone, zoom out and take a look at it. Walk away from your monitor and come back to it. See whether the clone stands out from the image. If it does, fix it or start over.

Cloning Between Two Photos

Just as you can clone from one area of a photo to another, you can clone between two entirely different photos as well:

1. Open the image you want to clone to (I'll call this "Image A").

2. Activate the Clone tool.

3. Open the second image, which contains the clone source (I'll call this "Image B").

4. Activate the Clone tool here, also.

5. Move the clone source crosshairs over the area you want to clone from in Image B.

6. Return to Image A by clicking the image or the top title bar. Your clone tool should now be laying down pixels from Image B to the clone target in Image A.

The Least You Need to Know

➤ You can use the clone tool to cover up or move pixels in your image.

➤ You can clone with different opacities.

➤ You can clone from one image to another.

Yadda Yadda Yadda: The Text Tool

In This Chapter

➤ Including text in your images

➤ Secret type tricks, adding drop shadows, glows, and opacity

You might want to include type or text in an image to produce a greeting card or calendar. Fortunately, PhotoDeluxe includes a Text tool, which you can use to add comments or other text to your images—just watch your spelling!

Adding Text

You can add text to an image in several ways, but no matter which way you use, begin by opening the image itself (if you want to practice on a solid white background, create a new image by pressing **Ctrl+N/Command+N**). Then, open the Text Tool dialog box by opening the **Tools** menu and choosing **Text**, or by clicking the **Text** button (the one that has a "T" on it) in your image window's toolbar.

Use the Text Tool dialog box to add text to an image.

Font Won't Change?

If the font's style or appearance does not change, go back to your system software and check for the text control tools. On a Mac, look in the Fonts folder inside your System Folder. On a Windows machine, look in the Fonts Folder in your Control Panel Folder.

Font Size

Some versions of PhotoDeluxe, such as the Business edition and Version 3, have a box to specify the type size.

To add text to your image, do the following:

1. In the text field area, you can type anything you want. Notice how your text *wraps* around the box; you might want to press **Enter/Return** a few times to break up the lines of text.

2. Use the **Font** drop-down list on right side of the dialog box to find a *font* (type style) you like. If you are like me and can't remember what each font looks like, you will be happy to know that the font you select appears in the dialog box.

3. Below the **Font** drop-down list you can select from a series of option buttons that enable you to specify the type alignment—flush right, flush left, or centered. You can also specify that your type appear in columns by choosing the lower option buttons.

4. Click the **Color** box to open a color picker; it works the same way as with the painting tools (refer to Chapter 15, "Color Me Beautiful: Adding Fills and Color").

5. Click the **OK** button. After a moment, your image appears with the type in a selection box, as shown here. At this point, it's a good idea to open up the Layers palette (**View, Show Layers**); notice that the type rests in its own layer. Check out Chapter 18, "Layer Cake: Adding Elements," to find out more about layers.

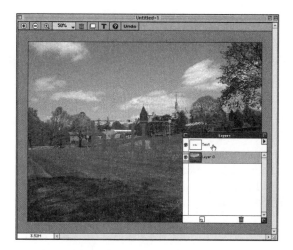

The text is contained on its own layer, allowing it to be resized and positioned.

6. Notice that the type is in a *selection* box (read about selections in Chapter 14, "Eeney, Meeny, Miney, Mo: Selections," if you skipped ahead). You can resize, move, distort, and rotate the type by grabbing the handles on the selection box and dragging.

7. After the type is as you want it to appear, click anywhere outside the selection box to make it "stick." The selection box disappears (if you change your mind about where you've stuck the type, click it; the selection box and handles reappear).

8. Save your image in a PhotoDeluxe (the default) format.

Demo: Applying a Drop Shadow

Drop shadows are literally a shadow of the type. They help define the type and add depth to the type and also make the type appear to float above the image. You will see drop shadows used a lot by graphic designers to enhance the type quality.

I suggest you read through this demo before you attempt it. You might also want to skim Chapter 18 to familiarize yourself with layers or come

Opacity Slider

You must use Version 3 to control the opacity of the Text Layer. Check the "cheater's way" to control opacity later in this chapter.

Edit Your Copy

As long as your image and text are in a PhotoDeluxe format, you can do an amazingly cool trick. Click your type to see the selection box; now double-click the type to open the Text Tool dialog box, where you can edit your text!

back to this after you feel comfortable with layers. If you want to take a leap of faith, just follow along with the demonstration.

1. Open up an image. Add any text you want in the Text Tool dialog box, pick a color, and click **OK**.

2. Open the **Selections** palette. (**View, Show Selections**)

3. Grab the selection handles and enlarge your type so that it covers about 50% of your image. (If you need help, refer to Chapter 14.)

4. Don't ask why, but PhotoDeluxe will not allow you to activate (manipulate) the type layer—but, as always, there is a workaround. The first thing you need to do is to save your image in the Photoshop format (you'll see why in a minute). You don't need to have Photoshop. To do so, open the **File** menu, choose **Send To**, and select **File Format**.

5. The dialog box shown here opens. Give your file a name (make it different from the original to avoid overwriting it), and select the Photoshop format from the **Format** drop-down list. Click **Save**.

By using the Send To option under the file menu, you can save your file in the Photoshop format.

6. Be sure the Layers palette is open, and then open the image you just saved to your hard drive.

7. Notice that a new layer has appeared in the *layer stack* in the Layers palette. Rename this layer by double-clicking it in the stack and typing `original text` in the dialog box that opens.

8. Click the **original type** layer. Ha! You can activate it!

9. Open the **Selections** palette (**View, Show Selections**) and select the **Color Wand** from the drop-down list.

10. Click to select all the type. (You might need to click the **Add** button in the Selection palette to select all the type; refer to Chapter 14 for more information on selections.)

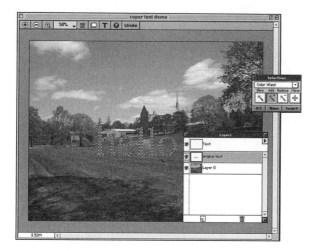

The text has been selected by using the Color Wand selection tool.

11. Open the **Effects** menu and choose **Drop Shadow** to open the Drop Shadow dialog box. Select the color (be sure the color of your shadow is different from the original type color), direction, and offset of the shadow, and click **OK** to apply the drop shadow.

The Drop Shadow dialog box enables you to pick the shadow, opacity, and color.

12. The Layers palette should have a layer called Object, which refers to the original type layer. Just to be tidy, grab this layer in the palette and pull it into the trash at the bottom of the palette.

13. Click the **Shadow** layer, which appears above the original text layer in the Layers palette, and drag it so that it is underneath the original text layer.

271

The Shadow layer is positioned underneath the original text layer.

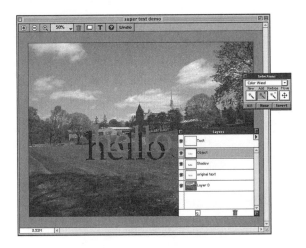

14. Now you have a drop shadow; let's fine-tune it a bit to make it look good. To begin, click the **Shadow** layer to activate it.

15. Press **Ctrl+G/Command+G** to activate the Move Selection tool, and move the shadow around until you think it looks good. It should look rather like the image shown here (a copy of this image can be found on this book's companion CD called "super text demo").

16. Save the file.

Using the Move Tool, the shadow is moved to the right side of the text.

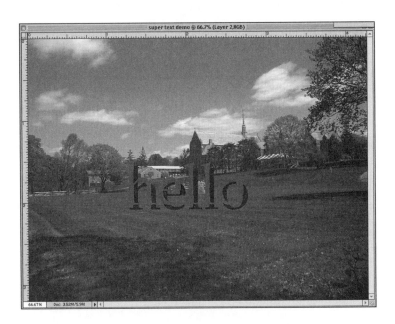

Changing the Opacity of Your Type

Officially, there is no way to change the opacity of your type, but I'll show you a way to cheat (to be politically correct, we'll again call it a workaround). Actually, I already have! If you followed the preceding demonstration, by changing the file into a Photoshop format, you will note that the type now appears in the layer stack as a normal layer. Well, guess what, that layer can have its opacity changed. Double-click on the layer in the Layers palette and you will see the opacity controls. Go ahead and change the opacity and watch your type become transparent. Again, this procedure relies on layers, so you might want to come back to this after you read Chapter 18.

Demo: Making Your Type Glow

In this demo, you'll learn how to make a glow appear around your type. To begin, open the file you just worked on, or repeat steps 1–16 in the previous demo to generate a new image with type (I decided to go back though the previous demonstration and change the text to say **Healthy**), and then do the following:

1. Open the **Layers** palette.

2. Duplicate the drop-shadow layer by dragging it over the **Page** icon at the bottom of the palette.

3. Rename this new layer by double-clicking it in the layer stack and typing `Glow` in the dialog box that opens.

4. Deactivate the original drop-shadow layer by clicking the **Eye** icon—we'll keep this around for safekeeping, but leave it hidden from view.

5. Click the **Glow** layer to activate it, and then select it with the Object Selection tool. (Be sure you click directly on the type when you use the Object Selection tool; otherwise, you will activate the base layer.)

6. Enlarge the Glow layer until it is about 20% bigger than the original text layer, and position the Glow layer so that it is almost directly behind the original text layer.

7. Before we go much further, let's change the color of the "glow" text. Open the **Selections** palette (**View, Show Selections**) and select the **Color Wand** from the drop-down list.

8. Using the Color Wand, click to select all the type. (You might need to click the **Add** button in the **Selection** palette to select all the type; refer to Chapter 14 for more information on selections.)

9. Open the **Effects** menu and choose **Selection Fill** to fill the selected area with the color you choose (I'll use yellow because it stands out well).

10. Be sure the Glow layer is selected, and then open the **Effects** menu, choose **Blur**, and select **Soften**.

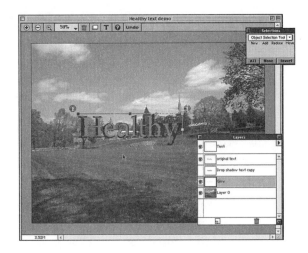

The Object Selection Tool; enlarge the Glow layer so that it is larger than the original text. The Glow layer should be directly behind the original layer.

11. Move the radius slider to the left until you get a nice healthy glow. After you are finished admiring your work, click the **OK** button.

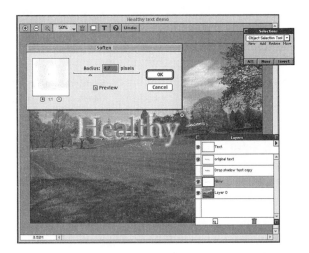

By using the Soften filter, you can adjust the amount of glow.

12. Click the triangle in the top-right corner of the Layers palette, and choose **Merge Layers** from the menu that appears.

13. Save your file (you'll find a copy of mine, called Healthy Text demo, on this book's companion CD).

The Least You Need to Know

➤ Text can be put onto a photograph.

➤ Text will have its own layer.

➤ Text can be manipulated to change its size, position, and color.

➤ With a little bit of workaround, text can have drop shadows, glows, or opacity added.

Layer Cake: Adding Elements

The biggest advance in digital imaging happened only a few years ago, when Adobe brought out Photoshop version 3, which enabled the use of layers. Many other companies soon followed Adobe's lead. Layers make imaging fun, spontaneous, and artistic. Before the advent of layers, every image brought into a Photoshop document had to be pasted onto the background layer. Every time you brought an element into an image, you had to save and rename the image to avoid overwriting earlier versions. If you didn't and made a mistake, you had to start all over.

What's a Layer?

Think of a *layer* as a plate of glass on which part of an image can reside. For example, one layer might have text, another might have the original photograph, and another might have a selection from a second photograph. (Usually, it is best to keep each image element on its own layer so that the element can be moved and manipulated without affecting the rest of the composition.) Each plate can be opaque, semitransparent, or fully transparent.

These layers are stacked one on top of the next to create one entire image, and each layer can be reshuffled in the stack to alter the image's composition. Layers can also be turned on or off, making its contents visible or invisible.

Lemme See One

With an image open in PhotoDeluxe, open the Layers palette (**View, Show Selections**). By default, every image in the PhotoDeluxe format (PDD) starts with two layers (Photoshop images start with only one):

➤ The first (bottom) layer is called the *base* or *background* layer. When image pixels are erased from the base layer, white color shows through—much like when you erase pencil from a piece of white paper. The base layer itself cannot be erased, but it can be duplicated.

➤ The second layer is the *text* layer. This is where any text you add to the image is located. The text layer resides above all the other layers. (Refer to Chapter 17, "Yadda Yadda Yadda: The Text Tool," for more information about adding text.)

The Layer palette shows base layer, additional layers, and top text layer.

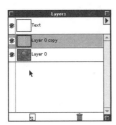

Using Layers: The Basics

The easiest way to learn about layers is to experience them for yourself. To begin, let's create a new image:

1. Create a new image by pressing **Ctrl+N/Command+N**.

2. Because the image will be for onscreen viewing only, keep the resolution at 72dpi, and size it at 5×4 inches.

3. Open your Selection palette (open this palette by opening the **View** menu and choosing **Show Selection**) and click **Select All**.

4. With the base layer, Layer 1, selected in the Layers palette, open the **Effects** menu and choose **Selection Fill**.

5. Select a real ugly pattern and get it out of your system, and click **OK**.

Adding Layers

If you want to bring in new elements into your image and keep them separate from your original image, you will need to put them on their own layer. To add new layers, do the following:

1. With the image you just created open on the desktop, click the triangle in the top-right corner of the Layers palette, and choose **New Layer** from the menu that opens. We will be using this image a little later on in the chapter for a continued demonstration.

2. The New Layer dialog box, shown in the following figure, opens. Type **Layer 1** in the **Name** box. You will notice that PhotoDeluxe automatically names the base layer "Layer 1," but I want to give you a little practice naming layers.

3. Repeat steps 1 and 2, but this time type **Layer 2** in the **Name** box.

In the New Layer dialog box, you can enter the name of the layer. Click **OK** *when done.*

4. Repeat steps 1 and 2, but this time type **Layer 3** in the **Name** box.

5. Rename the original layer, which is on the bottom of the stack, **Base**. Double-click on the layer in the Layers palette and the Layers Option box will open where you can type in the new name of the layer. This should be the layer that contains the pattern you applied in step 5 of the preceding section. I like to think of this layer as the base or foundation, and not a layer at all. It is a personal preference, but something I've been doing for years. It is also a good way of keeping track of the original image.

6. Save your image.

On the CD...

You will find a copy of this finished image, Layers demo, on the CD, which has been hermetically sealed (for your protection) on the back cover of this book.

Activating a Layer

No operation—such as a color change, fill, or movement—can be done to a layer until that layer has been *activated*. Conversely, when a layer has been activated, operations on it will not affect any other layers. Activating a layer is simple. Click the layer in the Layer palette to highlight it; that's all there is to it.

Nothing's Happening!

If you are trying to paint or delete on a layer and nothing is happening, be sure that you have activated that layer. If you have indeed forgotten to activate your target layer, check the other layers to be sure you didn't end up painting over or deleting something on them! (I can't tell you how many times I've done this.)

Layer 3 is activated, as indicated by the highlight box.

The activated layer is highlighted.

Showing and Hiding Layers

On the left side of each layer in the Layers palette is a small Eye icon. When the Eye appears, by clicking on the space on the left, next to the layer, the contents of the layer are visible. By making the Eye icon disappear, by clicking on the Eye, the layer is invisible. Notice in the following figure that the green circle is no longer visible in the image; not surprisingly, that layer does not have an Eye icon next to it in the Layers palette. Note: A layer can be active and yet invisible.

The Text Layer

The text layer cannot be activated unless the file is in a Photoshop file format (PSD). See the section titled "Demo: Applying a Drop Shadow" in Chapter 18 to learn how to export your file into the PSD format.

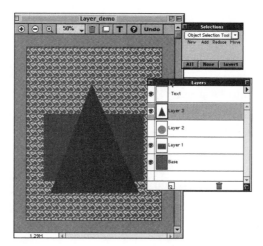

Layer 2 visibility is turned off.

Deleting Layers

This can't get much simpler. If you want to delete a layer, grab it in the Layers palette and drag it onto the Trash Can icon at the bottom of the palette. If you goof up and drag the wrong layer—or change your mind—you can undo the action (remember, however, that you can undo only the last action you performed). If you are not quite sure you want to delete a layer, try hiding it instead (see the preceding section to learn how).

Making Multiple Layers Invisible

More than one layer can be made invisible at the same time, but at least one layer in the image must be visible.

Understanding Layer Hierarchy

The only thing that is better than having layers is the ability to shuffle the layers up and down the Layer pile or stack. A layer on top of the stack will always cover whatever layer is below it. But, you can take this top layer and move it lower down the stack, closer to the base. This allows us to change how the layers, and the elements on the layers relate to one another.

Before we delve into layer hierarchies, let's draw on the layers of the image we created in the section titled "Using Layers: The Basics" (If you want to save some time, open up the image Layer_demo.pdd from the demo CD):

1. Activate Layer 1 and be sure its Eye icon is visible.
2. Draw a rectangular selection (it should cover about half of the image), and fill it with red.
3. Hide Layer 1.
4. Activate Layer 2, and be sure its Eye icon is visible.
5. Draw a circular selection (again, try to make the selection fill about half the image) and fill it with green.
6. Hide Layer 2.
7. Activate Layer 3, and be sure its Eye icon is visible.
8. Use the Polygon selection tool to draw a triangle, and fill it with green.
9. Save the file. You've come too far to lose it now! It should look like the following figure.

To demonstrate the hierarchy of the layers, do the following:

1. Show all three layers (the Eye icon for each layer should be visible in the Layers palette). Notice how the green triangle on the top (Layer 3) covers all the layers below.

All layers are visible.
Notice how layers cover
one another.

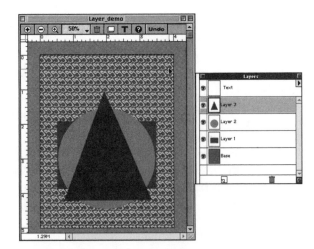

2. Hide Layer 3; the Layer 2 circle covers the square on Layer 1. This demonstrates that each layer covers the layer below it.

3. Let's shuffle the deck a bit. With your cursor, which should look like a little hand, grab Layer 3 in the Layers palette and pull it down below Layer 2. The green circle will be the top layer, covering the layers below it. This is a great way to hide an element behind another element, as shown here.

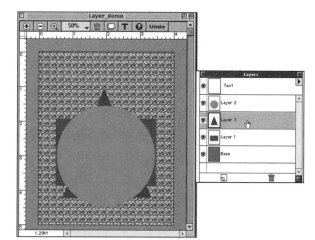

Layer 3 is now positioned below Layer 2.

Working with Layers

After you've got the basics of using layers down, you can get into the nitty-gritty of really making them work for you.

Rotating, Distorting, and Resizing Layers

While you have a layer activated, open the Selection palette (open the **View** menu and choose **Show Selection**) and select the **Object Selection** tool from the drop-down list. As soon as the layer is selected, the selection handles appear. As before, you can resize, distort, and rotate the layer. Remember, all the objects on the layer are going to be affected. If you want to rotate just one part of the layer, you must first select that area using the Rectangle or Trace tool.

It Even Happens to a Pro!

I've noticed, more than a few times, that getting the Object Selection tool can be troublesome. I'm sure there is a good reason for this, but I keep doing it anyway. Try choosing another selection tool, and then going back to the Object Selection tool. This time you should get the right tool to activate.

Moving Layers

To move a layer within an image, do the following:

1. Click to activate any layer in the Layers palette.

2. Press **Ctrl+G/Command+G** to move the layer. Your cursor should change into a four-sided arrow.

3. Place the cursor over the image itself, and then press and hold the mouse button down.

4. Move your mouse to move the layer.

To move a layer from one image to another, do the following:

1. With Layer_demo.pdd image still open, open up any other image.

2. Position the images so that both are visible onscreen (if you need to make the images smaller, go ahead).

3. Use a selection tool to select an area on the new image. Don't be cheap, pick up a good amount of the image.

4. Press **Ctrl+G/Command+G** to select the Move tool. Your cursor should change into a four-sided arrow.

5. Drag the selected area onto the Layer_demo.pdd image; doing so activates the demo image.

6. Take a look at the Layers palette; the new element appears as a *floating layer*.

Don't Want to Use the Layers Palette?

If you don't feel like using the Layers palette to activate the layer you want to move, click directly on the object in your image that you want to move. (Note that if you inadvertently pick the wrong spot, you might activate the wrong layer.)

The new selection is added as a floating layer.

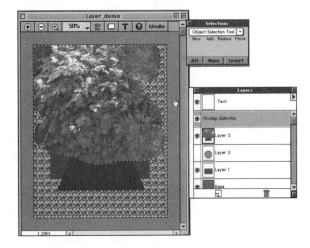

7. To make this a new layer, drag the floating layer to the icon at the bottom of the Layers palette that resembles a piece of paper.

8. The Layer Option dialog box opens; name the new layer, and click **OK**.

Demo: Beautifying Your Garden by Copying and Pasting Layers

Floating Selections

When you make a selection, it *floats* between the layers, which means that you can apply that selection to any layer. However, it is effective on the active layer only.

One way to manipulate an image is to copy sections of it and paste them elsewhere in the image:

1. Be sure the Selection and Layers palettes are open on your screen.

2. Insert this book's companion CD into your computer's CD-ROM drive, and open the image Greens.tif.

3. Zoom in on the flower on the right side of the image.

4. Choose the **Color Wand** tool from the Selection palette's drop-down list.

5. Click the flower (be sure your tolerance is set to 32; if you need help with this, see the section "The Color Wand" in Chapter 14, "Eeney, Meeny, Miney, Mo: Selections"). You might have to click the **Add** button in the Selection palette to select the entire flower, and you might need to use the Trace tool to trim your selection if you grab some of the green leaves by accident.

Zoom in to get a close-up view of the flower and select it.

6. Open the **Edit** menu and choose **Copy** (alternatively, press **Ctrl+C/ Command+C**, the same keys used in almost all programs, word processing and spreadsheets alike, to perform copy-and-paste operations) to copy the flower to the Clipboard.

The flower element is pasted onto the leaf. Note that the selection handles are automatically present.

7. Open the **Edit** menu and choose **Paste** (alternatively, press **Ctrl+V/Command+V**).

Got a Bug!

Well, I think we just found a bug in the program! When a new image is created, the base (lowest) layer is called Layer 1 by PhotoDeluxe. When an image is open, such as one taken with a camera, the base Layer is called Layer 0, again by PhotoDeluxe. Very interesting and confusing, also! Maybe Adobe has a reason for this, but for now it eludes me. Sorry about this, folks.

8. Zoom out to get the entire image onscreen. Notice that you have created a new layer, called Layer 1, in the Layers palette for your new flower, and that the entire flower is selected (which allows you to move, rotate, and resize it). This flower is a new element.

9. Press **Ctrl+G/Command+G** on your keyboard to bring up the Move tool (your cursor should change to resemble a four-sided arrow).

10. With Layer 1 still active, move the flower, placing it somewhere that you think looks good.

11. Before we go too far and confuse ourselves, let's rename Layer 1. Double-click Layer 1 in the Layers palette to open a dialog box, and type `1st Flower Copy` in the **Name** field. Click **OK**.

12. At the bottom of the Layers palette, notice the icon that looks like a piece of paper. This is the Duplication icon. Drag the 1st Flower Copy layer over the **Duplication** icon; after a moment, you get a new layer called **1st Flower Copy 2**.

13. Rename this new layer 2nd **Flower Copy** (original, huh?).

The copy of the Flower Copy layer is named 2nd Flower Copy.

14. Click to activate the **2nd Flower Copy** layer in the **Layers** palette.

15. Press **Ctrl+G/Command+G** on your keyboard to bring up the Move tool (your cursor should change to resemble a four-sided arrow).

16. Place the four-sided arrow over the **2nd Flower Copy** flower, and move it wherever you want on your image. You have moved the duplicate of the duplicate of the original flower.

17. Repeat this process as many times as you like; put flowers everywhere! (Keep track of the layer names to avoid confusion.)

Deleting Extra Layers

If you are finished using a layer and want to get rid of it to avoid confusion, drag it over the **Trash Can** icon.

Copying and Pasting Between Images

Not only can you copy and paste within a single image, you can also copy a portion of one image and paste it into another image. Often, when you paste part of one image into another image, the pasted-in area seems too large or too small. After all, when you took the two different pictures, you probably weren't standing the same distance from each subject. To resize the pasted-in area, select it using the Object Selection tool and resize as needed. (If you need help with resizing using the Object Selection tool, refer to the section titled "Resizing Your Image" in Chapter 13, "Improving Your Images.")

Erasing Layers

The Erase tool allows you to erase pixels from one layer, and have pixels from the layer below show through. This can be quicker than making a selection and then deleting an area. To use the Erase tool, open the **Tools** menu and choose **Erase**. Choose a brush size from the Erasers palette, and then drag the Erase tool over an active layer (use a large fuzzy brush and carefully erase around the edge of your image to achieve a nice blended effect).

The Erase tool allows you to erase pixels on one layer and have pixels from the layer below show through.

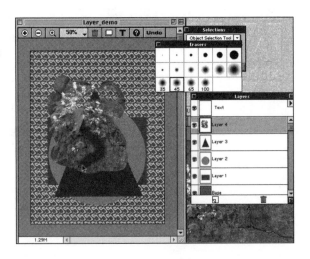

Transitioning from One Layer to Another

When you place one layer on top of another—especially if the top layer has been selected and copied or cut from one location to another—you sometimes end up with what I call a *cookie cutter* effect, where the edges look abnormally sharp. Follow these steps, and I'll show you what I mean!

1. Be sure the Selection and Layers palettes are open on your screen.

2. Insert this book's companion CD into your computer's CD-ROM drive, and open the image **Greens.tif**.

3. Zoom in on the flower on the right side of the image.

4. Choose the **Color Wand** tool from the Selection palette's drop-down list.

> **Keep an Extra Layer**
>
> The first stroke you make with the erase tool can be undone using "Undo." But after you start the next stroke, the stroke before it can no longer be undone. My suggestion is to duplicate the layer you are about to erase, and keep the duplicate in reserve in case you goof. When you are happy with your eraser effects, you can go back and delete the extra layer.

5. Click the flower (be sure your tolerance is set to 32; if you need help with this, see the section "The Color Wand" in Chapter 14). You might have to click the **Add** button in the Selection palette to select the entire flower, and you might need to use the Trace tool to trim your selection if you grab some of the green leaves by accident.

6. Open the **Edit** menu and choose **Copy** (alternatively, press **Ctrl+C/ Command+C**, the same keys used in almost all programs, word processing and spreadsheets alike, to perform copy-and-paste operations) to copy the flower to the Clipboard.

7. Open the Tower.tif image from this book's companion CD.

8. Paste the flower on the top of the tower in the Tower.tif image (open the **Edit** menu and choose **Paste** or press **Ctrl+V/Command+V**). The flower appears on the bank building.

9. Zoom into the flower. You will notice that the edges look very sharp—what I call a *cookie cutter* appearance.

Two methods are available to correct this cookie-cutter appearance: Feathering and Blending.

The flower is pasted onto the building creating a new layer. Doesn't it look good here?

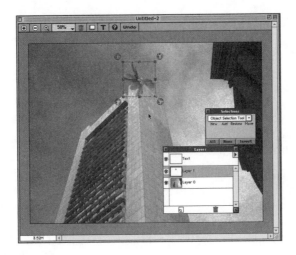

Feathering

Many imaging software programs allow you to *feather* a selection, which makes the elements on one layer "flow" nicely to the layer below. Using the previous example, you can soften the edges of the flower and make it blend a little better into the building by doing the following:

1. Be sure the flower's layer is active, and then open the **Effects** menu and choose **Feather**.

2. The Feather dialog box opens. The boxes along the bottom describe what part of the image will be deleted when it is feathered. Choose **Delete Background** to delete everything that exists outside the selected flower in that layer (in this case, whitespace).

Use the Feather dialog box to blend your images together.

3. Use the field in the upper-left corner to set the amount of feathering (that is, how much of the flower's edge will be deleted to soften the image). The number you enter varies depending on the size of the floating image and your image resolution. You'll have to experiment with it until you get the hang of it, but for now, type **5**.

4. Click **OK**.

5. Drop your selection (**Select, None**) to get rid of the dancing ants; the final image should look somewhat like this one.

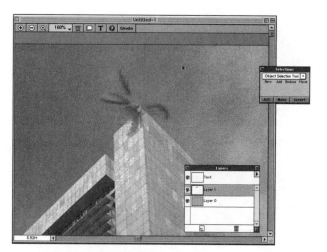

The final feathered flower.

Demo: Using Feathering to Make Cameos

You can use the **Feather** dialog box to create a nice cameo:

1. Open any image (a portrait works well).

2. Using the Oval selection tool, draw an oval selection on the image.

3. Open the **Effects** menu and choose **Feather** to open the Feather dialog box.

4. Because we want a nice, big, soft feather, let's dial in a high number in the **Feather** box (I entered **30**).

5. Double-click the **Color** box to open the Color Picker dialog box.

6. Pick your color, and click **OK**. The color you selected appears in the **Color** box in the Feather dialog box.

7. Click the **Fill Background** selection box (we want the color we selected in step 6 to be outside the oval selection).

8. Click **OK**.

Experiment!

Remember, you can undo the feather and play around until you get the effect you like. Experiment with all the options to get the hang of how feathering works. Mastering this part of cutting and pasting really makes your images come together and look untouched (of course, we know better).

A selection is made around Wrinkles the Wonder Dog and a feather of 30 is chosen in the Feather menu.

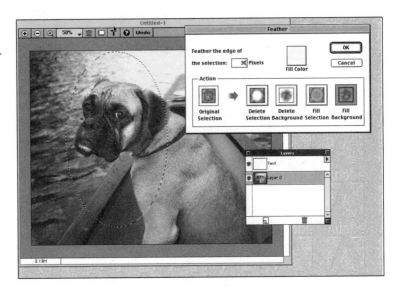

The feather tool can be used to create feather-edged fills.

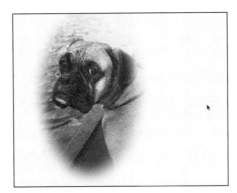

Blending

The *blend mode* describes how each layer interacts with the layer below it. To set the blend mode, double-click a layer in the Layers palette to open the Layer Options dialog box.

The Layer Options dialog box is where you control the blend and opacity of your layer.

This dialog box's Blend offers these options:

➤ Select **Normal** so that the top layer completely covers the layer below.

➤ Select **Color** so that the hue and saturation of the active layer's colors are visible, with the layer below the active one keeping all its shadows and highlights.

This is a good way to lay a color tone over an image while retaining the original image detail.

➤ Select **Lightness** to apply color to pixels in the active layer that are lighter in color than pixels in the layer below. All the pixels darker than in the layer below are left alone.

➤ Select **Darkness** to do the opposite, applying color only to pixels in the active layer that are darker than in the layer below.

➤ Both the **Overlay** and **Difference** options require a technical explanation that, when finished, would not help you understand what they do. Suffice it to say that they both involve multiplying or comparing color information—they can, however, produce cool results. The best thing to do with these modes is to try them out.

The best thing to do is to experiment to see how the blend mode affects each layer. Sometimes the effects are subtle, whereas other times they are dramatic. Try them out and have fun.

Blending by Adjusting a Layer's Opacity

The opacity of each layer can be controlled individually, providing a wonderful way to blend images into one another. Setting the opacity is easy to do, and the results can be dramatic. To set a layer's opacity, do the following:

1. Double-click a layer in the Layers palette to open the Layer Options dialog box (refer to the previous figure).

2. Type a percentage in the **Opacity** field. Choosing 100% means that the layer will be completely opaque. If you want the colors in the layer to resemble tints rather than being robust, try setting this field to 50%.

Flattening Your Image

Every layer you add to your image effectively doubles the size of the file. If you have a few layers going, your file size can creep up quickly (don't ever try to print an image that is still in layers: It takes forever).

When you have finished working on your image and you are delighted with it, you can *flatten* it before you save it. This reduces the file's size. Click the triangle in the upper-right corner of the Layers palette and choose **Merge Layers** from the menu that appears. All the layers merge together; save your image, and you're done!

Hidden Layers

Note that any layer that is hidden (no Eye icon appears next to it in the Layers palette) will not be flattened. At this point, you might want to delete the invisible layer.

The Least You Need to Know

➤ Elements can rest on their own layers.

➤ Layers can be rearranged in their hierarchy.

➤ An element on a layer will cover the element on a layer below it.

➤ A layer can have opacity.

➤ Selections can be feathered.

Filters: Funky and Fun

In This Chapter

➤ What's a filter?

➤ Applying filters

➤ Applying multiple filters

Filters can be used to improve or add visual effects to your photos. Sharpening filters make your images look crisp and clear. Blur filters help you create effects such as depth of field and can help blend areas of your image together. Artistic filters can add texture, color, brush strokes, and a whole range of visual effects to your images. A whole range of filters are available to help you make your imaging experience fun and enjoyable.

Daddy, What's a Filter?

Filters are magic! Well, okay—to be honest, filters are simply mathematical formulas (called *algorithms*) that, when applied to an image, perform a specific task. That task can be as simple as finding every green pixel and changing it to red, or as complex as finding every pixel that has a neighboring pixel darker than it and darkening it. Some filters are easy to apply to an image and *actuate* very quickly, whereas others cause your computer to grind away for many minutes.

Sharpening Filters

The most amazing—and most used—filters are the sharpening filters, which we covered way back in Chapter 13, "Improving Your Images." These filters, and in fact much of digital photography, owe their existence to scientific and military research. The ability to single out a specific star amongst a cluster of constellations or to determine the crop yield of a Nebraska farm from space is all due to digital photography and the filtering, or sharpening, of digital information.

Whoa, There!

Filters can be a lot of fun to play with; making and applying special effects to your images can keep you busy for hours on end. You can create new "looks" for your images, and change their mood and intent. But before I let loose and describe all the wonders of filters, I must warn you that filters can be harmful to your images if used in excess or applied too strongly. I might or might not have been the first to coin the phrase *filter surfing* (trying out every filter until you find one that you like), but I believe it describes a serious problem in that covering up an image that might not be good in the first place with filters might not make the image better.

Use filters sparingly. Let them add a sparkle or a subtle hint to your photos. Don't apply a filter just because you can. If you find that you need to apply filter after filter to make your image look better, I've got some news for you: You probably don't have a good image to start with. Leave your image alone, retake the image if you can, or go on to another image. When I teach digital photography or electronic imaging, I don't let my students anywhere near filters until they demonstrate creative composition and basic photographic skills.

Obtaining Filters

Many filters are included with your basic imaging software, whether it be PhotoDeluxe, Photoshop, or any other program that might have come bundled with your camera. Many companies, such as Meta Creations, Extensis, and Eye Candy, offer specialized filters, or *plug-ins*, for your imaging software. (Filters are often called *plug-ins* because of the way they are added onto the original program code. Most programs have a folder called Plug-ins, where the filters are stored.) Some of these filters can be had for free, whereas others might cost up to $150.

Any number of third-party filter companies have Web sites where you can get information and descriptions about their filters. Many also offer a demo version of their product for you to download. In most cases, demo filters are limited in their functionality or durability—but you can be sure that there will be more than enough to whet your appetite. Note: If you decide you like a filter's demo version so much that you can't live without the real thing, be sure that it will be able to run on your platform and with your specific version of software. It would be a shame to find out that the $100 filter you just purchased won't work with your software unless you upgrade or spend even more money on more RAM.

On the CD...

We have included many wonderful plug-in filters on the demo CD. Enjoy them!

Practice Safe Downloading!

Viruses travel from computer to computer, hidden within files or even as files with friendly names. New viruses are being created every day, and they are getting more and more dangerous. They might well gain access to your computer during downloads from the Internet or from email attachments. So before you go downloading filters willy-nilly from the Internet, by all means, buy some virus-detection software!

Many varieties of virus-detection software are on the market; one example is Virex, which looks at every file, disk, or download that comes near your computer and evaluates the files for viruses. Virus-detection software companies post "inoculations" for new viruses on their Web sites. No matter what type of virus-detection software you decide to buy, install it and keep it active at all times.

When you download a file—no matter where it came from—check it for viruses. If you receive a file attached to an email message, run the file through a virus checker *before* you open it. (Note that viruses cannot be transferred via email messages themselves—only through file attachments.)

Let's Go

We could explore every filter ever known to man, but that would take a lot of time—and it would also take all the fun out of it for you. Instead, we will look at one or two filters in a few of the filter families or groups. A good way to familiarize yourself with the various filters is to open an image and pull down the *Effects* menu. There you will find many filters. Go ahead and try out any filter that catches your fancy, and enjoy yourself!

When working with filters, keep the following in mind:

➤ Most filters in PhotoDeluxe can be found in the **Effects** menu.

➤ Filters can be applied to entire images, but you can also isolate an area of an image, applying your filter only to the selected area. (I often create a small test selection and apply the filter to that area first, which allows me to test the filter without wasting a lot of time.)

➤ If you don't like the result of a filter, immediately undo it by pressing **Ctrl+Z/Command+Z**.

➤ Save your images before you apply filters, or work on a copy.

Artistic Filters

Artistic filters are generally filters that add effect over the top of images, such as adding colored pencil strokes or glowing colors. PhotoDeluxe provides tons of different artistic filters; here, we'll take a look at the Colored Pencil filter.

1. Open the Flowers/Rock.tif image on this book's companion CD-ROM.

2. Open the **Effects** menu, choose **Artistic**, and select **Colored Pencil**.

3. The Colored Pencil dialog box opens; click and drag the three different sliders to vary the filter effect. The preview area enables you to see how the filter effect will look before you apply it to the entire image.

Many filters use dialog boxes with preview areas to help you visualize the filter's effect before you apply it.

4. Click **OK** when you like what you see in the preview box.

5. Open the **File** menu and choose **Save As**, and rename the image to preserve the original.

Blurs

Usually, blur filters are used to improve image quality. However, in some cases, such as with the Motion blurs or Circular blurs, very nice effects can be rendered:

1. Open the image Old Tree.tif from this book's companion CD.

2. Open the Layers palette (**View, Layers**).

3. Duplicate the base layer by pulling the layer down over the "page" icon at the bottom of the Layers palette.

4. Click the duplicate layer in the Layers palette to activate it.

 Open the **Effects** menu, choose **Blur**, and select **Motion Blur** to apply the filter to the entire selected layer.

6. Adjust the settings however you like, and click **OK**.

The Preview Area

You can zoom in or out of the preview box by clicking the + or − button below the box. If you put your cursor on the image inside the preview box, you can drag the preview to view a different section of your image. This comes in handy when you want to check an effect on a specific part of your image.

You can leave a portion of your image unaffected by a filter. Check out the lower-right part of the tree. I used the **Reduce Square Tool** *and unselected the area. The filter was applied to the rest of the image.*

As an Alternative...

Another way the same effect described in the previous set of steps involves a bit more brush work: Use the Eraser tool to erase the unwanted blur from the upper blur layer. (Keep your Undo techniques handy in case you erase something you wanted to keep.) Both methods work well; I would probably use a combination of both to facilitate control. Remember, there are many ways to achieve effects and perform tasks in PhotoDeluxe!

You'll notice the entire layer has blurred. A little much, don't you think? Your goal is to have the motion blur affect only the tree branches themselves:

1. Click the base layer in the Layers palette to activate it.
2. Using the Trace selection tool, loosely trace around the tree.
3. Invert the selection.
4. Activate the duplicated layer (the one with the blur effect).
5. With your selection still inverted, press the **Delete** key.

Voilà! The base layer shows through the top blur layer.

Smudge Tool

Similar to blurring, the Smudge tool enables you to, well, smudge areas of your image. As you drag the Smudge tool through an image, the image "melts" and follows the cursor. (You can go over an area a few times to enhance the effect.) The floating palette for this tool, which you access by opening the **Tools** menu and choosing **Smudge**, enables you to pick the smudge's size and fuzziness; no color selection need be made. This is a slow filter, which is why I'm not its biggest fan.

Using the Smudge tool gives the building a wind-blown effect.

Using the Page Curl Filter, Layers, and the Text tools, a nice little album cover can be made.

PhotoDeluxe Filters

PhotoDeluxe comes with a few filters that have been included by Adobe. These filters are sometimes supplied by third-party software developers and can vary from version to version.

To access these filters go to **Effects**, **PhotoDeluxe** and for this illustration add **Page Curl**. As you can see, this is not a filter you can use everywhere, but it can come in handy. I'll show you how I made a quick opening page for a Web site:

1. Open up an image that you want to use for the vacation shot.

2. Add a new layer above the vacation shot from the Layers Palette. You can refer to Chapter 19 if you need help with this.

3. Select the entire new layer (**Ctrl+A**) or (**Command+A**). Fill the layer with a solid color, (**Effects**, **Selection Fill**.) Save your file for good measure here.

4. Now use the page Curl Filter (**Effects**, **PhotoDeluxe**, **Page Curl**). Coool, huh? We're almost there.

5. Using the **Color Wand** from the **Selection Palette**, select the right side of the page, below the curl. Now press your delete key. Voilà, the "vacation" photo shows through under the curl. If you need to, you can adjust the size and position of the "vacation" photo. The easiest way to do this is to duplicate the "vacation" layer, and place it above the original "vacation layer" in the **Layers Palette**, and then use the free resize under the **Resize** menu. (See, we're using every trick in the book here!)

6. Okay, one more step. Save your file because you've come too far to lose it now! Using the **Text** tool from the **Tools** menu, go ahead and drop in some type. You're done! Save your image and pat yourself on the back—you are becoming a pro!

Texture Filter

Don't close that image just yet; I'm going to show you how to use one more filter. This time, we'll use the Texture Filter from the Effects menu. Texture filters can be a lot of fun and can be used to create many wonderful backgrounds. Don't be afraid to experiment. Try using a few different filters together to achieve unique effects. There are also many third-party filter software programs such as Alien Skin that will help you along with some special effects.

1. Open up the Page Curl demonstration you made previously. (If you didn't do the demonstration and just followed along, keep on following!)

2. Go to the layer of solid color (the layer with the page Curl) and activate it (click on the layer name in the **Layers Palette**. The layer will highlight and activate).

3. Go to **Effects**, **Texture**, **Crackle**. This will be very quick. Select the filter variations you like from the Crackle menu by adjusting the sliders. You can see what you'll get in the preview box. When you like what you see, hit the **OK** button. How about that: Now you have a leather-bound album!

Demo: Applying Multiple Filters

More than one filter can be used on an image. You can build some interesting effects by applying one filter on top of another:

1. Open the **File** menu and choose **New** and create a new image that is 4 inches wide, 5 inches tall, and 150dpi. (Actually, you can make it any size you like, but this will match the demo image that can be found on the CD.)

2. Use the selection tools (**View, Selections**) and select the entire image.

Start with a solid color background.

3. Go up to the **Effects** menu and fill the entire image with a solid color (**Effects, Selection Fill**) (I chose blue, my favorite color—today).

4. Open the **Effects** menu, choose **Noise**, and select **Noise** again.

5. In the **Noise** filter dialog box, click the **Gaussian Blur** option button, and type **155** in the **Amount** field.

6. Click **OK**. Nice background!

7. Using the Rectangle selection tool, select about two-thirds of the center of the image.

Experiment!!!

You don't have to use the filters I have in this demo; use any ones you want. By all means, experiment!

Noise filter applied to solid color background.

8. Open the **Effects** menu, choose **Blur**, and select **Motion Blur**.

9. Adjust the settings however you like in the Motion Blur dialog, and click **OK**.

10. Again using the Rectangle selection tool, select an area inside the blur area.

11. Open the **Effects** menu, choose **Distort,** and select **Ripple** to apply the Ripple filter to the image. Your results, which are subtle, should look like the following image.

12. To take the image one more step, draw another selection and invert the colors by opening the **Effects** menu and choosing **Negative**. The final image, called noise demo.tif, can be seen on the demo CD.

Apply a motion blur to the selection.

The Ripple filter applied to center of motion effect. Look closely; the effect is subtle.

The Least You Need to Know

➤ A filter is a mathematical algorithm that is applied to the image.

➤ Besides the filter that comes with your software, third-party filters can be purchased.

➤ You can select areas of your image to filter and also protect areas from being filtered.

➤ You can use multiple filters together on the same image.

What You See Is What You Get: Calibration

In This Chapter

➤ Color calibration

➤ Calibrating your monitor

➤ Calibrating your printer

➤ When all else fails

The next time you are in an appliance store, take a good look at all the televisions lined up next to one another. You will notice that every screen in the store looks different! Some are dark, some are light, one is too green, and another is too contrasty. But which one has the *right* color? Which one do you prefer? Is the one you prefer the right one?

You have run smack into one of the most aggravating problems of digital photography: color management. How do you know that what you see on your monitor is correct? If the image looks good on your screen, will it look good on someone else's? Will it be too dark, or too green? Will the contrast look right?

Color management doesn't end at the monitor; printers can also wreak havoc. Every printer reproduces an image differently. You can go to a computer store and print the same image on three different brands of printers, and get three totally different results. In fact, you can take three printers of the same model and get three different-looking prints.

But have no fear. Color can be successfully and easily managed. With a little bit of testing and careful planning, you can get consistent and predictable results every time.

How the Pros Do It

To get a good idea of how color management can be achieved, I am going to talk you through a system that professional photographers and printers use; we will adapt it so everybody can use it without too much trouble. This system not only provides consistent color, but also allows for different devices (monitors and printers) to be swapped in and out and have the color results remain the same. We're going to get a little technical here for a while, so don't worry if you get confused. Just sit back and relax, and it will all make sense in the end.

CIE

Suppose you took all the colors that the human eye can perceive and globbed them all together in a three-dimensional space, such as a cube, sphere, or even a pyramid. It doesn't matter which colors went where in the space or whether the dark colors were on the inside of the space or the outside. The important concept here is that the colors all have a relationship to one another, and that relationship exists in three dimensions.

To describe where a color exists in that space, you can use a system based on three axes: L, A, and B. In this manner, you can accurately describe where a specific color is in the color space. For example, suppose that the color "Fire Engine Red" exists at 44-L, 25-Y, and 100-Z. (I made these numbers up; don't go looking for them!) As long as the color world we made up stays consistent from person to person, the coordinates used to describe the location for the color "Fire Engine Red" will be the same for each person.

*A simple diagram shows the three color axes used to describe the L*A*B* color space.*

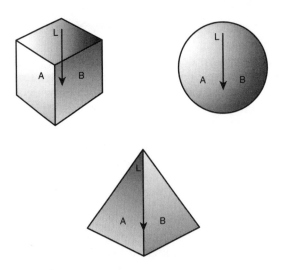

Well, in 1931, the folks in the Commission Internationale de l'Eclairage (CIE) made up a color world just like we just did; they called their system *CIE LAB*. As long as everybody uses the CIE LAB space and its numerical description for finding colors, everybody will be looking at the exact same color when given its description. That is, when we are told to look at 65-L, 62-A, 64-B (orange), we will all be looking at the same color. This consistent approach to describing color is the key to color management, in that you can use this color model as a constant, or control, to compare other colors and color devices to.

So, What's Wrong with RGB/CMYK?

All through this book, I have been talking about RGB and CMYK color spaces. So, why all of a sudden am I hawking CIE LAB? Here's the deal: Both RGB and CMYK color spaces describe how *much* color is present. The RGB color space describes how much red, green, and blue light is present—in the case of a monitor, how many pixels are illuminated and at what intensity. CMYK, which is used in printing, describes how much cyan, magenta, yellow, or black ink is on the paper.

The problem is that different monitors use more or fewer phosphors to produce the same color. On monitor A, you might need 235R, 28G, 28B to produce Fire Engine Red. On monitor B, 235R, 25G, 31B will produce the exact same color. In a like manner, for CMYK, different quantities of ink are used by individual printers to reproduce the same color.

Because the RGB and CMYK color worlds measure how much phosphor or ink is needed to reproduce a color, both systems are considered *device dependent*. Depending on the device, a color's description changes according to what is needed to reproduce the color. Because the CIE LAB space describes where a color is in its color world and not how much ink or phosphors are needed to render the color, the color space is considered *device independent*. No matter what device is used, Fire Engine Red will look the same—although different devices will use differing amounts of inks or phosphors to reproduce it.

ICC Profiles

Using the CIE LAB color space, you know how to describe every color we want, including Fire Engine Red. Now that you have a target to aim at, you need a method to tell you how far you are from that target. The International Color Consortium (ICC)—which is made up of a group of industry leaders such as Kodak, Adobe, Apple Computing, Agfa, and many more—developed a method to do just that.

The ICC system is simple. With it, you can calibrate every device that handles color. To begin, you display series of colors for which you know CIE LAB coordinates on your monitor or printer (I'm using a monitor for this example). After a color is displayed (say, for example, that you're displaying color L-100 A-80 B-60), you must use a monitor calibrator, shown here, to measure it. The calibrator reads the color displayed by the monitor, and describes it in CIE LAB space. So suppose the L-100 A-80 B-60 color you sent to your monitor measures up on your screen as L-98 A-80 B-60. What do you do, panic? Nope, you're a professional. You take note that your monitor is –2 from your CIE LAB space. This notation is called an ICC *profile*.

Monitor calibrator measuring monitor color to develop an ICC profile.

Dial Me In

Monitor calibrators are a very handy tool to help calibrate your monitor and are easy to use. They are a simple device which attach to the front of your monitor with a small suction cup. Here they will read the colors displayed by your monitor. With the aid of monitor calibration software, a monitor can be calibrated or profiled.

Many professional-grade monitors come with calibration packages and monitor calibrators included. You may also purchase calibrators and software separately. These devices and software might range in price from $100-$1,000. Unless you are very serious about your color, or a professional photographer, a low- to midrange calibrator will do. The best place I have found to purchase a calibrator is through a catalog or on the Web. Take a look at `http://www.color.com` (Color Solutions) to learn more about color-management software and calibrators.

Calibrating Monitors and Printers

So your ICC profile indicates that your monitor is off. What do you do? Well, it depends on what system you have, and what software you use to handle your digital images.

I have a confession: The ICC profile system I have been describing works only for Macintosh and Windows NT systems, and for Photoshop Version 5 and beyond. It will not work if you are using PhotoDeluxe or Windows 95/98. But fear not; I promise you that we'll work out a color-calibration method that will work on all systems.

Calibrating a Monitor with Macintosh/Windows NT

Macs have a Color Sync control panel, which coordinates, keeps track of, and implements, all of the profiles you have developed. (A similar

ICC Profiles

Many devices, such as printers and monitors, are supplied with ICC profiles so you don't have to make your own. Many systems, such as the new iMacs and the G-3 Macs, come with entire libraries of ICC profiles. Window NT systems also support ICC profiles. If you have access to a monitor and printer calibrator and you are running a Mac or a Windows NT system, you can make your own ICC profiles. Maybe soon Windows 99 or 2000 will also be able to use ICC profiles.

tool is found on Windows NT systems.) The ColorSync control panel reads the profile you developed for your monitor. "Ah hah," it says, "according to its ICC profile, this monitor is –2. I'm going to add 2 to everything that the computer sends to the monitor. That way, the color #100 will look like it is supposed to." Pretty smart little control panel!

Every calibration system is going to go about the calibration task a bit differently, but here is the basic procedure.

1. Warm up your monitor by using it for about an hour.

2. Calibrate your calibrator. Your calibration software will have a procedure for this. Usually this will entail measuring a bright white color and an absolute black (measure by taking a reading with the calibrator's "eye" cover).

3. Attach the monitor calibrator to your monitor.

4. Start up the calibration software. You will see a series of colors, about 100-300 depending on the software, displayed on your screen.

5. After the light show is finished, your software will save the profile it makes in your ColorSync system-level folder.

6. It's a good idea to calibrate your monitor about once a month or after you have moved your monitor from one room to another, for example.

The File Remains Intact...

It is important to note that the ColorSync control panel does not change the original file. It changes only how it is reproduced on the screen or the printer. When the file is sent to someone else's printer or monitor, and that person has ICC profiles for his or her devices, the file will reproduce just the way it did on your system.

If you were to calibrate a second monitor, this one with a profile of +4, the control panel would subtract 4 any time the computer sends color to the monitor. If you placed the two monitors side by side, both aiming at the same CIE color, both would display exactly the same color.

Calibrating a Printer with Macintosh/Windows NT

With Macs and Windows NT systems, you can calibrate printers in the same manner as monitors. Print a file containing colors whose CIE LAB values you know, and measure the printout with a printer calibrator, such as the one shown here. The calibrator, with a little help from some software, develops an ICC profile for the printer. For example, my printer reproduces the color #100 as #110, which means it has an ICC profile of +10.

A printer calibrator is used to read any reflective medium, such as paper.

When my system sends color to be printed, it subtracts 10 from the color as it is shipped to the printer. In this way, the color #100 will be reproduced as it should be, and also how it appeared on my monitor. This all happens on-the-fly and is controlled by the ColorSync control panel. If a different printer with a profile of +8 is hooked up to the computer, the computer will subtract only 8 from the color it sends to the new printer.

Calibrating a Monitor with Windows 95/98

If you use Windows 95/98, you cannot use the CIE LAB space and ICC profiles as a control reference. You must develop a new control source to use. Because most of your work will be viewed on your monitor, it makes sense to use the monitor as the control. You must, however, try to make your monitor as "unsubjective" as possible—that is, you need to find a way to make your monitor look like everyone else's.

On the CD included with this book, you will find a file called Monitor calibrator, a simple-stepped grayscale. Each step of the gray bar increases in steps of 10% from white to 100% black. Open this file and display it on your screen as large as possible without cropping it.

Monitor calibration file.

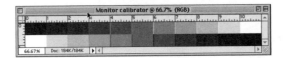

Before we start, let's be sure our monitors are set up properly. If you are running a Windows system, do the following:

1. Click the **Start** button, choose **Settings**, and select **Control Panel**.
2. Double-click the **Display** icon.
3. In the **Appearance** tab, click the **Color** drop-down list and select gray.
4. In the Background tab, select **None** in both the **Pattern** and **Wallpaper** lists.

The Display Properties box on a Windows platform is where you set background colors and make other adjustments to your monitor.

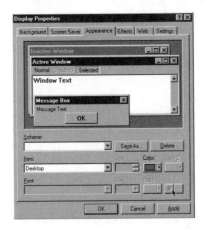

(If you are working on a Mac, it is still a good idea to set your background color to a neutral color—I prefer gray. The procedure is similar. Set your background color to gray in the Desktop Pictures Control panel. In this way, even though the ICC profiles and ColorSync will control your color, your eye will not be led astray by wild colors or distracting patterns.)

On both systems, be sure your color depth is set as high as possible. Your color depth is determined by what type of display card you have on your system, and what size monitor you have.

1. You will find the color-depth option in the Monitor control panel on both systems.
2. Set the color depth to "millions."

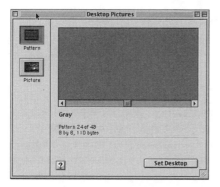

On a Mac, set the color depth and remove color backgrounds by using the color control panels.

3. If the only options you see are less than millions (thousands, for example), your display card does not have enough VRAM (Video RAM) to run your monitor. Either get a smaller monitor or have more VRAM installed in your system.

4. When all else fails, refer to your computer system manual or call for tech support!

Setting the Brightness Value

In the first part of the calibration process, you want to set the brightness value for your monitor.

(This procedure can be applied to both Windows and Mac systems.)

Please do the following:

Why Gray?

The reason I wanted you to set the monitor's background to gray was so your eyes would not be "polluted" or influenced by the screen color. If your monitor background is set to blue, all your images will have a yellow tint to them. (Remember, yellow is the opposite of blue.)

1. With the Monitor calibrator file displayed on your screen, remove as many screen options, dialog boxes, and other "clutter" on your screen as possible.

2. Find the screen adjustment controls for your monitor (on some models, these are small knobs that can be turned; on other monitors, like mine, you'll find small buttons that you can push to bring up a graphic control on your screen). Set the brightness and contrast controls at their midpoints. Take a look at the Monitor calibrator file on your screen; your goal is to manipulate the brightness and contrast buttons so that you get even steps between each shade of gray. In many cases, this step alone might be enough to calibrate your monitor.

3. If after step 2 your monitor is still uncalibrated, play with the brightness level until it is comfortable to look at, and then reduce it back about 20%. Then adjust the contrast so that the steps look even. This might take a while, and can be frustrating (which is why they invented monitor calibration meters).

313

Wait!

Don't confuse the color temperature with the color settings. You want to be able to adjust the red, green, and blue monitor guns individually.

Calibrating the Color

After you've gotten the brightness figured out, you'll want to go ahead and calibrate the color. Here's what you do:

1. Find the color controls for your monitor. Again, depending on what type monitor you have, these might be small knobs on the monitor itself, or you might be able to press a small button on the monitor to bring up a graphic control on your screen.
2. Adjust the color controls. The idea is to drive the colors on your monitor so the Monitor calibrator file looks dead neutral gray.

Helpful Hints

You might find that having a gray piece of paper on your desk as a reference might help. Be sure the paper is illuminated by daylight (if you use a desk lamp with an incandescent bulb, the gray card will look too yellow). Another good reference might be the clouds on an overcast day. You might want to go so far as taping a piece of paper over your monitor to block out anything that might distract your eye.

3. After you have the color set, leave the image on the screen and walk away for a minute. Go pet the dog or water your lawn. When you come back, take a look at the screen and be sure it still looks okay to you.
4. When you are satisfied with the color, open up a few images that you are familiar with. Be sure they look as you expect them to.
5. If you are happy with the settings, lock down your monitor's controls, or close and save the graphic control on your screen. If you have a set of dials that can be fiddled with, slap a piece of tape over the buttons to secure them. If you have a set of buttons on your monitor bezel, either tape over them or cover them with a "Warning: Do not change these settings under the penalty of [your punishment here]" sign.

Calibrating Your Printer with Windows 95/98

PhotoDeluxe Version 3 for Windows only offers a great built-in way to calibrate your printer:

1. Open PhotoDeluxe Version 3.

2. Be sure your color printer is online and working.

3. Check to see that you have paper in the printer that will be similar to what you will be printing your photos on.

4. Open the **File** menu and choose **Adjust Color Printing**.

5. The Adjust Color Printing dialog box appears as shown here. Check the **Adjust Color Printing** check box.

Paper Types

Paper types are a factor in calibration. If you were using a warm-colored paper or a glossy stock and switched to an uncoated or more neutral color, your results will change.

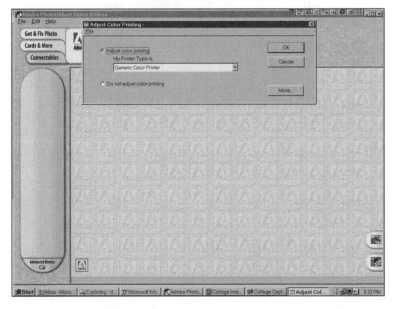

The PhotoDeluxe Adjust Printers tool makes calibrating your printer easy.

6. In the **Printer Type** pull-down menu, choose your printer type. If you don't see your printer in the list, try to pick a model similar to yours (many times, the difference between one model and another model from the same manufacturer might be only the paper capacity or page-per-minute speed); alternatively, choose **Other** or **Generic Color Printer**.

7. Click the **More** button to see the full dialog box.

8. Click the **Print** button. Follow the normal procedure for your system to send the image to your printer.

9. Compare the print your printer produced with the image on your screen. You will see nine different images on your page; find the one that best matches the image on your screen, and click the appropriate screen button. For example, if the image on the upper-right corner of your printout matches the sample image, pick #3.

10. Click **OK** to close the dialog box.

Drift

Remember that devices, especially printers, drift with age. As your monitor ages, it shifts color. When your printer's inks run low or toner cartridges begin to empty, you will notice a color shift in your printer. You might want to recalibrate both devices using the procedures in this chapter.

Now try a few prints. They should match your monitor. If they don't, you might want to go back and pick a different thumbnail button. If you find that none of the thumbnail options works for you, click the **Do Not Adjust Color** button and try that.

Manual Labor: Printer Calibration Made Hard

If you can't use Photoshop Version 3 or ICC profiles, you're going to have to calibrate by hand:

1. After adjusting your monitor using the instructions in the section "Calibrating a Monitor with Windows 95/98," open any image you like.

2. Cut and paste the Monitor calibration file into the image you opened; name the file `Original Image`.

3. Print the Original Image file.

4. Compare the print to the onscreen image. If it is an acceptable match, you are done. If, however, you feel the print is bluer and, say, darker than your onscreen image, you have some more work to do.

5. Copy the onscreen image and save it. Name the copy `Test #1`.

6. Adjust the color of the Test #1 image (refer to Chapter 13, "Improving Your Images") so that it is less blue (more yellow) and lighter. The idea is to drive the onscreen image the opposite the color of your print. (If your image is too red and too light, drive the test image toward green and make it darker.) You might have to adjust the contrast, also.

7. Keep track of the amount of color you added or subtracted from the test image, and how dark or light you made it. Jot this information down on a piece of paper—better yet—tape it to your monitor. Call these changes your "calibration set," which you will be applying manually as follows.

8. Print out the Test #1 image.

9. Open the Original Image file; close the Test #1 image or hide it from view. Does your new print look closer to the Original Image? You might have to go through this test a few times until you get a good result (remember to keep track of your color changes).

Applying this system is easy:

1. Adjust and manipulate any image you want to print, so that it looks best on your screen.

2. Save the image.

3. Before you print the image, apply the color, brightness, and contrast calibration adjustments you made previously (refer to your calibration set).

4. Print the image.

5. Your printed image should look like the image you had on the screen before you made your calibration changes.

I realize that this is a contrived and weird way to print out an image, but it works. You might find that your calibration set varies with different images, but it's a good starting point.

The Least You Need to Know

➤ Predictable color can be achieved by using ColorSync, which employs ICC profiles.

➤ Macintosh and Windows NT computer systems can take advantage of the ColorSync system. If you are using Windows 95/98, you must calibrate your system and apply the color management manually.

➤ You can make ICC profiles for your monitor and printer using a color calibration meter.

➤ If you do not have access to a monitor or printer calibrator, you can calibrate your system manually.

Part 5

Output

Seeing your image glowing on your screen is fun. Printing out your image is even more fun. Producing a beautiful print that is "suitable for framing" is a rewarding experience.

Printing is easy to do. By applying calibration techniques, you can make prints that look just like your monitor screen. What is more, is that you can repeat your results as many time as you like. Just think—you will never have to buy another greeting card again. Just flip on your printer and make your own!

Print It Out

In This Chapter

➤ Printing out your images

➤ Making multiple copies

➤ Printing directly from the camera

➤ Making contact sheets

The only thing more exciting than seeing your image appear on your screen is seeing it emerge from your printer.

In Chapter 4, we reviewed printers and described the benefits of the various technologies; now let's take a look at how to print out your images. Printing is fast, fun, and easy!

Get Connected

Before you spend a lot of time, paper, and ink, you should familiarize yourself with your printer. If your printer is not yet connected to your computer, connect it now—follow your printer's setup instructions and be sure to load all the printer drivers (computer-to-printer instructions) into your operating system. All printers should come with an installation program that will automatically install the printer, or at the very least guide you through the installation process.

It can be very frustrating to try to print out a photo from your imaging software only to have your printer sputter ink and spit out paper shreds. Try testing your printer out on familiar software, such as your word-processing software. That way, you will eliminate any questions about whether you have properly installed your imaging software. Chances are good that if your word-processing software prints correctly, your imaging software will, too.

Resolution: One More Time

I have talked about image resolution many times in the book; this is where it all pays off. If your image doesn't have enough resolution (that is, if your file is not big enough), you are not going to have good results. Your images are going to look *pixelated*, or unsharp. Without enough digital information, you won't see much in the way of detail. To put it more simply, garbage in…garbage out!

Printer Resolution Versus Image Resolution

You measure a printer's resolution by counting how many dots the printer can reproduce on a line one inch long. This is referred to as *dots per inch*, or *dpi*, and has pretty much been the standard of measure for a long time.

The Olden Days…

Back when "real" printing presses were used, resolution (or dpi) was determined by how many dots could be *resolved* on the negatives from which the printing plates were burned. (Negatives were made and then contact printed, or burned, onto a metal plate. The metal plate was used to transfer ink to the *blanket*, which in turn transferred the ink to the paper.)

Put simply, ppi, or pixels per inch (image resolution), does *not* equal dots per inch (printer resolution). Many printers can resolve many dots for each pixel in the image. Your best bet is to read your printer's instruction book to find out the optimal pixel-per-dot ratio.

Comparing Printers

Modern computer printers can resolve smaller and smaller dots than ever before. You might see printer manufacturers hawking "Micro Dot," "Tiny Dot," or even "Teeny Weeny Dot" technology. This differing terminology sometimes makes it hard to compare one printer with another. Unfortunately, the only real way to tell which printer makes the best prints is to test them and compare the results. Check out Chapter 4 for more information on how to evaluate and buy a printer if you haven't already done so (you weren't skipping ahead, were you?).

After you have found the optimal ppi for your printer, you can determine how large you can make your print. If you reverse the process, you can find out how big your file needs to be to make a specific-size image. For example, say your printer likes to see a 300ppi (remember, that's pixels per *inch*) file. If your file measures 675×1200 pixels, your output print will measure 2.25×4 inches (675 pixels/300 pixels per inch = 2.5 inches; 1,200 pixels/300 pixels per inch = 4 inches). In the same manner, if you want to print out a 6-inch-long image on that same printer, you will need a file that is 1,800 pixels long. In most cases, or when in doubt, assume that your printer likes to see 300ppi file resolution.

If you lower this ratio, you will start asking your printer to print at a less-than-desirable resolution, and your prints will look the same: less than desirable. For example, if you took that same 675×1,200 file and printed it out to be 5 or 6 inches long instead of 4 inches, your files would look less than optimal. You would start to see pixelization and fuzzy images.

LPI

When you bring your file to a commercial printer, yet another standard is used to determine file size and resolution. Commercial printers establish the resolution of a printed piece by counting how many lines (of all those dots) per inch can be printed. In trade lingo, this is called *lpi*. Ask your printer (the human one) what lpi he will be using. The standard ratio between dpi and lpi is 2:1, so if the job will be printed at 150lpi, your file should be 300dpi. If this gets really confusing, ask your printer how big your file needs to be for him to print the job at the size you've specified.

Let's Print!

To print your image from within PhotoDeluxe, do the following (note that you should read Chapter 20 if you haven't already; you will be glad you did):

1. Open your final, ready-to-print image. (That was easy.)

2. Use your selection tools to select the area of the image that you want to be printed. (If you want to print the entire image, don't select anything.)

Layers

If you haven't yet flattened the layers of your image, you can hide layers to prevent them from being printed. For more information about hiding layers, refer to Chapter 18.

3. Open the **File** menu and choose **Page Setup** to open the **Page Setup** dialog box, shown below (this dialog box might vary from printer to printer, and might look a little different depending on whether you're using a Mac or a PC).

4. Select which printer you will be printing to, and what paper size you will be using.

Paper Size

The paper size is important. If you are printing on a smaller-than-normal sheet of paper or on an envelope, you need to fill in that information here. Otherwise, you might find your printer losing track of the page count and not feeding paper correctly.

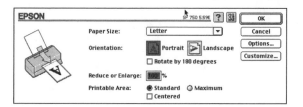

Set your paper size and image orientation in the Page Setup dialog box.

5. If you have not yet done so, set your image size and resolution. Do this by entering the appropriate information in the **Photo Size** dialog box (to view this dialog box, open the **Size** menu and choose **Photo Size**).

6. Preview the image to see how it will fit on your page (this is a great way to avoid wasting paper!); open the **File** menu and choose **Print Preview**. The choices you made in previous steps will affect how the page looks (if you need to, readjust your paper size or page orientation), and will become the default settings until you change them again.

The print preview will help you avoid making costly printing mistakes.

7. Okay, let it rip. Open the **File** menu and choose **Print** (alternatively, press **Ctrl+P/Command+P**) to activate the printing process.

8. The **Print** dialog box pops up on your screen. (This dialog box might differ depending on what type of printer you have; many of the options should be present, but arranged differently.) There are many options to play with here—you can choose paper quality, dpi, color inks, and the number of copies you want to print.

The Print dialog box will let you select the options for your printer.

Printing Multiple Copies

If you haven't printed your image out before, I suggest that you make only one copy to start with. Then, if you like the way it printed, go ahead and make as many as you like.

Printing Multiple Copies on One Page

It is a shame to waste paper, especially the good, high-quality, expensive stuff. If your image is small, why not print up a few on the same page? It will take only a few moments more to do, and you'll have copies to give out to all your friends. After all, everybody wants to see a picture of your kid's first bath (just as much as you wanted to see a picture of their kid's first haircut!).

If you have a copy of PhotoDeluxe version 3.0 hanging around, you are in luck. You can print multiple copies on a single sheet by opening the **File** menu, choosing **Print Multiple**, and making your selections in the dialog boxes that appear. For the rest of us using standard PhotoDeluxe or Photoshop, I offer a simple solution:

1. With your image open, open the **Layers** palette (**View**, **Layers**) Determine how many of these precious images you can fit on one page by sizing them. Remember to leave a little room on the edges of the page and to include space between the images.

2. Make as many copies of the original layer as you need (if you can fit four images on the page, make four copies). Refer to Chapter 18 if you need help with this.

3. Activate the bottom base original layer.

4. Press **Ctrl+A/Command+A** to select the entire layer.

5. Fill the layer with white. This will serve as the base or background color for your page, and will ultimately be the border of your print. (Refer to Chapter 15 if you need help with this.)

6. Activate each copied layer, moving each one into position on the page. Remember to leave space between each print for a border (if you want a 1/4-inch border around each print, leave a 1/2-inch space between the pictures because you will be cutting this border in half when you separate the prints).

Aligning the Images: Using Rulers

If you need help aligning the images, you can turn on the rulers along the side of the print by pressing **Ctrl+R/Command+R.** If you look carefully, you will see a small indicator in the rulers that show your cursor's position; this can aid in the positioning of your copies.

Aligning the Images: Using a Grid

When aligning your images, you might even want to go one extra step: Add another layer just above the base (white) layer. Using the Line tool, draw a grid on this layer. You can use this grid as a guide for placing your images; just be sure you hide the grid layer before you print. Save a copy of this image with the grid to use as a guide for your next set of multiple prints.

7. Save and rename your image (be sure you identify it as a "multiple").
8. Although you can now print the image as is, I suggest that you flatten the layers before you do so. The file size will be smaller, and your image(s) will print out much faster. If you need help flattening the layers, refer to Chapter 18.
9. Print the image, and use scissors or a razor blade to separate the prints.

Printing a Contact Print Directly from Your Camera

Believe it or not, many—if not most—cameras enable you to print directly from the camera. The camera is hooked up directly to the printer; no computer is needed. I frequently use this feature to get a *contact print*, which is a catalog of thumbnail-sized images currently in storage on the camera.

As each camera and each printer will handle it differently, I won't go into the nitty-gritty of how to accomplish this task. Suffice it to say that your camera and your printer must be connected (in most cases, you'll use a cable to connect the port on your camera that you normally use to transfer data to your computer to the port on your printer that is usually used to receive information from your computer). Read your camera's and printer's manuals for more details.

Printing directly from your camera can be a quick way to see all the images you have taken.

Photo-Quality Papers: Suitable for Framing

Many printer manufacturers sell "photo quality" paper for their printers (you might have gotten a little sample pack when you bought the printer). As these photo-grade papers are expensive, you might want to try a few alternatives. If you are using an inkjet or laser printer, you can substitute any type of paper that you would normally print on (be sure it will travel through your printer without jamming). For example, you might go to your local office supply store and pick up some good-quality stationery or laser paper and try it out (you'll find that paper with a glossy surface works the best). You might also want to go to an art-supply store and try out some artist papers. A thin, good-quality watercolor paper can make a very good and interesting surface for your images. Try using colored paper. Experiment and have fun!

Go Acid-Free

Some types of paper have a very high acid content, which will cause the paper to yellow or discolor over time. To avoid this problem, ask your paper dealer for archival paper. You will have a good chance of getting this in an art-supply store. You might find the acid content of stationery paper written on the package.

Third-Party Inks

Third-party printing inks for the dye-sub printers can be found in professional photo stores or in photo magazines. These inks can yield even more beautiful colors than the inks supplied by the manufacturers. For example, some of the black-and-white ink sets yield startlingly beautiful quality—many let you print a four-color black-and-white image using subtly different colors of gray and black for the inks. I've seen prints made from inexpensive (under $600) printers sit beside traditional (analog) black-and-white prints with no discernible differences. With all that power and technology at your fingertips, you can make a superb color or black-and-white print and never get your hands wet! That's why we're digital. Viva control!

The Least You Need to Know

➤ For a quick-and-easy print, use 300dpi as the printing resolution of your images.

➤ You can print multiple copies of your image when you send the first image to the printer. You can also gang up multiple copies of your image on one page.

➤ Better-quality paper for your printer will give great results. Try to use a glossy stock.

Showing Your Pictures to Mom

In This Chapter

➤ Sending email and attaching photos

➤ Building a Web site and including text and photos

It might not always be convenient to drag someone over to your computer screen to look at your new beautiful piece of art, and printing an image out on paper and mailing it off to someone seems so slow and antique. After all, we live in the world of high-speed Internet connections and email. We can zip a message or file to someone anywhere in the world within minutes. So why not take advantage of this and send out your photos via the Web?

Let's look at two ways of getting your images out in the world:

➤ **Via email** I might not go into great detail on how to use your specific email program to send images to friends and family—there are so many programs out there that it would be impossible to cover them all. I will, however, show you the basics on how to prepare an image for transfer, and briefly discuss sending attachments via Microsoft Outlook and embedding images in messages in Netscape Communicator.

➤ **Via a Web site** Most Internet providers will allow you some space on their server to post a Web site. Why not take advantage of this great technology?

So read on and let's get ready to go cyber!

Preparing Your Images

The first thing you need to do is to determine what you want the receiver of your image to do with the file you are sending. Do you want her to be able to print the image out, or just admire it on her screen?

Remember, it can take a long time to push a big file down a phone line. You can get someone on the receiving end of your email pretty mad if a huge file jams up her download, especially if she has a slow modem. If you want the user to be able to print out the image, you will need to send her the entire file. If you want her to just be able to view it on her screen, you should reduce the file size to speed up the download time.

Here are some guidelines:

➤ If your image is destined for a monitor only, reduce the resolution of the file to 72ppi. After all, your screen reproduces an image at only 72ppi, so any more information will just be wasted. (Note: If you make your file size 5×7 inches at 72ppi, it will reproduce on the recipient's screen at 5×7 inches.)

➤ If color is not very important and if it's a monitor-only image, you can reduce the file size by changing the bit depth. When viewing an image on the screen, the difference between millions of colors and 256 colors is negligible. (Refer to Chapter 13 for more information.)

➤ Compress your file. All files, whether for printing or screen display, should be compressed before being sent. The best compression format for photographs is JPEG (**File, Send To, File Format**). As far as settings go, I find that **5** works fine, but you can experiment to find a setting that works best for you. (Note: The lower the setting, the more detail is lost.)

➤ If you are sending a few images at the same time, you can shed some additional file size by grouping the files together and "zipping" them in a lossless compression program such as StuffIt or PKZip. Many times, you will gain 100KB or so.

➤ Watch your file size. Depending on your modem speed and the receiver's modem, a large file can really clog up the works. Files larger than 300–400KB can take forever to transfer. To test how long it will take to send a file, I sometimes start a transfer as a test. Most modem software will give you an estimate of how long it will take to upload a file. If you find that it will take longer than you are willing to have your phone line tied up, cancel the upload, reduce the image's file size, and resend it.

Sending Digital Photos via Email: Attaching and Embedding

Just like any other type of file or document, you send digital photographs via email as *attachments*. If you've ever attached a document to an email message using your

email program, then you already know how to send photos! If you attach an image file to an email message, the email recipient must then save the attachment to her hard drive. Then, she can open and print the file using an imaging program.

Beware of Flu Bugs!

I cannot stress enough that you should use a virus-checking program to check all files that are downloaded to your computer. If possible, set your virus-protection program to automatically check all downloads. If you are the recipient of an attached file, check it before you open it. If you are sending or forwarding files, take the responsibility to check your files before they go out. You never know when some little varmint has gotten into your machine.

Depending on what type of email program you have, you might also be able to embed the image right into the body of an email, which means that when the recipient opens the email message, the image is visible (she need not download it and open it in an imaging program to view it). The downside to this is she might not be able to have access to the entire file. Also, although it can be printed out as part of the email message, it most likely will not contain a lot of resolution.

Demo: Sending Attachments Using Microsoft Outlook Express

Attaching a photograph to a Microsoft Outlook Express, which is a popular email program, is easy.

1. After you've compressed your image file, open Outlook Express, and click **New** in the top menu toolbar.
2. A new message opens. Type the recipient's email address in the **To** field, and type the subject of the message in the **Subject** field.
3. Type your message. To attach a photograph (or any other type of file) to the message, click the little **Add Attachments** button (the one with the paper clip).
4. Navigate your file directory until you find the file you want to attach.
5. Select the file you want to attach, and click **Add**.
6. When all the files you want to attach have been added, click **Done**.

335

7. In the lower section of your message, you will see a thumbnail for the photo(s) you have chosen. This indicates that the photo will be delivered to your recipient with your message.

The Add Attachments button

Microsoft Outlook Express allows a photo to be sent with email as an attachment.

Attached photo

8. Click **Send Now**.

When the email message arrives at its destination, the recipient will be able to see the image in the body of the message. Pretty cool!

Demo: Embedding Attachments Using Netscape Communicator

Sending an attached file in Netscape Communicator is similar to using Outlook Express:

1. After you've compressed your image file, open Netscape Navigator.
2. Open the **Communicator** menu and choose **Message Center**.
3. In Netscape Communicator, click the **New Message** button.
4. A new message opens. Type the recipient's email address in the **To** field, and type the subject of the message in the **Subject** field.
5. Type your message. To embed a photograph in the body of the message, open the **Insert** menu and choose **Image**.
6. Navigate your file directory until you find the file you want to attach.

7. Select the file you want to embed, and click **OK**.

8. Your photo will be inserted into the text body. Click **Send** to send the file.

The letter appears at the recipient's computer with the image as part of the text body.

What's Your URL?

Last weekend, I attended a family party. At the end of the party, I gave all my relatives my Web site address. When I got home, I quickly downloaded all the images from my camera and did a bit of editing. I then built a Web page and posted it and the images to my Internet service provider (ISP). Everyone at the party was able to log on to the Web site and view my images!

What better way to show the world your photographs than posting them on your own Web site? There are many Web page authoring programs available; many offer WYSIWYG (*What You See Is What You Get*) page building. These programs, such as NetObjects Fusion—which can be found on the CD that came with this book—are easy and fun to use, and will help you design and build Web sites without requiring you to know HTML (Hypertext Markup Language).

Demo: Got 10 Minutes? Let's Build a Page!

Before you start building your site, you should contact your ISP (Internet service provider) and find out the procedure for posting a Web site. Also, as this is a trial version, you might not be able to build the site you see in this demonstration. Be sure you follow the standard naming conventions to allow your friends to find your page easily.

The .nod Extension

Notice that NetObjects Fusion will append **.nod** (NetObjects database) to the site's name.

Starting to build a Web site with NetObjects Fusion.

1. Save an image to your disk in JPEG format, and crank up NetObjects Fusion (it's on the CD that came with this book; you might have to install it first).

2. When the **Welcome** screen appears, select **Blank Site**, and click **OK**.

3. The **New Blank Site** dialog box opens. In the **File Name** field, type *Your Name's* **Wonderful World** (replace *Your Name* with your name), and **Save**. Congratulations—you have just built your first page! This is called your *home page*.

4. Let's add another page. With the home page selected (it will have a blue outline), click the **New** button in the menu bar.

5. A new page will appear just below the home page. With **Properties** dialog box open (open it if it isn't already open—**View, Properties**), you can name the page whatever you like.

6. Let's start to add some text and graphics to our site. Select the home page, and click the **Page** button in the menu bar.

7. You will see the home page and a layout grid. To add text, begin by selecting the **Text** tool from the floating tool palette (click the button with the **A** on it).

8. On the layout grid, click and drag to create a box of any size. In this box, type **Welcome to** *Your Name's* **Web Site**.

Many pages can be easily added.

9. The **Text Properties** dialog box should be floating on your screen (if it is not, open the **View** menu and choose **Properties Palette**). In the dialog box's **Format** tab, select the type size and color. Note: You can also select a font, center the text, and more from this palette. However, because of HTML language limitations, these options will not be as flexible as you might be accustomed to.

Text is easily added.

10. To add a photo, begin by selecting the **Picture** tool from the floating **Tool** palette (the **Picture** tool is just below the **Text** tool).

11. Just as you did with the **Text** tool, click and drag to create a box of any size in the layout grid.

12. When you release your mouse button, the **Open** dialog box will appear on your screen. Navigate to the folder where the photo you want to add resides (remember, you're using the photo that you compressed in JPEG format in step 1), and double-click to select the photo.

13. The photo appears on the layout grid. You can use the Arrow tool from the floating **Tools** palette to move the photo (or anything else) around on the page.

Adding photos is a snap!

14. To preview what you have accomplished so far, click the Preview button on the menu bar. Fusion will quickly convert your site into HTML code and open your Web browser for you. Pretty fancy!

15. Go ahead and add more images or text to your home page or to your second page (the one you created in steps 4 and 5).

16. To save your page(s), open the **File** menu and select **Save Site**.

17. To exit NetObjects, open the **File** menu and select **Exit**. You're done!

18. You should also contact your ISP (Internet service provider) to find out their procedures on uploading a Web site.

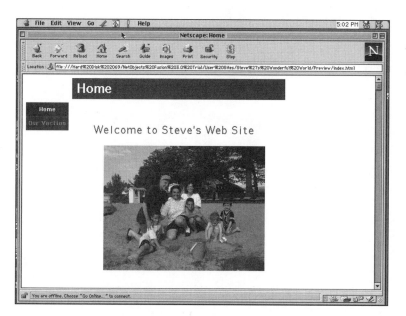

The Web site can be previewed in a browser to see what you have accomplished.

To learn more about posting your Web site, check out NetObjects' Web site (**http://www.netobjects.com**) and download the demo or manual. Note, however, that you will not be able to publish (post) your site with this trial version. You might also want to check out a few other Web authoring programs before you decide which one to buy. Unless you are going to be building a professional site, most authoring tools will more than meet your needs.

The Least You Need to Know

➤ You can send your images attached to your email.

➤ You can also embed your images into your email text.

➤ A personal Web site can be made very easily and quickly, where you can post your photo for the world to see!

A Few More Points of View

We have had a lot of fun learning about digital photography! Before I let you loose on the countryside taking pictures at will, let's look at a few more fun ways to see photographs.

Hi, Mom! I'm on TV!

Many newer digital cameras have the capability to send out a video signal, which enables you to view the images stored in the camera's memory on your TV! Actually, the TV is not the only device that you can send a video signal to. The camera can be hooked up to an LCD screen or overhead projection system, which means that you can use your camera for a business presentation. Imagine you just spent the day touring your manufacturing plant and need to show the bosses how they can increase production. All you need to do is hook your camera to a projection system and give your show.

To do this, insert one end of a video cable in your camera's video out port, and the other end to the port on your television or VCR, or your projection system. (And some people think torture via slideshow was a thing of the past!)

Sprucing Up Your Screen with Wallpaper

It is very easy to take your favorite photo and use it as a background, or *wallpaper,* as we computer jocks call it, for your Windows or Macintosh screen.

Before you actually turn your image into wallpaper, you want to adjust its size so that it fills the entire screen. To do so, you must first find out the pixel dimensions of your screen. If you run Windows, you can determine this by opening the Control Panel (click **Start**, choose **Settings**, and select **Control Panel**) and looking up the resolution in your **Display**, **Settings**. Folder. If your computer is a Mac, simply look in the Monitor control panel, found in the Control Panels folder. Then do the following:

1. In PhotoDeluxe, open the image you want to show on your screen. (Be sure you are working on a copy of your image as opposed to the original.)
2. Open the **Size** menu and select **Photo Size**.
3. Resize your image to match your screen resolution. For example, if your screen resolution was 640×480, make your image those dimensions.

Distortion?

You might find that your image becomes stretched or distorted if it is not in the correct *aspect,* or ratio from height to width. If you don't like this unintended special effect, just change *one* of the dimensions—the length, for example—and let the width *fall,* or self-determine. You could also add a little black background to your image to fill out the frame, if needed.

4. Save your image.

Demo: Creating Wallpaper for Your Windows Machine

To turn your image into wallpaper for a Windows machine, do the following:

1. Open your resized image in PhotoDeluxe.
2. Open the **File** menu, choose **Send To**, and select **Wallpaper**.

3. PhotoDeluxe makes a copy of your image, saving it in the BMP format. The copy, called **PhotoDeluxe.bmp**, is stored in your main **Windows** folder with the rest of the Windows wallpaper files.

4. PhotoDeluxe automatically places the wallpaper you just created on your screen.

You can select whether you want your image to be tiled (that is, smaller versions of the image are repeated onscreen) or fill the entire screen:

1. Right-click an empty area of the Windows desktop.

2. Choose **Properties** from the menu that appears.

3. Click the **Background** tab.

4. Choose either **Tile** or **Center**.

5. Click **OK**. You're finished!

Demo: Creating Wallpaper for Your Macintosh

Turning an image into wallpaper for your Mac is pretty easy, but the procedure will be a little different depending on what version of the Mac OS you have. I'll demonstrate the technique for Mac OS 8:

1. In PhotoDeluxe, save the picture you want to turn into wallpaper as a PICT file (open the **Send To** menu, choose **Image Format**, and select **PICT**) on your hard drive.

2. Open the **Desktop Pictures** control panel. (Note: If you don't see this control panel listed, find it in your **Disabled Control Panels** folder, move it into your **Control Panels** folder, and restart your machine.)

3. Choose **Select Picture**, and find your photo. Click to select it; the image should pop up in the dialog box.

4. Use the **Position** drop-down menu on the left side of the dialog box to specify the position of your image and whether you want it to be tiled.

Solid Gray

I suggest that while you are working on an imaging project, you have a solid gray background on your screen. Otherwise, your color perception will be influenced by the colors in the background.

5. You're finished! Check out the wallpaper picture of my sister-in-law and her daughter that follows.

6. Please note that in System 8.6, the control panel is named **Appearance** and within that is a section named **Desktop**. You have to choose "**Place Picture**."

345

A cute picture of my sister-in-law, Renana, and her daughter, Moriah, for my wallpaper du jour.

Oh, Say, Can You See: QTVR

A wondrous technology called QuickTime Virtual Reality (QTVR) is evolving at a spectacular rate. QTVR technology, which was developed by Apple Computers and is available for both Macintosh and Windows platforms, rapidly exchanges images on your screen in order to *animate* them—making what appears to be a movie. Because this technology uses small, low-resolution JPEG images, it is the perfect vehicle for delivering movies on the Web; you might have even seen one.

QTVR movies are used primarily in two ways:

➤ **Object movies** rotate an object, such as an automobile or some other product, in front of a camera. Each time the object rotates 10°, for example, a photograph is taken. After all 36 images are taken (36×10° = 360°), all the images are processed into an object movie. The viewer can rotate the image on his screen and see the front, back, and sides of the image. To take the process one step further, the camera's point of view can be moved below the image, in front of the image, above the image, and behind the image—again in 10° increments. The results are a 360°×360° view of the product. Simply put, virtual reality!

➤ **Panoramic movies** (also called *panos*) rotate the camera 360° from a fixed point. With a panoramic movie, you could show the entire view from a country hilltop or the entire interior of a room. You could dial up a realtor's Web site and take a virtual tour of a home, or see what the catering hall you want to rent looks like before you visit! A panoramic movie is made by taking many photographs—up to 20 or more—and "stitching" them together to make one large and long image. After this is done, the software will *blend* the images so

that the entire panoramic image is uniform in exposure. If you don't want to make a pano movie, you can take the same photos and make a large panoramic image as follows.

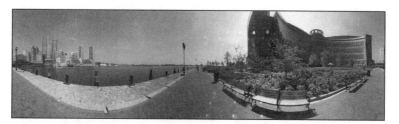

A wonderful panoramic view of Boston Harbor as seen from in front of the new U.S. District Courthouse.

What's with the Distortion?

You might notice that the preceding image looks a little distorted—see how the sidewalks approach and lead away from the camera? This is because you are looking at a 360° view. The stitching software will remove the apparent distortion during the process of making the movie.

Demo: Making a Panoramic Movie

We will use the program VR Panoworx (included on this book's companion CD) to build a QTVR pano movie. Before you start to work on your pano, however, you'll need to do the following:

➤ Download the QTVR plug-in from the Apple Computing site (`http://www.apple.com/quicktime/download`). You will need this plug-in to build your file and also to view it. The file will also need to be in your Web browser plug-in folder in order to view a QTVR movie.

➤ Acquire a very steady tripod with a level on it to allow you to ensure the camera is level to the ground. The tripod should be marked with degrees so you can make precise movements. I use a special panoramic tripod head (that follows) that enables me to level the camera and rotate it in precise increments. If you want to use a panoramic tripod head like I have, more power to you. If not, be sure you have a steady tripod head, and bring a small spirit level with you (you can buy one of these in a hardware store).

➤ Set your camera lens at as wide a setting as possible or, if your camera is capable, attach a wide-angle lens adapter to it (the lens used to take the panorama in the preceding figure was a 20mm lens, 35mm equivalent).

A panoramic head ensures your camera will be level and rotate precisely around the center of your tripod. The Kodak 265 camera shown here is mounted with an additional wide-angle lens.

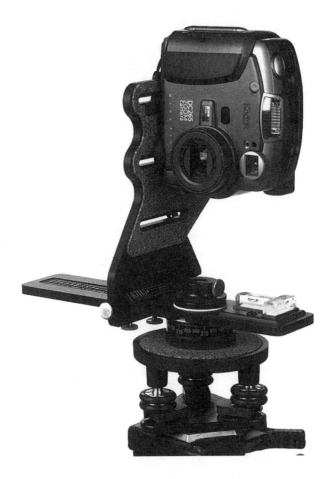

Next, go outside and pick a wonderful place to photograph. Remember, a panoramic image will show a 360° view; be sure to have interesting subject matter all around you. After you've found your spot, do the following:

1. Mount your camera on the tripod head (note: the camera lens should be centered directly over the center of the tripod's rotation) and orient the camera so it will take a vertical picture.

Don't Want to Take Your Own Pictures?

For those of you who don't want to take your own pictures—or can't wait to do the demo—I have supplied images on the demo CD. If you really don't want to do any work, open up the file **Harbor.pvr** and follow along. Please remember that the demo image—and all images on the demo CD, for that matter—are copyrighted and not to be published or included on a Web site.

2. Using the level you brought with you in combination with the levels on your tripod head, be very sure the camera is level to the ground. The base of the camera (where it attaches to the tripod head platform) must be exactly 90° from the ground, and the lens must be parallel to the ground (it must not be tilted forward or back). It will take a few minutes to get leveled out, but it is critical to the entire process. Take your time.

3. Rotate your camera 18°, and take a picture.

What About Resolution?

If you are planning to use the images only on a Web site, you don't need to take very large images. You can set your camera on low to medium resolution. If, however, you are planning to print out your image, go for it! Get as big an image as possible.

4. Repeat step 3 until you've completed the 360° clockwise rotation (you should end up with 20 pictures). Be careful not to miss a position, and be sure you don't repeat any.

An Alternative...

You don't *have* to take 20 pictures, each 18° apart; the trick is to take a number of pictures that easily divides into 360. So you could take 18 pictures at 20° apart; you could take 15 pictures at 24° apart; 24 pictures at 15° apart; and so on. The more images you take, the smoother your final animation will be. I find that 20 images works nicely.

Tab-Driven Software

One thing I like about this software is that it is *tab driven*. That is, you must complete each detail in a tabbed section before you are allowed to continue. This helps guide you through the program smoothly.

5. Open the PanoWorx software found on this book's companion CD.

6. In the **Setup** tab, select **Multiple Images** from the **Source Format** drop-down list.

7. Set the **Max Frames** spin box to **20** (or however many photos you took in steps 3 and 4).

8. In the **Lens Params** area, enter the focal length of your lens in a 35mm equivalent format. (I used a 20mm lens to take the images for my demo, so I've entered **20**.)

9. Fill in the **Image Size** field (you might have to open one of your images in PhotoDeluxe to check the size of the image).

10. Click the **Acquire** tab.

11. The **Acquire** tab is where you import your images; images are inserted in the ring in the center of the page. Click the **Multiple** icon.

12. In the **Open** dialog box, navigate your file directory until you get to the folder where you stored your images (or to the CD where my demo images are stored). When you find the images, click the first one to select it (in my demo, it is called **untitled 101**).

13. Click the **Add 20** button.

14. When all the files appear in the lower section of the dialog box, click **Done**.

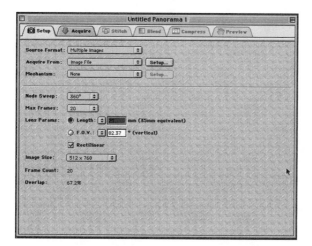

The first step in building the pano is to specify the lens size, the number of pictures taken, and so on.

A Preventive Measure...

Computers place files in order by using the first letter or digit in the files' names. So if you were to look at a list of files in numeric order from 1–20, the list would be in this order: 1, 2, 20, 3, 4, and so on. If you were to import those files into the stitching program, which automatically imports in numeric order, you'd have a mess on your hands.

To prevent this, you should rename your files by adding 100 to the file name. For example files 1–20 would become 101–120. This way, your files will be imported into the stitching software in the correct order.

15. The **Open** dialog box closes. You are returned to the **Acquire** tab, where the images you selected fill the ring in a clockwise rotation.

16. Click the **Stitch** tab.

The second step in building the pano is to import the images.

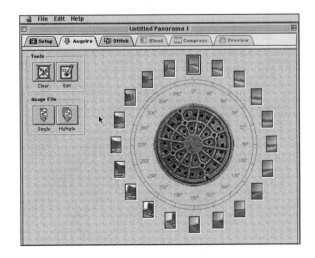

17. Click the **Stitch** button in the **Stitch** tab to begin the stitching process. When the process is finished, it will look like the following figure.

The images are stitched together.

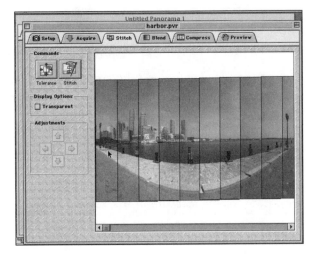

18. Click the **Blend** tab.

19. Leave the **Sharpen** and **Blend** sliders at the defaults, and click the Blend button. This will smooth out the stitched image and blend the exposures together. Your screen should look like the following figure.

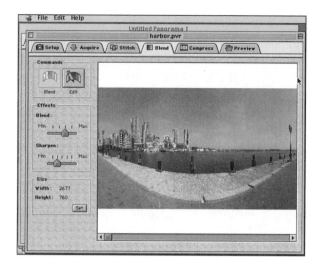

The images are blended together to smooth out the stitching process.

20. Click the **Compress** tab.

21. Click the **Set** button to view a menu of compression routines.

22. Select **JPEG**, set the compression rate at **40** (just below midway), and click **OK**.

23. Click the **Compress** button. The progress bar will show "tiles" being compressed; these tiles are the images that the QTVR software will rapidly display when viewed.

24. Click the **Preview** tab.

25. The preview page shows your image, all but finished (see the following figure). Click and drag in the preview area to spin in one direction or the other. (If you get dizzy, you might want to sit down!) If you move your cursor up, the image will tilt up; move it down to tilt down.

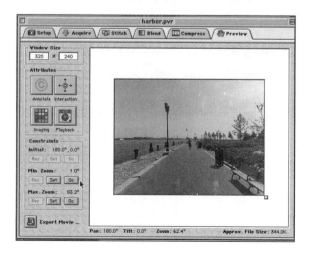

The image is complete and ready to compress into a QTVR movie.

353

26. Rotate the movie until the city comes into view.

27. Find the **Initial** area in the **Constraints** box; click the **Set** button to set the starting point for the movie.

28. Click the **Export Movie** button in the lower-left corner of the Preview tab to create the QTVR movie.

29. Name your QTVR movie, but leave the settings alone (they should be set for QuickTime 2, and the **Optimize for the Web** box should be checked).

30. Be sure to save the VR PanoWorx file. (Open the **File** menu and choose **Save**. I like to give my file the extension **.pvr**, for Pano Virtual Reality, so I can tell it apart from other files.)

You can view the movie by playing it with the QTVR Movie Player. Just double-click the movie file, and it will play.

Demo: Making a Panoramic Image

To make a single panoramic image as opposed to a panoramic movie, do the following:

1. Open your saved PanoWorx file from the preceding demo.

2. Skip to the **Blend** tab. You should see a complete blended image in the preview box (which is why the **Blend** button is grayed out).

3. Open the **File** menu and choose **Export**. The software will then make a panoramic image and save it to your hard drive.

4. You can open this image in any image-editing program, such as our old friend PhotoDeluxe.

The Least You Need to Know

➤ You can show your images on a TV screen and impress everyone!

➤ You can create "wallpaper" for your monitor with your images.

➤ You can make wonderful panoramic images with QuickTime Virtual Reality software by "stitching together" images.

Part 6

Appendix

Are you confused by terminology? Check out the Glossary and find easy-to-understand explanations for all those new "digital" words. You will be able to amaze your friends and impress your boss with your newfound knowledge.

Speak Like a Geek: Digital Photography Words

acquire To transfer files from digital equipment such as a camera or scanner. Also used to transfer from one format or program to another.

aperture The mechanical opening in the lens that lets light in. Refers to the *iris* or *diaphragm*.

artifact Erroneous information in the image. Usually due to faults in compression, low light, or poor-quality cables.

ASA/ISO Rating given a camera or film denoting its sensitivity to light.

auto focus A camera or lens that focuses itself.

available light Light present in a room or environment, such as sunlight or existing room lighting, without the addition of flash or flood lamps.

bit Geek speak for a *binary digit*.

bit depth Refers to the color capacity of a pixel. For every bit, a pixel can carry one color.

bitmap The description of an image or graphic onscreen bit by bit.

bleed When an image exceeds the size of a page. If an image needs to cover an entire page, it is bled off the page so no edges show after the page is trimmed by the printer.

bounce light Light that is reflected off a card or wall.

byte 8 bits equal 1 byte.

CCD Charged couple device. A CCD converts light into electrical current.

CIE Color model developed by the Commission Internationale de l'Eclairage

cloning To copy one part of an image over another part. Also an essential part of a Fellini movie.

CMOS A Complementary Metal-Oxide Semiconductor that converts light to electrical current. Cheaper to manufacture but not used as much as CCD devices because of noise issues.

CMYK Cyan, magenta, yellow, and black color world used in printing. A color press uses cyan, magenta, yellow, and black inks.

color balance The process of compensating for too much of one color in an image. If an image is too blue, or out of color balance, yellow is added to bring the image back in balance or neutral in color.

color model A method of defining color. RGB, CMYK, and HSB are examples of color models.

color temperature An indication of the relative redness (warmth) or blueness (cool) of a light source. Color temperature is measured on a Kelvin scale. A household light bulb has a color temperature of 2800° Kelvin. Daylight has the color temperature of 6500° Kelvin.

compression The process of shrinking or squeezing data in an image file.

continuous tone Continuous and uninterrupted flow of bright to dark tones in an image.

contrast The ration of dark tone to light tones. An image with much contrast will lack mid or gray tones.

crop To remove unwanted portions of an image.

cyan A bluish/green color.

data Digital information in a computer.

default setting A preset setting suggested by the software; a starting point.

depth of field The measure of what area of a photograph is in focus.

digital Describes a system or device that stores, computes, or manipulates binary information. Also, a soon-to-be-forgotten computer company purchased by Compaq Computers.

disk A device that stores digital information. Usually, it is transportable.

download To transfer from one computer device to another, usually from a larger one to a smaller one. Example: You would download from an Internet Web site.

dpi Dots per inch. Refers to the measure of detail on a printer.

driver Software that communicates between two devices, such as between printer and a computer.

EPS Encapsulated PostScript. A type of graphics file usually associated with printing.

export To change from one file format, usually the native format, into another. Example: exporting a native PhotoDeluxe format to a TIFF format.

exposure To let light strike film or a digital chip. Also the determination of how much light strikes the film and for how long.

exposure meter An instrument that measures light to determine which aperture setting and shutter speed to use.

f/stop The measurement of the diaphragm or iris opening. The smaller the f/stop (higher the number), the greater the depth of field. Example: F/16 will have more depth of field than f/2.8.

file A collection of information such as an image or document.

file format The description of the arrangement of information within a file. Many software programs have native file formats, which enable them to read the file. Some file formats are specific to a program.

filter A color piece of glass which is attached in front of a lens. Also, an algorithm that is applied to an image to change it. Example: a sharpening filter.

fish-eye lens An extremely wide angle lens that yields distortion.

fixed-focus lens A lens that cannot be variably focused. It is preset to one range of distance, usually 12 feet to infinity.

Flash Pix A multiresolution file format. Not as yet widely recognized.

focal length Distance from the midpoint of the lens to the convergence point on the film plane. The focal length of a lens determines whether it is a telephoto, wide, or normal lens.

gamut Range of colors that a device can reproduce.

GIF Graphic Image Format. Originally a file format used by CompuServe and now a standard on the Web. A lossless file compression.

grayscale An image containing no color. Grayscale images contain white, gray, and black shades.

halftone An image produced on press. The press plates are exposed through a screen of dots to give the image a continuous tone.

HSB A color model describing hue, saturation, and brightness.

HSL A color model describing hue, saturation, and lightness.

hue Color.

index color Reducing the colors available to fit a smaller fixed gamut. Eight bits or less in depth. Usually used to reduce file size. Many colors used in images delivered on the Web are indexed.

jaggies Stair-stepped pixels usually on diagonal or curved parts of an image. Caused by low resolution.

JPEG Pronounced Jay-Peg. The Joint Photographic Experts Group developed a de facto standard lossy compression routine.

key light Main light source.

kilobyte 1,000 bytes.

lossless compression A file compression routine that does not lose any information.

lossy compression A file compression routine that does lose information. Unnecessary information is thrown away.

lpi Lines per inch. A measure of resolution on a printing press.

Mask A layer or selection in a file that is used to protect a portion of the image.

mega-pixel The measurement of a CCD field that totals more than 1,048,576 pixels.

Megabyte 1,000,000 bytes.

noise Unwanted artifacts in an image. Usually, noise appears in the dark areas of an image.

normal lens A lens that has the same focal length as the human eye. Approximately 50mm in relation to a 35mm camera.

PCMCIA card A removable memory card.

PICT File format, standard on Macintosh computers.

pixel Short for *picture element*.

pixelation A special effect that produces small squares or rectangles on an image. Also a result of low resolution.

platform Computer system.

plug-in Add-on technology or computer code. Usually associated with a filtering or special-effects program.

PPI Pixels per inch. Measure of image resolution.

RAM Random Access Memory. The thinking capacity of a computer. The part of the computer where information is processed.

red eye A red appearance of your subject's eye caused by the camera flash bouncing off the back of the eye. Red eye can be avoided by moving your flash farther away from the taking lens.

resolution Detail.

RGB A color model with red, green, and blue.

ROM Read Only Memory, where the computer stores its operating instructions.

saturation Purity or intensity of color.

shade A gradation of color with reference to its mixture with black.

sharpness Refers to focus, the ability to display detail.

shutter Device that opens and closes to allow light to strike film or a chip. Shutter speed determines your ability to capture action.

SLR Single Lens Reflex. A camera that allows the user to see through the taking lens.

speed The sensitivity of film or a chip to light.

strobe Electronic flash.

TIFF Tagged Image File Format. An image file format that is recognized by Macintosh and Windows platforms.

tone Value, brightness, or lightness. The amount of light a color reflects.

TWAIN A standard of communications between digital devices such as cameras and scanners, and computer software. TWAIN drivers allow the import of data from cameras and scanners.

vignetting Gradual falling of detail and tone of an image at the edges.

wide-angle lens A lens that has a very wide field of view. It can see a wide area. A typical wide-angle lens is 35mm (35mm camera equivalent).

WYSIWYG What You See Is What You Get. A term that refers to what is seen onscreen being what and how it will reproduce in print.

zoom lens A multiple focal length lens. A zoom lens can zoom between 80mm to 250mm, for example.

Index

D

N

O

P

U

V

Get FREE books and more...when you register this book online for our Personal Bookshelf Program

http://register.quecorp.com/